Sir John Boardman
was born in 1927, and educated at
Chigwell School and Magdalene College, Cambridge.
He spent several years in Greece, three of them as Assistant
Director of the British School of Archaeology at Athens,
and he has excavated in Smyrna, Crete, Chios and Libya.
For four years he was an Assistant Keeper in the Ashmolean
Museum, Oxford, and he subsequently became Reader in
Classical Archaeology and Fellow of Merton College,
Oxford. He is now Lincoln Professor Emeritus of Classical
Archaeology and Art in Oxford, and a Fellow of the British
Academy. Professor Boardman has written widely on the art
and archaeology of Ancient Greece. His other books in the
World of Art series include *Athenian Black Figure Vases*;
Athenian Red Figure Vases (volumes on the *Archaic* and
Classical periods) and three volumes on *Greek
Sculpture* covering the *Archaic, Classical*
and *Late Classical* periods.

Thames & Hudson world of art

This famous series
provides the widest available
range of illustrated books on art in all its aspects.
If you would like to receive a complete list
of titles in print please write to:
THAMES & HUDSON
181A High Holborn, London WC1V 7QX
In the United States please write to:
THAMES & HUDSON INC.
500 Fifth Avenue, New York, New York 10110

Printed in Singapore

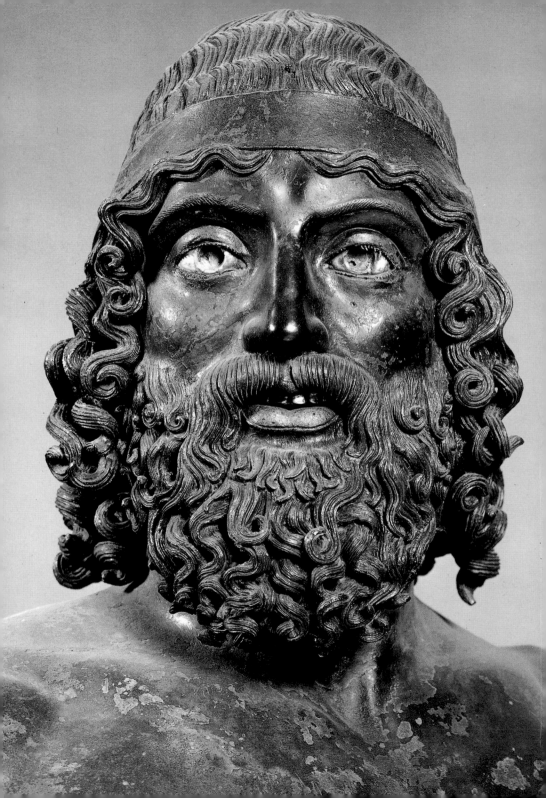

JOHN BOARDMAN

GREEK ART

Fourth edition revised and expanded

302 illustrations, 73 in colour

Thames & Hudson world of art

Frontispiece. See p. 15

*First published in the United Kingdom in 1964 by
Thames & Hudson Ltd, 181A High Holborn,
London WC1V 7QX*

www.thamesandhudson.com

© *1964, 1973, 1985 and 1996
Thames & Hudson Ltd, London*

Reprinted 2006

*British Library Cataloguing-in-Publication Data
A catalogue record for this book is available from
the British Library*

ISBN-13: 978-0-500-20292-0
ISBN-10: 0-500-20292-3

Printed and bound in Singapore by C.S. Graphics

Contents

THE GREEK WORLD

Olbia

Istros

nube

BLACK SEA

ACE

Sinope

Trapezus

Byzantium

Bosphorus

erinthus

Chalcedon

Heraclea

Halys

Sea of
Marmara

Cyzicus

Gordion

TROAD

PHRYGIA

AEOLIS

Pergamum

Tigris

os

Cyme

LYDIA

Karatepe

Phocaea

Sardis

Smyrna

CILICIA

IONIA

Maeander

Tarsus

nos

Ephesus

Antioch

Priene

CARIA

Perge

Euphrates

Miletus

Halicarnassus

Al Mina

Orontes

Cos

Cnidus

LYCIA

Xanthos

Phaselis

SYRIA

Lindos

CYPRUS

RHODES

Citium

Salamis

Paphos

raesus

RETE

Byblos

PHOENICIA

Sidon

Tyre

N E A N

Jerusalem

PALESTINE

Jericho

Alexandria

Naucratis

Memphis

Nile

RED SEA

Preface

The first edition of *Greek Art* was written in the early 1960s and later was only modestly adjusted to accommodate new pictures. When I wrote it I was, frankly, learning much of the subject as I was describing it. I cannot guarantee that I understand it better now than I did then, but I think I do, and have certainly had a wider experience of studying various aspects of it. New attitudes have also to be allowed for, though not all are proving fertile, and, as before, I am seeking a common ground of description and explanation that I hope will survive some years at least, to serve the general public and students embarking upon the study of classical antiquity and art. I have included some of the more peripheral areas of the subject and here have necessarily had to simplify, but I hope that this treatment will at least give an indication of wider horizons. The difference in this new edition lies partly in its increased length, in fuller account of various aspects of architecture and decoration, and of the role of art and artists in Greek society. Much of the last has been more carefully explored in the last thirty years. It enhances the possibility of our understanding what Greek art meant in antiquity and why it was so influential in later years. In a way I am trying to put Greek Art back into Greece and away from the traditional Art Book and Gallery. We admire it partly because it is from Greece rather than from any other source, partly for qualities to which we are still able (or have been conditioned) to respond.

I use the term 'classical' generically, 'Classical' for works in the high style of the 5th century. Formulations such as 'the Geometric', 'the Archaic', 'the Orientalizing' are simply a matter of convenience since the development from one style to another is smooth, only accelerated by outside influence or the brilliance of particular schools. It is easy to be deceived by terms such as 'about 500' or 'the 6th-century style', which were meaningless in an antiquity which did not know what century BC it was living in, but it is convenient for us. We can talk with more conviction about the different spirit of Quattrocento and Cinquecento Italy, and the passage into a new decade, century or millennium in modern times is more readily felt to be significant in some way – 'the nineties', 'the 'twenties', *fin de siècle*.

9

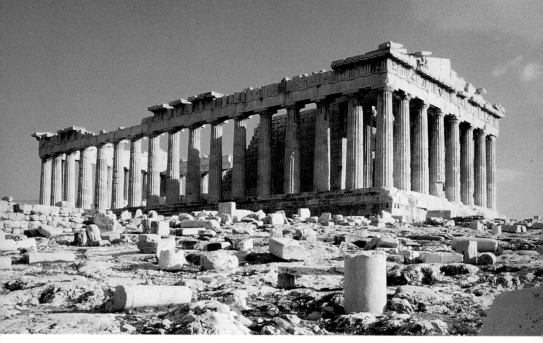

1 The Parthenon today in an unimpeded view not possible to an ancient visitor (compare [2]). Built 447–433 BC to the plans of Ictinus and Callicrates. All the ancient sculpture remaining (after Elgin had taken his Marbles to London), much damaged by pollution in the last fifty years, has now been removed, and the architecture is being skilfully restored

2 Model restoration of the Athenian Acropolis with the Propylaea and the Temple of Athena Nike in the right foreground, the Parthenon beyond, and the Erechtheion to the left centre. (Toronto)

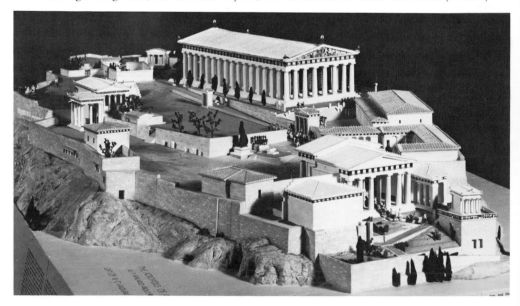

Introduction

I would say that the Parthenon now is probably much more impressive than
when it was first made. You feel the spaces much more, and the openings,
and the fact that it's not solid throughout and that the light comes in, makes
it into a piece of sculpture and not, as it was before, a building with four
external sides. It's completely spatial now.

The enthusiasm for light and space evoked by the greatest monument
of classical antiquity in a great modern sculptor, Henry Moore,
expresses much of what has for many seemed to be the principal appeal
of Greek culture and art: the expression of a people unsurpassed for
their purity of thought, behaviour and design, democrats, philosophers,
poets and historians, the true precursors of the modern world and all-
time successes in the pursuit of the true and the beautiful, expressing a
humanity that anticipated or even surpassed all that Christianity has
been able to achieve [1, 3]. The truth about Greek art and antiquity is
very different, yet in its way no less marvellous. For about half the time
span of this book Greek art was heavily dependent on non-Greek
example; thereafter it was a leader. That Athenian democracy should be
remembered by the name (Pericles) of the man who effectively ruled
the city in the mid-5th century BC says something about how demo-
cratic it was; Greeks could be ruthlessly cruel and spent more energy
fighting each other than any foreigners; slavery was an essential element
— but so it was worldwide at that date, and it seems that slaves, women,
the disabled and foreigners were marginally better treated in classical
Greece than in most places.

The starry-eyed view of Greece of a century ago was bred by genera-
tions of a classical education for western ruling classes, by the
undoubted role of classical literature in forming later western literature,
by the feeling that Greeks were proto-Christians, and by an almost
wholly distorted view of what Greek art amounted to. The brilliance
and pervasive quality of its legacy has little to do with its original func-
tion and appearance, but it has taken, and is taking, a long time to
understand just what these were. The Renaissance rediscovery of clas-
sical art led to a variety of Greek revivals in the arts and architecture,
culminating in the later 18th and 19th centuries in both fine architec-

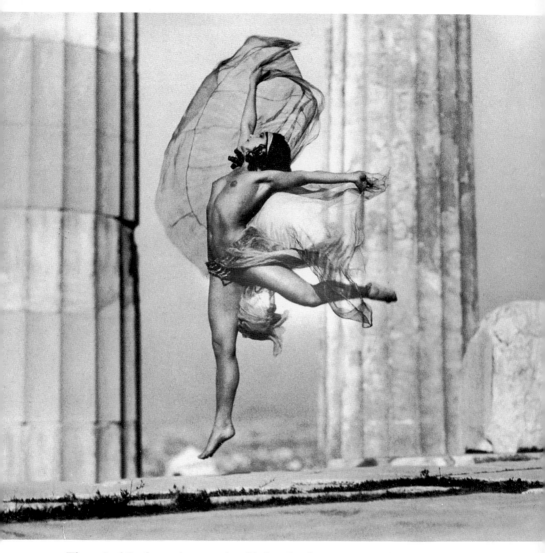

3 The ruined Parthenon has proved an ideal setting for a romanticized view of ancient Greece. Isadora Duncan danced on the steps, and here a Russian dancer, Nikolska, responds to its appeal in 1929

ture and rather vapid sculpture and painting. As a result, the architecture of many western buildings of up to fifty years ago was dominated either by a revival of a European Gothic style, or by classical colonnades and mouldings, often both together, while representational art in painting or sculpture (especially for cemeteries and memorials) was determined by a style invented in 5th-century BC Greece, transmitted by Rome and misread by the Renaissance. Even much modern art has been determined by the classical styles it has been consciously trying to shake off, and post-modernism still makes deliberate reference to the classical. We are conditioned to, or against, it by our man-made environment, and this does not make it any easier to judge dispassionately. Indeed, there is now a fashionable bias against the 'classical', even in scholarship.

We have then to try to understand Greek art in the terms in which it was devised, whatever the functions it may have exercised since antiquity, and however interesting it may be to observe modern reactions to the way it is presented in museums, books and the art market. It is retrievable. Even for Henry Moore who once

> thought that the Greek and Renaissance were the enemy, and that one had to throw all that over and start again from the beginning of primitive art. It is only perhaps in the last ten or fifteen years [his 40s] that I began to know how wonderful the Elgin Marbles are.

Even so, we may wonder whether his appreciation of the Elgin Marbles came anywhere close to their function and the intention of their creators, or was just a recognition of other, timeless standards of excellence. There is nothing improper about admiring them for the wrong reasons, but to try to recover the right reasons is a worthwhile exercise.

And for the Parthenon itself – that windswept child of space and beauty – in antiquity only its upperparts were visible from afar. On the Acropolis rock, crowded with statuary, monuments and other buildings [2], long since lost, it was mainly obscured until the visitor was close beside it, dominated by its size and the massive columns receding into the sky. It was bright and colourful, not white and austere, but hardly a temple of light. High above, the realistic statues and reliefs provided a presence of gods and heroes and mortals whose actions reflected on Athens' glory. The main part of the building behind the columns seemed a massive, solid marble block, floor to ceiling, pierced only by two doors, usually closed, and two windows. Within lay much of

Athens' treasure, and a rich symbol of her goddess' wealth in her forty-foot-high gold and ivory statue. The whole ensemble said more about power, prestige and patriotism than religion, and although the art and architecture were exquisite by any standards, their intent was far from what we would call artistic.

Empathy with a people long dead and appreciation of their art require a knowledge of their environment, their everyday visual experience, how they dressed, what they ate, how much or little they believed, how they treated each other, what their politicians and generals sought for themselves and their people. The richness of classical literature and monuments makes this a not impossible task, if we allow for the prejudices of intervening years; at any rate, it is worth the attempt, and although we know that each age creates its own view of history, we must hope that we become better able to make due allowances, can identify our prejudices, and avoid judging antiquity in terms of concepts created to help us survive and understand the 20th century and some of its arts.

In dealing with ancient art it is particularly important to try to see or envisage objects as they were intended, to remember that both sculpture and architecture were coloured, that the sculpture had a setting quite unlike that of any modern gallery, that even the most precious objects were for use and never displayed as in a museum showcase. Thus, the two splendid bronze warriors from Riace in South Italy [4] are exhibited several feet apart and almost alone in a large gallery in Reggio Museum where they can be viewed all round and separately. In antiquity they may well have been shoulder to shoulder, with others, and against a wall, and if we add in the mind's eye their missing spears and shields we have to acknowledge that, as presented, they wholly disguise their artists' intention. Or the Delphi charioteer [131], who is now the focus of a museum gallery, and not standing in his chariot with a team of no less admirable horses under a Greek sun. Furthermore, the accidents of survival, added to the esteem in which classical art is held, have made us not only tolerant of the fragment, the noseless, the limbless, but ready to accord them aesthetic status as subjects for the artist. This, indeed, they may deserve, but they were never so regarded by any Greek artist.

There are other respects in which the art of ancient Greece had a very different role to that of Art today. Until near the end of our period 'Art for Art's sake' was virtually an unknown concept; there was neither a

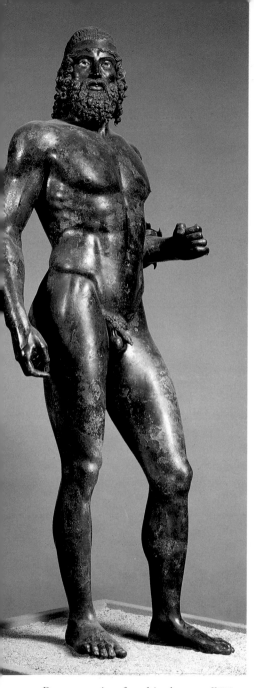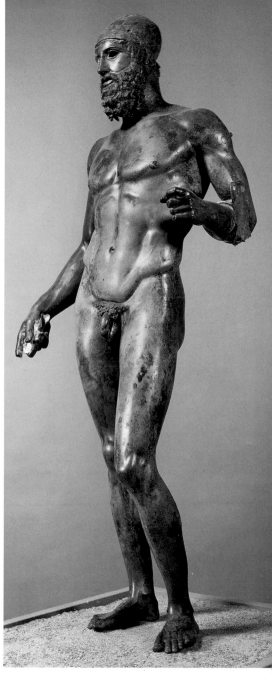

4 Bronze warriors found in the sea off Riace, near Reggio, S. Italy. To be restored with shields (both), spear (A), sword (B) and helmet (B). Copper inlay on lips and nipples, silver on teeth of A (*see frontispiece*). B's arms were restored in antiquity. They could be from a single group of heroes commemorating a victory and set up in a Greek sanctuary before being stolen for a Roman setting which they never reached. They are slightly over lifesize. About 460–450 BC. (Reggio)

real Art Market nor Collectors; all art had a function and artists were suppliers of a commodity on a par with shoemakers. Greek had no separate word for Art in our sense; only Craft (*techne*). The Muses of antiquity inspired writers, not artists; and the artists of Athens were under the protection of gods (Athena and Hephaistos) whose crafts were essentially practical or technological.

Finally, we must remember that a major part of Greek art, at least until the Hellenistic period and to a large degree thereafter, evoked images of their past – what we call mythology but what was to them history. And, as we shall see, they used their past in a remarkable way to reflect on the present, no less in their art than in their literature.

The principal sources for original works of Greek art are modern Greece and western Turkey (ancient East Greece), and the Greek colonial world of the Black Sea coast, South Italy and Sicily, but many works and artists travelled much farther. For the evidence of copies made in later periods our sources range the whole Roman Empire, and it is from these that we often have to judge important works of sculpture and painting.

The debris of classical antiquity was very conspicuous in classical lands, though always at the mercy of the lime kiln and melting pot or incorporation in new building, until deliberate collecting and the search for more began in 13th-century Italy. There the antiquities were almost wholly of the Roman period, although classical in style. The clay relief bowls (Roman Arretine) and coins were being collected already in the 13th and 14th centuries, while many classical gems and cameos had survived above ground incorporated in mediaeval furniture or bookbindings despite the new Christian settings for the pagan subjects. In the 15th century even Athenian red figure vase painting was being observed from fragments of the vases imported in the 5th century BC and deposited in Etruscan tombs. Some of the big Italian collections of sculpture were being formed, and not only from finds in Italy, for scholars were beginning to visit Greek lands and both Venetian and Genoese families were trading freely in the Aegean. The young Michelangelo was proud that his work could be mistaken for antique, and later artists like Piranesi ran studios in which incomplete statues, such as the pieces found in Hadrian's Villa at Tivoli, were repaired and completed.

Some major Greek works had reached Italy even earlier. The great gilt bronze horses which today stand over the entrance to St Mark's,

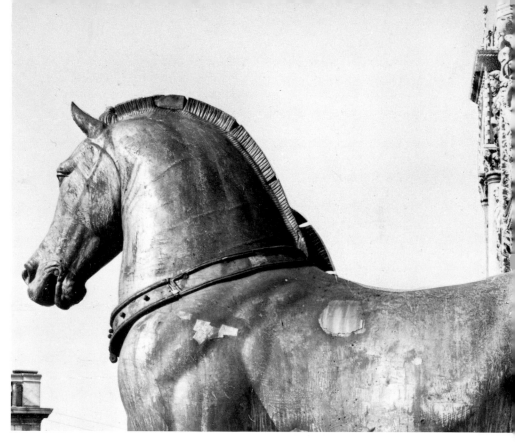

5 One of four gilt bronze horses above the entrance to St Mark's, Venice. Probably from a Late Hellenistic Greek chariot group

Venice [5], had been taken to the Hippodrome of Constantinople, from Chios in the 5th century AD according to one account, and thence to Venice, as part of the Crusader booty, in 1204. Others say they started their career in Rome. In Venice they were threatened with being melted down in the Arsenal, but the poet Petrarch and others recognized their value and beauty: 'Works of Lysippus himself', they said, since they were more familiar with the names of Greek artists from texts than they were with true Greek sculpture. The horses demonstrated the brilliant casting techniques of the ancients, to be rediscovered by Donatello. The prizes have not stood undisturbed on St Mark's. Napoleon took them to Paris in 1798 and mounted them on the Arc

du Carrousel in the Tuileries. They were returned in 1815, despite the popular outcry for their retention. And in the First World War they came down again under the threat of Austrian bombardment. Marble lions before Venice Arsenal also came from Greece: one from Piraeus, port of Athens, another a fine Archaic creature from Delos, which was brought in the early 18th century and had to be provided with a new head in contemporary style [6].

The big Italian collections remain an important source for the study of Greek statuary – in Roman copies – although the cult of the figleaf persists here and there, and the copy of Praxiteles' Aphrodite in the Vatican only lost the lead drapery swathed decently round her hips in 1932. Similar collections grew in France, where Louis XIV's sculptor, Girardon, was called upon to perform an early instance of plastic surgery on the Venus of Arles (another Praxitelean copy) to reduce her pose, dress and the contour of her breasts to something nearer contemporary taste. In England the Earl of Arundel [7], much of whose collection is in Oxford, had travelled in Greece and was able to acquire several

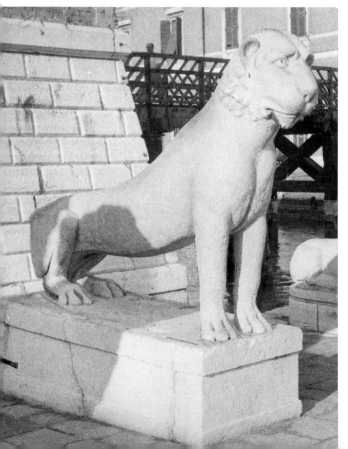

6 Marble lion before the Arsenal at Venice. The body is from Delos, of the early 6th century BC; the head is an 18th-century addition

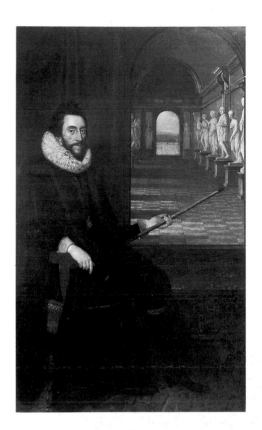

7 The Earl of Arundel (1585–1646) in his sculpture galley at Arundel House, London. Painted by Mytens. The Earl had visited Italy with the architect, Inigo Jones, and sponsored excavations there. Later he collected marbles from the Aegean area and his gallery was visited and admired by Rubens. Much of his collection is now in Oxford. Canvas, 2.04 × 1.25 m. (Arundel Castle)

interesting Greek originals in the early 17th century. One piece from his collection, now recognized as from the Great Altar of Zeus at Pergamum, wandered as far as Worksop, where it was built into the front of a Georgian red-brick house and refused by a firm of masons for breaking into chips before it was recognized and rescued in 1961.

But it was the really big finds of the late 18th and early 19th centuries that opened the eyes of western Europe to original Greek art. The sculptures of the Temple of Aphaea at Aegina went to Munich [79, 80]. The Parthenon marbles from Athens were acquired from Lord Elgin for the British Museum in 1816, and despite the condition of exhibition and some strong expression of prejudice, came to be valued at their true worth, and had a profound influence on artists, and on the more popular and scholarly ideas about Greece [134, 138–9]. C.R.Cockerell explored and drew the Temple of Apollo at Bassae, and its relief sculptures too came to London. When he built the University Galleries at Oxford

8 The staircase in the Ashmolean Museum, Oxford, with a restored and part-coloured cast of the frieze from the Temple of Apollo at Bassae (see [155]). Designed by C.R. Cockerell, 1845

(now the Ashmolean Museum) in 1845 he recalled the unusual column types of Bassae in the exterior, and at the top of the staircase set a cast of the sculpture frieze from the inner room of the temple, where, with its painted background and in an architectural setting at an appropriate height though far better lit, it can give some idea of the part such architectural sculpture can play in decoration [8]. Even the Great Exhibition of 1851 paid its tribute to antiquity, although when the historian of Greece, George Finlay, visited it with 'Athenian' Penrose, who had studied and elucidated the architectural refinements of the Parthenon itself, he wrote afterwards in his diary, 'Crystal Palace with Penrose. The frieze of the Parthenon is fearful coloured and the Egyptian figures not only men but lions and sphinxes look as if they were drunk.' There can be few civic buildings of Victorian Britain that did not have the Parthenon frieze somewhere on their walls.

Greek vases were being found in quantity in the cemeteries of Etruria and South Italy from the 18th century on. At first called Etruscan, their Greek character was eventually recognized, although the earlier vases of Greece, when they first appeared in Greek lands, were dismissed as Phoenician or Egyptian, so unlike were they to the classical statues and vase paintings. Greek and Roman gems and cameos were being copied

freely. The Grand Tour brought many more classical antiquities to the west, especially to Britain, to stock country houses. When marbles could not be afforded, plaster casts were bought instead, and the appreciation of ancient art in facsimile has played, and continues to play, an important part in studies. Coins were easily portable records of mythical figures and ancient portraits. Massive collections of moulds from ancient gems and cameos were assembled in the 18th century from which a selection of types – gods, heroes, emperors – could be selected by any collector, rather like Belgian chocolates, and mounted in book form [9] or in cabinets. This manner of study of ancient art in fac-simile (photo or cast) is by no means outdated, and indeed essential for direct comparisons to be made between pieces widely dispersed or even lost.

The 19th-century excavations in Greece itself revealed new treasures, both of major statuary such as the Olympia sculptures and the Archaic marbles on the Athenian Acropolis, with a host of other works on which scholars can now base a reasoned history of the whole develop-ment of Greek art. Later excavations have provided both new works of art and fresh evidence for the understanding and dating of works already known. Not all the finds are quite deliberate. Wrecked ships carrying statues, probably intended for Roman palaces or villas, have yielded some of the finest major bronzes of the Classical period. The Roman General Sulla sacked Athens' port of Piraeus in 86 BC, and seems to have surprised a shipment of statuary which never got away but was burned in its warehouse. The statues were rediscovered in 1959 while a sewer was being dug [118]. The dramatic find of the two bronze warriors from a wreck off Riace in South Italy has revolutionized our knowledge of

9 A 'book' of drawers of casts of ancient gems, published by P.D. Lippert, 1767. (Tübingen, Univ.)

the styles and techniques of the mid-5th century and taught us the inadequacy of judgements based wholly on surviving marbles. It might well be thought that the major sites likely to yield notable works have by now all been explored and exhausted. This is far from true. In the first place there are the many unexpected finds far from Greece which sometimes offer works unrivalled in Greece itself: I think of the tomb at Vix, little over one hundred miles south-east of Paris, which in 1953 yielded the largest and finest of all Archaic bronze vases yet known [*119*]. There are new sites in Greece too, such as the royal tombs of Vergina in Macedonia [*189, 191, 192*] where, it may be, we have the burial of Alexander the Great's father, Philip II. Meanwhile, the old sites are far from exhausted and the lower levels of great sites like Delphi and the Heraion on Samos still surprise us with their treasures. At Olympia it was too late by nearly two millennia to rescue the gold and ivory statue of Zeus, made by Phidias, and one of the Seven Wonders of the Ancient World. But in 1954–58 Phidias' workshop, in which the statue was made, was excavated, with its tools, scraps of ivory, moulds for the glass inlays and matrices on which the golden dress was formed; and in the corner the great artist's own tea-mug with his name incised on the base, 'I belong to Phidias' [*10*]. These finds may not take us much closer to the great statue, but they teach us a lot about how it was made, as well as offering a rather poignant relic of the greatest of all Classical artists.

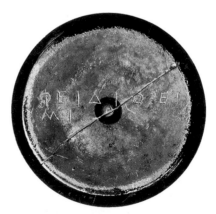

10 Base of an Athenian black cup with graffito of the signature of the sculptor Phidias, found in the studio at Olympia where he made the cult statute of Zeus. (Olympia)

Before the 5th century BC Greek art was *not* so different. In many ways the Aegean world had long been a westward extension of the civilizations of the Near East rather than European; not dependent upon them but similarly motivated and differing mainly in the smaller scale and lesser resources upon which power was based. This was partly a function of the relative poverty of the land in essential materials and of its geography, and in no way detracts from the quality of achievement in some periods and places (I think of early Cycladic art and that of the Minoan palaces). There is not *that* much to differentiate the sculpture and drawing of 8th- to 6th-century Greece from that of Anatolia, Mesopotamia and Egypt either in concept or physical appearance; it was more a matter of scale. But the 5th century introduced to world art the Classical revolution and an idiom which was totally at variance with the way in which man had hitherto desired to create images of himself, his gods and the world of and even beyond his experience. It was an idiom based essentially on idealized but realistic presentation of the human figure: a counterfeit of nature but somewhat more as she should be than as she was. The idealization was nothing new since it is almost normal in stylized and unrealistic figures such as the Archaic, but in the 5th century it involved adjustment of realistic anatomy in the interests of perfect symmetry, and suppressing much expression of particulars such as individuality, age, emotion. The realism *was* new, and for the first time in the history of art the artist shows complete understanding of how the body is constructed, how to express nuances of movement and, even more difficult, repose. Such impersonations or mimicry (*mimesis*) of the real world perplexed Greek philosophers, especially Plato, who was suspicious of art's deceits and its inability to express the absolute. Other cultures which seem to have been well capable of such realism, such as Egypt, had deliberately shunned it in favour of measures of stylization that in their way distanced art from life. This was very effective but not what the unusually humanist society of Classical Greece wanted. There was nothing essentially *better* about their approach, although it did prove, in its essentials, to have a more truly universal appeal than did the arts of other early cultures. This phenomenon is explored briefly in Chapter Eight because it helps us to understand what the differences are, regardless of whether Greek art is still capable of moving us or not. Part of it is explained by the way Greek art could provide a vivid means of recording the present and the past in images, and, however literate the society, images can always communicate more directly than words.

Renaissance scholars knew Greek and Latin texts, Roman art, and Greek art in Roman guise. The texts enabled recognition of subject matter and encouraged attempts to attach names of Greek artists (there were no names of Roman artists of consequence recorded). In the later 18th century the German scholar Winckelmann recognized that there was a problem in accepting an undifferentiated legacy of 'classical art' along with uncritical identifications, and attempted a real History of Greek Art and definition of the excellence of Greek style of the best period as well as its eventual decline. It was a remarkable achievement given that real Greek art was not available for study except in Roman copy and that he was led to over-emphasize the idealizing tendencies, as did contemporary neo-Classical artists (see Chapter Eight). His Apollonian view, extolling the Apollo Belvedere [11] as the epitome of Greek taste, inevitably found its counter in studies which emphasized the darker, Dionysiac, side of Greek culture, a view developed by the philosopher and classicist Nietzsche. Exploration of this balance, or polarity, depending on what you wish to prove, has remained important in later studies and abets the mood of a scientific age that likes to impose patterns of thought and behaviour on the history of man.

For the 19th-century connoisseur and scholar knowledge of original Greek sculptures, and the ability to recognize the Greek origin of pottery imported to Italy in antiquity, helped to redress the balance, if slowly. A major period of organization of material, mainly by German scholars, in the later 19th and early 20th centuries, successfully identified sources and dates for most major classes of surviving Greek art. Knowledge of the date and origin of works is a necessary prerequisite for exploration of their function and quality. The process continues with greater refinement to the present day although such connoisseurship is sometimes disparaged by scholars who prefer wider horizons and may have been put off by the rigours of the discipline. Thus, techniques of attribution devised for Italian painting by Morelli were applied successfully to Greek vase painting, which is in fact a more receptive medium for such techniques, and the styles and careers of many nameless ancient artists recovered. Recognition of the role of the individual in the history of Greek art then proves to be as important as recognition of the needs and expectations of the society he served.

Art history in the later 20th century has been driven largely by other preoccupations, all of which can be found to have bearing on our understanding of Greek art, though to varying degrees. Many of these

11 The Apollo Belvedere, copy of a Greek bronze original of the 4th century BC. Known in Rome by AD 1509 and hailed, wrongly, as a sublime Greek original. It shows the god stepping forward to threaten with his bow. Height 2.24 m. (Vatican)

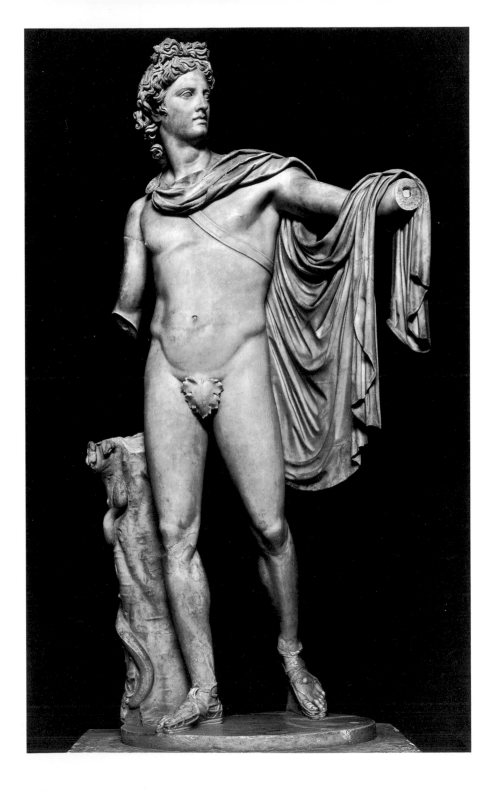

have been generated by anthropological, philosophical, psychological and perceptual studies provoked to some degree by the problems of the 20th century, much of whose intellectual life has become positively anti-classical in mood or conditioned by new social pressures. Ordinary people learn to live with these; scholars have sometimes found it more difficult to reconcile new approaches with their study of antiquity, and it is possible to be seduced into application of theories which could have had no comparable application in the distant past, and to fail to try to formulate afresh those that might. The most important progress has been through recognition of the fact that Greek art needs to be, and can be, understood on Greek terms, requiring a far fuller understanding of the society for which it was made than can be provided by preconceptions about ancient Greece based solely on conventional interpretations of Greek texts. Thus, the fact that we understand better now the role of Greek myth, or of Greek theatre, also enhances our understanding of Greek art. We have learned to discount the impression given by the realistic appearance of classical art and to recognize how much it depended also on formula, convention and even mathematics. We have learned to understand that the rich subject matter, mythical and genre, that had seemed simply a valuable illustration to texts, had a far greater contemporary significance and conveyed important messages about status, politics and religion. All this brings us much closer to a people whose intellectual achievements (also much disparaged by some today) we have good reason to admire. We are learning the language of Greek art, how it could communicate ideas, its remarkable role in a society more encompassed with figurative art than most in antiquity.

The New Archaeology of the 60's encouraged a more scientific approach to problems of antiquity. The importance of the work of the scientist, in collaboration with the archaeologist, in elucidating problems of technique, date and origin of materials, cannot be overestimated and these studies have revolutionized some areas of the subject. Elementary statistics too can prove a valuable corrective to obsession with the better-known but perhaps unrepresentative single monuments, but need to be used with the knowledge that we have a tiny percentage of antiquity surviving for study, that most samples are biased and inadequate, and that whole classes of objects are lost for ever (most wood and textiles, for example). There is a danger too that formulaic or graphic presentation of material or problems may carry an air of scientific credibility that the evidence cannot sustain. Strangely, even the

wisest seem capable of being led into the mistake of thinking that what we have is all there was, or that a single monument of importance to us was also itself influential in antiquity, rather than any of its myriad kin. The Structuralist approaches of anthropologists to the understanding of society and behaviour were illuminating, even in the study of art, but in some hands acquired the status of a faith that was deemed to over-rule contrary evidence. Womens' studies encourage us to think about what contribution might have been made by women, especially indi-rectly to crafts they did not normally practise themselves in the home. Could their role have been as notable as was Sappho's in the history of literature? They were also the prime customers for some products, and customers to some degree always determine what is made for them. No less than men they were confronted with the messages of major public art, although their restricted role in society probably meant that their point of view was seldom much regarded, and their reactions may have been profoundly different. It seems possible for resentment over this restricted role, from antiquity to the present day, to colour interpreta-tion of antiquity. A developed historical sense is required, and generally most extreme or uncompromising modern attitudes to the past prove to be wrong, though seldom entirely unrewarding.

One last problem in the study of Greek art is that of copies and forgeries. Ancient copies of earlier, famous works, are often our only evidence for the appearance of masterpieces, yet expertise with ancient descriptions and Roman copies, whatever its intrinsic merit, can bring us but little closer to the originals, and in a brief history such as this, these studies can be largely ignored in favour of the many original works surviving. The Neo-Classical copyist or forger can seldom deceive us – but the modern one can, and so hard does he press on the heels of the scientist that it is better now to ignore any work which has no pedigree and exhibits any peculiarities of style, plausible or not. It is sometimes hard to decide who is working the faster – the forger or the illicit exca-vator. Neither deserve continuing success but the many genuine and important works which appear from nowhere must be taken into consideration by any serious student. Yet even in this area a measure of censorship of scholarship is being practised by those who rightly dis-approve of a practice that no one can effectively control. The scholar who 'sits on' important finds without publishing them, while denying access to others, is hardly more tolerable than the grave robber.

The perplexity with which scholars faced the evidence of those works of Greek art which are earlier than the Classical has already been remarked. Certainly, a Geometric vase is as different as it can be from a red figure one, and there is little in 7th-century sculpture to suggest that within two centuries Greek artists were to carve statuary of the quality and appearance that we admire on the Parthenon. In a way this is the most remarkable lesson of any history of Greek art: its rapid development from strict geometry admitting hardly any figure decoration, to full realism of anatomy and expression. Perhaps this was the result of continual dissatisfaction, an unease which the Egyptians, for instance, never felt with an idiom that served them successfully for millennia. In Greece we shall see how the early geometry broke before the influence of foreign arts, and how the Greek artists absorbed these alien techniques and forms to weld them into an art in which the best formal qualities of a native tradition remained dominant. And then, at about the time of the Persian Wars in the early 5th century, a break with Archaic conventions heralded the Classical revolution, achieving that unparalleled blend of realism and the ideal which we recognize as the hallmark of the classical, centred on representation of the human body. In the Hellenistic period, following the short but brilliant and influential career of Alexander the Great, new functions for art and an almost baroque tendency begin to break down classical standards until all is resolved into the more nostalgic, or selfconscious and, in all but architecture, repetitive styles of the Roman Empire. These were to be the inspiration for new arts, generally far from Rome itself, but they were the modern world's first introduction to Greek art.

In these chapters the theme is one of change and development with some emphasis on the less well-known arts which are too readily forgotten, and special emphasis on original works rather than copies. Histories of art tend to be written around the few stock masterpieces. It is well to realize how much more there is and the fullness of the evidence. In choosing the pictures no conscious effort has been made to include all the old favourites, any more than to deliberately seek out the unknown. So this is less a handbook than an attempt to explain Greek art, with as full description and illustration as space permits.

The Beginnings and Geometric Greece

There is no difficulty in tracing the development of the classical tradition in Western art from Greece of the 5th century BC, through Rome, the Renaissance, to the modern world. Working backwards, to its origins, the story is no less clear, but it is extraordinarily varied and there are two views about what should be regarded as its starting point. Once the Geometric art of Greece was recognized as Greek, the steps by which it was linked to the Classical period were quickly discovered. This was the work of scholars of the end of the 19th century, who were at last able to show that Classical art was not a sudden apparition, like Athena springing fully armed from the head of Zeus, nor a brilliant amalgam of the arts of Assyria and Egypt, but independently evolved by Greeks in Greece, and its course only superficially conditioned by the influence and instruction of other cultures, however important these had been in the preceding three hundred years.

But even while the importance of Geometric Greece was being recognized, excavators such as Schliemann and Evans were probing deeper into Greece's past. The arts of Minoan Crete and of Mycenae had to be added to the sum of the achievements of peoples in Greek lands, and now that it has been proved that the Mycenaeans were themselves Greek-speakers the question naturally arises whether the origins of Classical Greek art are not to be sought yet further back, in the centuries which saw the supremacy of the Mycenaean cities.

The problem has been to find links across the Dark Ages which followed the violent overthrow of the Mycenaean world in the 12th century BC. It would be idle to pretend that there are none. There was continuity of race, and of language (although not writing) and craft continuity, albeit at a fairly low level. Moreover, the Dark Ages are now not so dark, and there were some stirring architectural achievements and indications of artistic activity at a high level though of foreign aspect already in the 11th century. But the fact remains that Mycenaean art, which is itself but a provincial version of the arts of the non-Greek Minoans, is utterly different, both at first sight and in many of its prin-

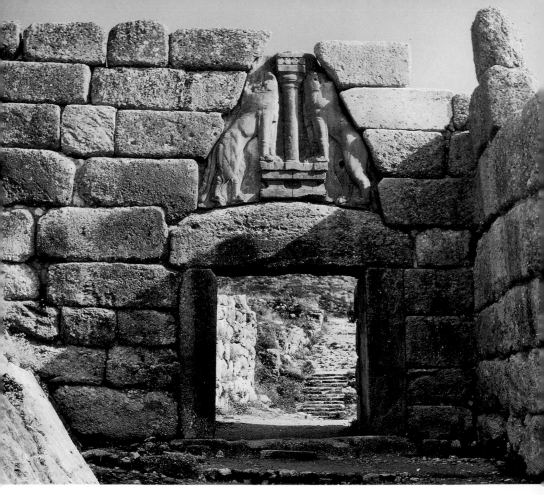

12 The Lion Gate at Mycenae. Two lions, their heads missing, stand at either side of an altar supporting a column. The triangular gap filled by the relief slab helps relieve the weight of the great lintel. 13th century BC

ciples, to that of Geometric Greece. For this reason our story begins within the not-so-Dark Ages, with Greek artists working out afresh, and without the overwhelming incubus of the Minoan tradition to stifle them, art forms which satisfied their particular temperament, and out of which the classical tradition was to be born.

For this reason the only picture here of Bronze Age, Mycenaean Greece is probably the most familiar one – the Lion Gate at the main entrance to the castle at Mycenae [12]. There is more, however, than its

familiarity which suggests its inclusion. It was one of various monuments of Mycenaean Greece which must have remained visible to Greeks in the classical period, beside massive walls which they attributed to the work of giants. And it illustrates two features of Mycenaean art which were not learnt from the Minoans, and which the Minoans had never appreciated. Firstly, the monumental quality of the architecture, colossal blocks and lintels piled fearlessly to make the stout castle walls which the life of Mycenaean royalty found necessary. Secondly, the monumental quality of the statuary, impressive here for its sheer size rather than anything else, since the forms derived directly from the Minoan tradition which was essentially miniaturist and decorative. More than five hundred years were to pass before Greek sculptors could command an idiom which would again satisfy these monumental aspirations in sculpture and architecture. It reminds us too that, from the earth, the new Greeks could recover and admire, if seldom imitate, other artefacts of their heroic past.

The architectural achievement of the Dark Ages is a discovery of recent years: a large apsidal building of brick and timber over stone, built around 1000 BC at Lefkandi, a port on the central Greek island of Euboea [13]. It contained two rich, indeed royal burials, equipped with foreign exotica, so it has as much the role of a hero-shrine as of a palace. The exotica, from the Levant and Egypt, are the harbingers of an Orientalizing revolution of which there will be more to say. The Euboeans were hardy seafarers and there is reason to believe that their

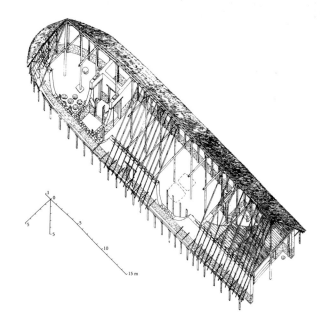

13 Reconstruction by J.J. Coulton of the 'heroon' at Lefkandi. Its form is palatial, in a Greek tradition, but it was found to contain rich pit burials of a warrior, a woman and a four-horse team, and the whole was soon covered with a mound. About 1000 BC. 47+ × 10 m

importance in this period was due at least as much to their own eastern adventures as to prospecting foreigners. They were to have a pioneering role in colonizing the west later, but for a fuller assessment of Greek art of the 10th to 8th centuries and the rebirth of Greek art after the fall of the Mycenaean world we have to turn elsewhere. Thus, the strange clay centaur found in the Lefkandi cemetery [14] has Eastern and perhaps mythical associations that can still tax us.

Athens seems to have become important only at the end of the Bronze Age, but the city dominates the story of the Geometric period. To some degree its Acropolis citadel had survived the disasters attendant on the destruction of other Mycenaean centres, and her countryside was to serve as a refuge for other dispossessed Greeks. It is on her painted clay vases that we can best observe the change that takes place, and since a substantial number of the pictures illustrating this book will be of decorated pottery, nowadays a somewhat recherché art form, it will be as well to explain why this is. Virtually all that we know about the art of these early centuries has been won from the soil, and the rigours of survival have determined what our evidence can be. Virtually no textiles, leather or woodwork survive, for one thing; and only by good fortune marble or bronze, since they were only too readily appreciated by later generations as raw material for their lime kilns or furnaces. But a clay vase, with its painted decoration fired hard upon it, is almost indestructible. It can be broken, of course, but short of grinding the pieces to powder something will remain. In an age in which metal was expensive, and glass, cardboard and plastics unknown, clay vessels served more purposes than they do today, and in Greece at least the artist found on them a suitable field for the exercise of draughtsmanship.

On the vases made in Athens (and to a lesser degree in other areas of Greece, including Euboea) in the 10th century BC, we see the simplest of the Mycenaean patterns, arcs and circles, which are themselves debased floral motifs, translated into a new decorative form by the use of compasses and multiple comb-like brushes which rendered with a sharp precision the loosely hand-drawn patterns of the older style [16]. A few other simple Geometric patterns are admitted, but because we have yet to reach the full Geometric style of Greece, this period is called Protogeometric. The vases themselves are better made, better proportioned, and the painted decoration on neck or belly is skilfully suited to

14 Clay centaur from Lefkandi (head in one tomb, body in another). The form has both earlier and eastern associations, notably with Cyprus. The man-horse is soon adopted by Greek artists and becomes their 'centaur'. We do not know whether it was identified as such so early, but a nick in its leg corresponds with the story of the wounding of the senior centaur Chiron. About 900 BC. Height 36 cm. (Eretria)

the simple, effective shapes. The painters had not forgotten how to produce the fine black gloss paint of the best Bronze Age vases, and as the Protogeometric style developed we see more of the surface of the vase covered by the black paint. The vases that survive come mostly from tombs and there is little enough to set beside them, except for simple bronze safety-pins (*fibulae*) and some primitive clay and bronze figures, especially from Crete [15] where, again, some of the Minoan forms and techniques seem to have survived.

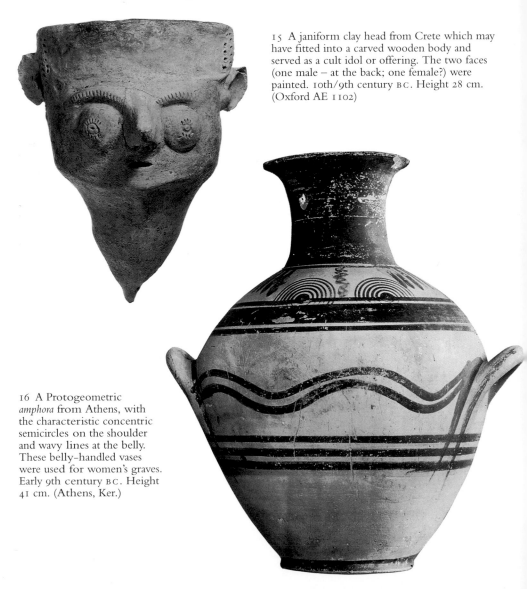

15 A janiform clay head from Crete which may have fitted into a carved wooden body and served as a cult idol or offering. The two faces (one male – at the back; one female?) were painted. 10th/9th century BC. Height 28 cm. (Oxford AE 1102)

16 A Protogeometric *amphora* from Athens, with the characteristic concentric semicircles on the shoulder and wavy lines at the belly. These belly-handled vases were used for women's graves. Early 9th century BC. Height 41 cm. (Athens, Ker.)

17 An Athenian Geometric *crater* with meanders, zigzags and early representations of horses. The lid knob is fashioned as a small jug. About 800 BC. Height 57 cm. (Louvre A 514)

GEOMETRIC VASES

The full Geometric period belongs to the 9th and 8th centuries BC. It begins, or rather slowly develops from the relative obscurity of the Protogeometric, and ends with a new, prosperous Greece of strong cities, whose merchants and families were already travelling far from the home waters of the Aegean to trade and settle, and whose nobles were already looking for something of the luxury and the trappings of court life as it was known in the older civilizations of the Near East and Egypt, and as it had been known in Greece's own Golden Age of Heroes, the Bronze Age.

On the vases we soon begin to see a new repertory of patterns as well as the decorative development of old ones. The vases are girt by continuous bands of meanders, zigzags and triangles, to name only the most popular motifs [17]. The circles and semicircles are seen less often.

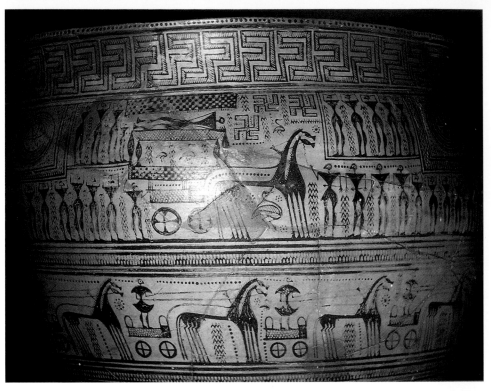

18 Detail from an Athenian grave-marking *crater* (for a man) with funeral scenes. The mourning women (breasts shown by strokes at either side of the triangle torsos) tear their hair. Helmets are reduced to a crest only but we see both chariot wheels and all the horses' legs, tails and necks. The men carry old-fashioned, light, body-covering shields (*Dipylon* type). About 750 BC. (Athens 990)

The friezes are divided from each other by neat triple lines, and the patterns themselves may be drawn in outline and hatched. Several new vase shapes are introduced, as well as refinements of the old, to suit the more varied needs of a more prosperous and sophisticated community. While in the Protogeometric period the artist confined his decoration to clearly defined areas of the vase, the Geometric painter soon let friezes of zigzags and meanders cover the whole vessel, filling in the blank spaces of the earlier vases with strips of simple pattern. The overall effect is fussy, but precise, and the shape is still well enough expressed by setting the emphatic patterns at the neck, shoulder or

19 This large *amphora* stood marking a woman's grave in Athens. The centre panel shows the dead laid out on a bier with mourners at either side. On the neck two of the friezes are of repeated animal figures. About 750 BC. Height 1.55 m. (Athens 804)

between the handles. But it looks as though the artist was more intent on the patterns themselves, and variants upon them, to the detriment of the general effect of the vase as an expression of the wedded crafts of potter and painter. The zones are broken into panels with individual motifs of circles, swastikas or diamonds, and the resultant chequered appearance has a depressingly rhythmic and mechanical effect. There seems almost a divergence of purpose, perhaps already a specialization of role, potter and painter, and it is possible to find two painters' hands on a single vase.

All the patterns are more characteristic of the appearance of basketry or weaving than of brushwork, and this is surely their source of inspiration. Indeed, some basketry shapes are copied. This raises intriguing questions. Weaving and probably basketry were essentially women's work; so, indeed, was potting in many early societies. Probably some of the enormous Late Geometric vases were beyond a woman's strength to build, and the later, developed pottery industry seems to have been in the hands of men, but weaving was supported on a loom and normally remained women's work. Was Geometric art the Greek woman's first influential contribution to our subject? Was it also her last?

By the time these changes were being made, in the early 8th century, the painters had already begun to admit figure decoration to the vases, and this marks the introduction of the most fundamental element in the later tradition of classical art – the representation of men, gods and animals. It also introduces problems about the character of Geometric Greek art, best considered after we have observed its expression on the pottery. At first there are isolated studies of animals, even a human mourner (a woman), rather lost in the Geometric patterning; but soon the animals are repeated with identical pose to fill a frieze where before a meander or zigzag ran. And the effect is still of a Geometric frieze, with the grazing or reclining animals presenting a repetitive pattern of limbs and bodies, rather than individual studies. By the mid-century human figures were admitted too in scenes of some complexity. The finest appear in the main panels on the big funeral vases which stood (some a metre and a half high) marking graves in Athens' cemeteries [*18, 19*]. Here we can best observe the way the artist treated his figure studies. It was an idiom which appears to have sprung from the discipline of the Geometric patterns and their sources, and it owes nothing immediately to the influence or example of other cultures, although similar conventions have been adopted in different parts of the world, including

22 (*Right*) A *crater* from a grave at Argos. Men lead horses, with devices below them recalling yokes of carts or chariots. Watery motifs between and around. In Homer 'thirsty Argos' was horse-rearing country. About 700 BC. Height 47 cm. (Argos C 201)

20 (*Left*) An Athenian pot stand. The frieze has warriors with alternately old (*Dipylon*) and new (round, as later for hoplites) shields. A man confronts a rearing lion: an eastern motif perhaps interpreted by a Greek as Heracles with the Lion. About 700 BC. Height 17.8 cm. (Athens, Ker. 407)

21 (*Above*) Athenian Geometric cup (*kantharos*). In the main frieze a man leads away a woman, a duel, two lions tear a warrior (an old eastern motif) and a lyre-player encounters two water-girls. About 720 BC. Height 17 cm. (Copenhagen 727)

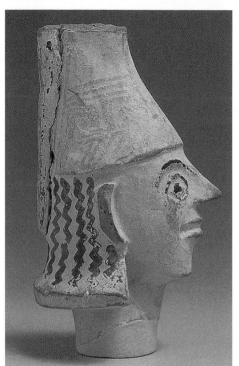

23 Clay head from a temple at Amyclae, near Sparta: a warrior wearing a conical helmet. About 700 BC. Height 11 cm. (Athens)

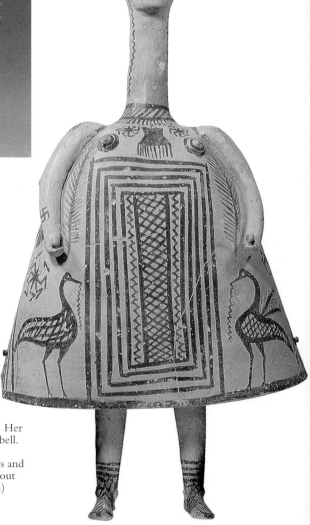

24 Clay figure of a woman from Boeotia. Her legs are suspended within, as though in a bell. The decoration is as on vases but the impression is given that she holds branches and has a comb hanging from her necklet. About 700 BC. Height 39.5 cm. (Louvre CA 573)

Greece, at different times. The parts of the body are rendered in angular sticks and triangles, blobs for the heads, bulging sausage-like thighs and calves, emphasizing the most important parts of the figure to indicate strength or swiftness. The whole figure is thus reduced to a Geometric pattern. All is rendered in plain silhouette and only later is an eye reserved within the head, and strands of hair are shown, as well as chins, noses, fingers and breasts. The artist paints what he (or in this context I should say he/she) knows of the figures, not what he sees, and though he would not show both eyes in a profile head, still, in chariot groups, all legs, tails and necks of horses are painted, and the two wheels put side by side. On the funeral bier the chequered shroud, lifted over the corpse, is cut away to show clearly the body beneath.

Action, like fighting, is shown easily enough with these stick figures and their spears, swords and bows; and emotion is translated into action – like the mourners tearing their hair. On the grave vases we see the body laid out for burial (*prothesis*), or the bier carried by carts to the cemetery (*ekphora*): the centrepiece flanked by rows of mourners so that the whole still forms a symmetrical, Geometric composition, although it is also telling a story or setting a scene. Sea fights are shown on some vases, vivid illustration of days in which Greek merchants and colonists were probing the shores of the Mediterranean, and Athens herself, though no colonizer, was sending her wares into distant waters or indulging the 'non-reciprocal exchange' of piracy.

On the smaller vases too these figure scenes become more and more common [21]. Here we are offered the earliest and clearest expression of that interest in narrative art which is another essential part of the classical tradition and demands a moment's attention although it will be repeatedly recalled. In literature it is expressed first in the Homeric poems, and it is no accident that it is just at this time that Homer must have been giving expression in epic form to those stories and lays about the Age of Heroes which were to continue to inspire artists – poets, dramatists, sculptors and painters – for centuries to come. Some of the protagonists on the vase scenes might be identified as heroes of popular Greek myths in characteristic exploits – such as Heracles' encounter with the lion [20]. Others might illustrate heroic episodes – duels at Troy, the shipwreck of Odysseus, but on this threshold of true narrative art in Greece it is easy to be over-optimistic and over-anxious to identify myth in what may be scenes of every day, of cult, or of foreign inspiration.

Foreign goods and foreign craftsmen were reaching Greek shores with mounting effect. We may judge this more readily in arts other that vase painting, never a favourite in the East, but the lions on Geometric vases are heralds of the new age, borrowed and translated from the arts of the Near East. It is likely enough that this whole phenomenon of developing a mainly figure art was inspired by Eastern example, but the Greek was quick to seize its new potential. There are scenes and groups which echo the easterner's reliefs, but the translation to a wholly different idiom is total, and the idiom itself may not be completely explained as a simple application of geometry to the problems of the figure. The last of the Mycenaean Greeks practised a stylized figure art which is superficially similar, and it might be wise not to underestimate the debt of Geometric Greek art to a past which was increasingly occupying poets and priests, just as it is certainly unwise to underestimate its sophistication.

At the end of the Geometric period the rigid silhouette drawing is loosened, detail is admitted, the lavish and intricate patterns of frieze and panel are subdued. In other parts of Greece local schools had followed Athens' lead, and some evolved styles of some independence and merit. The nature of such dependence or inspiration is not easy to fathom, nor their significance. A shared visual experience of pattern and design does not need to be the accompaniment to other shared social experience or structure, though it is likely to be. Simple geography determining local markets may be a major factor. Argos (in south Greece) and nearby towns were prominent, with a range of rustic figure scenes and pattern panels, often ill-composed on the architecture of the vase [22]. Crete and the islands have distinctive styles in Geometric painting, and in some parts of Greece (as the eastern Aegean) such styles died hard. In the next chapter we shall see what replaced the Geometric decoration on pottery, but it is worth remembering that the patterns long remained popular, and that the basic, architectonic, principle of Geometric decoration was never forgotten; indeed it is one of the underlying factors in Greek art of all periods.

OTHER ARTS

The figure style of the Geometric vases reappears on many other objects, in other materials. We know about these from the richer gifts which now accompany burials, and from their appearance as offerings

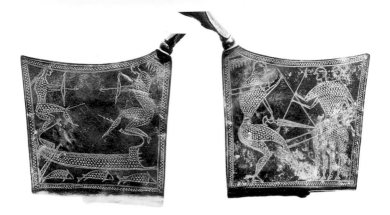

in sanctuaries – both the national sanctuaries at Delphi and Olympia which attracted dedications from all over the Greek world and sometimes outside it, and the local shrines. Their relevance to the life of the craftsman can be judged by the fact that many seem to have been made locally to serve the visiting market. This indicates a degree of specialization to serve religious needs as well as the obvious domestic ones, of life or cult (funerals), that were the stock occupation of craftsmen at home.

Figures resembling the more elaborate painted examples are found incised on the flat catch plates or bows of safety-pins (*fibulae*) found in Athens and Euboea as early as the 9th century, and made in a more elaborate form in Boeotia towards the end of our period [*25*]. There are simpler figures impressed on gold bands found on the bodies of the dead, but these succeed a more thoroughgoing Orientalizing type with animal friezes. Another early intimation of the influence of the Near East is the resumption of seal-engraving in Greece. There are 9th-century seals of ivory and in the 8th century stone ones made in the islands – simple square stamps with designs which are wholly Geometric and not Eastern in spirit [*26*].

25 (*Above*) Bronze safety-pin (*fibula*), its pin missing, made in Boeotia about 700 BC but found in Crete. One side of the catchplate shows a duel over a ship; the other, a hero fighting twin warriors. Length 21 cm (Athens 11765)

26 Impression of a Geometric stone seal showing a centaur (horse-man) attacked by a bowman, possibly Heracles. Width 2.2 cm. (Paris, BN M 5837)

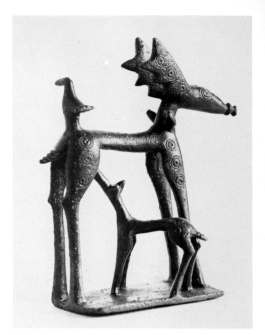

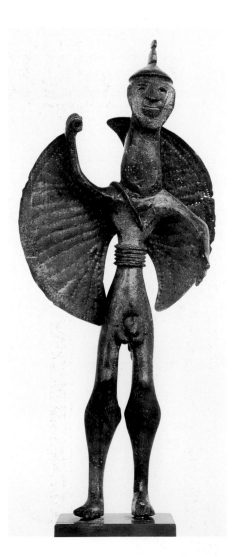

27 Bronze group of a deer with a fawn, a bird on the deer's rump. A small votive offering from Samos. About 725–700 BC. Height 7 cm. (Boston 98.650)

28 Bronze warrior from Karditsa in north Greece. His spear is missing; he wears the light *Dipylon* shield at his back, otherwise only a belt and cap-helmet. About 700 BC. Height 28 cm. (Athens 12831)

Opposite

29 Bronze group from Samos of a helmeted hunter with his dog attacking a lion, its prey in its mouth. About 725–700 BC. Height 9 cm. (Samos)

30 Bronze figure supporting the circular handle on the rim of a bronze cauldron dedicated at Olympia soon after 700 BC. Height of figure 37 cm. (Olympia B 2800)

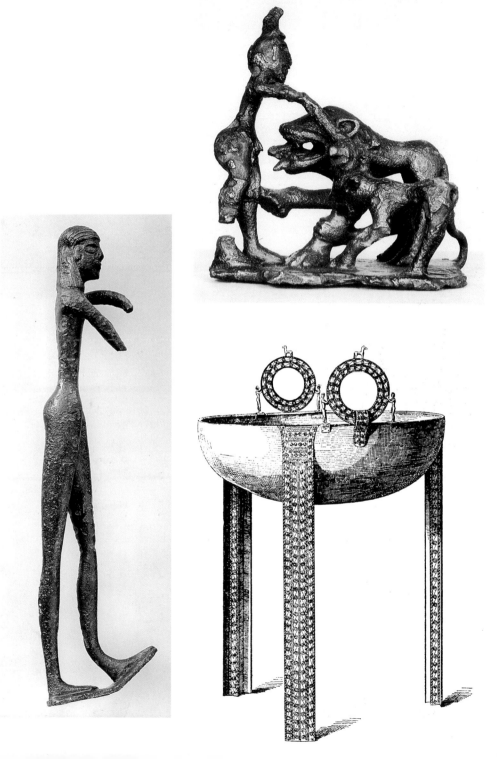

Bronze figurines, seldom more than ten centimetres high, include some stylish figures of horses and stags, which, although they are solid-cast in the round, strongly resemble the cut-out or flat hammered figurines from which they probably derive. Occasionally more elaborate groups are composed of such figures – mares or deer with their young [27], a centaur-like monster fighting a god. Telling a story in three dimensions was more of a novelty than we might credit today. Other bronze figurines, cast solid from an individual mould, are rendered in a much freer, plastic style, and reflect the easy modelling of soft clay or wax. Still, their broad shoulders and elongated bodies closely match painted figures on vases [28]. The bronzes are generally of naked men, perhaps intended to represent a god – Zeus at Olympia – and may be equipped with helmet, spear and shield. Rarely we find groups, such as a lion-hunt, or action figures, like a helmet-maker squatting at his work, or a charioteer. In the lion-hunt from Samos [29] the artist has given the monster elephantine legs, but appropriately massive jaws and shoulders. Many figurines of men and horses were intended as decorative attachments to the rims of bronze cauldrons [30]. These magnificent vessels were valuable offerings which stood on slender tripod legs. They were at first cast, with simple decorative patterns, and later worked with figure scenes in relief, or hammered and impressed with Geometric patterns. There are comparatively few small bronze vases. The metal was still somewhat scarce, and had to meet a growing demand for dedications and, soon, the new types of all-bronze armour.

In clay, apart from the simplest figures which show little sophistication, there are oddities like the bell-shaped idols of Boeotia which were painted like vases [24], and some far more elaborate works in which the features are picked out in paint while the whole heads are careful geometricized studies, far more detailed than the most elaborate of the bronzes [23].

Already in the 8th century Greece offers an assemblage of arts and techniques which begins to recall the variety of Mycenaean art, even if not the riches of Mycenae itself. The Lefkandi building shows that architecture was not always unpretentious, but for the most part we find, at best, one-roomed houses of mud brick with columned porches, and rare examples of larger complexes which just recall the simplest plans of Mycenaean palaces (as in Andros). There are some clay models made in Corinth [31], Argos, Thera and Crete, which give an idea of the upper works of the one-roomed houses: apsidal or rectangular in plan with

steep thatched roofs or, in Crete, like a cube with a flat roof, a central chimney and a bench or sleeping-platform at the back. The walls are patterned but we cannot say that this was true to life.

Several features of the Geometric Age are clearly more than a matter of natural, local evolution from Protogeometric. We have speculated already on the debt Geometric art itself owed to the East and remarked other tokens of new influences which invited the artist to exercise new crafts and new forms. His response and the resultant revolution in the physical appearance of the arts in Greece are subjects for our next chapter, parts of which overlap chronologically what has been described in this.

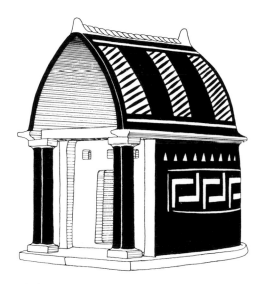

31 Restored clay model of an apsidal shrine or house found in the sanctuary at Perachora and probably made in Corinth. The painted decoration suggests thatch, but the meanders may just be borrowed from pot decoration. Late 8th century BC. Height 33 cm. (Athens)

Greece and the Arts of the East and Egypt

Greece is a poor country. Its mineral resources are slight and its farm-land neither extensive nor very fertile. In the 8th century BC the growing population had to look overseas for the materials to satisfy the new appetite, and eventually even for new homes for families whose own lands had become too small or uncomfortable for them. Contact had never been quite lost with other Mediterranean shores and it remains a matter for discussion who was responsible for developing new and fruitful exchanges with the east. These seem never to have been much diminished with Cyprus, where Greeks had settled at the end of the Bronze Age and of whose expertise in metallurgy the Aegean remained well aware. New exotica from or via Cyprus appear in 10th-century Lefkandi, but this was perhaps less a new start than a signifi-cantly more deliberate exchange, and its concentration in Euboea may well indicate that it was the fruit of Greek enterprise; easterners need not have been so choosy geographically and Euboea was not as obvious a goal as, say, Crete. Merchant-adventurers from Euboea and the Greek islands, and from the east, were travelling routes well known to both

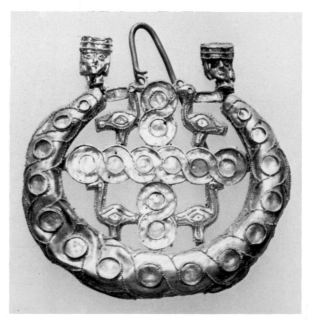

32 Gold crescent pendant from Knossos, with human heads and birds. The eyes of the Orientalizing cable pattern were once filled with amber paste. About 800 BC. Width 5 cm. (Heraklion)

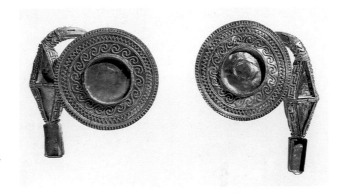

33 Gold earring pendants with patterns in wire and granulation, and settings for inlays of rock crystal or amber. 8th century BC. Diameters 3 cm. (London 1960.11–1.18)

Greeks and easterners at the end of the Bronze Age. Both may have been hungry for materials, the Greeks also for exotica to answer the new status of élite families, such as the occupants of the Lefkandi building. The Phoenicians were beginning to prospect westwards in search of materials for their masters in Assyria and for their own comfort.

There was no priority in exchange of goods, east-west. We shall see that eastern craftsmen could find a home or refuge in Greece. A plethora of Greek pottery in North Syria in the 8th century shows that the Greeks came to concentrate on the wealth of Syria/Assyria, perhaps a more passive market than Phoenicia, and what they acquired there was to revolutionize their material culture, and perhaps more. The prime site is the port at the mouth of the River Orontes, the access point from the Aegean to Mesopotamia, at Al Mina, backed by major inland cities whose Bronze Age counterparts had also dealt with Greeks and Cyprus (Atchana). Only the mishellenist denies the probability of at least a seasonal Greek presence there, given the proportionate volume of Greek pottery compared with other eastern sites, and the effects of the flow of goods to the Greek world and not beyond; there were fewer mishellenists in ancient Syria than there are among scholars today.

At the same time as this enterprise which had been bringing a trickle of Eastern bronzes and jewellery into the Greek world even before 800 BC, there were other arrivals of even greater potential. These were troubled times in the Near East and it seems that it was not only goods but craftsmen that were attracted westwards into Greek lands. In Cretan Knossos it appears that a group of Syrian artists had established a workshop for jewellery [32] and the working of hard stones and decorative

49

bronzes, and their distinctive style can be recognized here and elsewhere in the island for over a century. But although Cretan vase painters copied their patterns, other artists did not learn their techniques, which died with them. A similar group had perhaps worked in Euboea, and another in Attica, shorter-lived [33], while in another part of Crete Syrian bronzesmiths inaugurated an important school best known for the votive shields with animal-head bosses fashioned for dedication in the Idaean Cave. But it is not the immigrants, or at least not those whom we can detect, who had the most profound effect. The role of the Phoenicians in all this must have been relevant, as the major, but not the only, seafarers of the east, but it is difficult to assess. Their own art was heavily egyptianizing but theirs were not the styles that were to effect change in Greece, and even Greek adoption of the Phoenician alphabet was most probably effected via Syrians (who had adjusted the letters to their own language) on the east-west routes. But in their voyages west the Phoenicians were perforce using Greek ports and some lingered.

34 Three or six bronze griffin heads were fastened below the rims of Orientalizing bronze cauldrons dedicated in Greek sanctuaries. These are cast Greek versions of hammered Syrian prototypes. Late 7th century BC. From Olympia. Height 36 cm. (Olympia B 945)

35 (*Right*) Cast bronze siren attachment from the rim of a cauldron, facing in. Essentially it is a body supported by a winged disc – an eastern motif – but the head is Greek. From Olympia. Early 7th century BC. Width 15 cm. (Olympia B 1690)

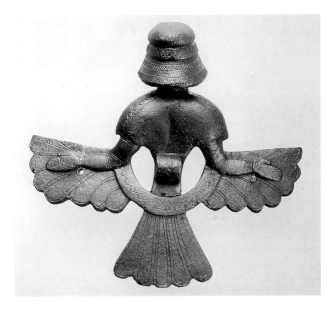

The Greeks acquired from the East expensive consumer goods, including works decorated in styles utterly foreign to the conventions of Greek Geometric art. We find especially bronze bowls decorated in low relief with animals and figure scenes, and ivory plaques carved in low relief as fittings for furniture or toilet articles. Several of these have survived on Greek sites, and there was no doubt much, woven or in perishable materials, which has not. All these things had their effect on both the style of Greek artists' work and the range of their repertory of figure and animal decoration. We can study this most easily in the changes which took place on decorated pottery, but there were other studios, not obviously initiated by immigrant craftsmen but dependent at first on Eastern forms and techniques, soon mastered and translated into what we can recognize as a purely Greek style. Hammered work in bronze is prominent, especially for the lion and griffin heads which project like lugs or handles on the deeper cauldrons of Eastern type which are coming to replace the open tripod cauldrons of Geometric Greece [30]. There are soon several Greek workshops producing these fine decorative attachments, the later examples being cast and not hammered. The motif is Syrian but the treatment is Greek, and Greek artists

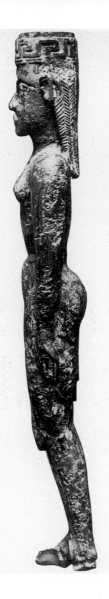

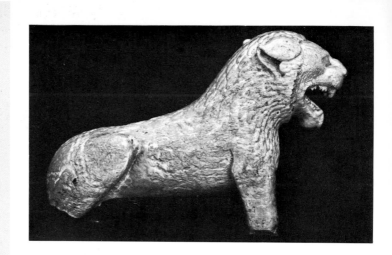

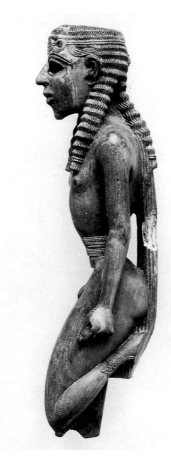

36 Ivory figure of a woman from a grave in
Athens, one of a set of various sizes, serving as
handles for mirrors or the like. Late 8th century
BC. Height 24 cm. (Athens 776)

37 Ivory lion of Assyrian type from Old
Smyrna. Late 7th century BC. Length 5.5 cm.
(once Ankara)

38 Ivory kneeling youth from Samos, perhaps a
fitting from the arm of a lyre. The eyes, earrings
and pubic hair were inlaid in other material.
Late 7th century BC. Height 14.5 cm. (Samos)

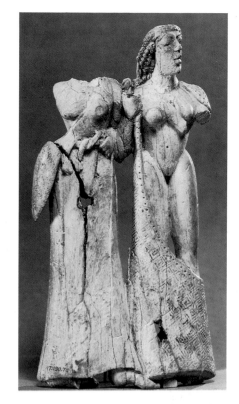

39 The two women with their clothes slipping
from them are the daughters of Proitos, sent
mad by the goddess Hera to range the land of
Argos waylaying travellers. Ivory relief. About
600 BC. Height 13.5 cm. (New York 17.190.73)

soon elaborate the monster's high ears, forehead knob, gaping beak and
sinuous neck into an entirely new decorative form [*34*]. The same hap-
pened to the solid-cast siren attachments for cauldrons, which are
quickly naturalized Greek, translating the puffy Eastern features of the
god in a winged disc into angular Greek ones for a creature more like
what would later be called a siren [*35*]. In these, as in all other instances
of borrowing or inspiration from the East, the Greek artist was dis-
criminate in what he took, and he very soon adapted the new subjects
according to his own sense of composition or pattern into forms which
went beyond the more repetitive designs on the Eastern bronzes or
ivories which had prompted them. The subjects themselves, of course,
had lost their meaning since the models did not travel with explanatory
labels. But we may be sure that they were chosen because they could be
reinterpreted to suit Greek life and thought, and from them Greek
artists were soon to be able to offer images for mythical creatures whose
physical appearance had hitherto depended on song alone.

Ivory too was brought from the East and Egypt. Already in a Geometric grave in Athens we find a group of ivory maidens, naked as the Syrian odalisques or goddesses who inspired them, but slimly built, with sharp features – the Geometric artist's translation of an Eastern physique – and with Greek meanders on their caps [36]. There were various schools of Orientalizing ivory-workshops in Greece. Those in the East Greek islands and on the shore of Asia Minor (Ionia), which was an area which the Greeks had settled in the Dark Ages, produced work closer to the Eastern prototypes [37]. This can be observed both in the subjects and in the treatment of the human figure, which is fuller and rounder – a persistent feature of East Greek art. From East Greece (on Samos) also we have a few examples of small wooden figures carved in a manner very like the ivories [57]. Small carvings travelled far in the Greek world: an oriental type of god and lion was found at Delphi, and on Samos the kneeling youth may resemble more closely works of mainland Greece, but is the figure attachment to an instrument of a type which is certainly East Greek [38]. It is still difficult to locate the workshops for many of the ivories of this period and not always too easy to be sure that we are not dealing with imports in unfamiliar Eastern styles, but some subjects are soon to be taken from Greek myth [39].

In mainland Greece the Geometric stone seals were being replaced by ivory seals. Some of these took the form of recumbent animals, with the intaglio devices on the base – a Syrian form but a Greek usage. Others – the majority – are discs with simple animal patterns on one or both sides. This wealth of work in ivory in the 7th century is not to be matched in any later period.

VASE PAINTING

The most obvious effects of the Orientalizing revolution are observed in a field largely ignored by the Easterner but which, as we have already seen, meant much to the Greeks. Few if any Greeks saw the figure painting on Assyrian walls, but on the imported bronzes and ivories the Greeks found an art which was as conventional as their own Geometric, though far more realistic. The strictly profile or frontal views were the rule but the masses of the body were more accurately observed, and anatomical detail stylized into more realistic patterns. They also found a variety of floral devices such as Geometric art had shunned, both as the principal subject of a pattern and as subsidiary decoration. Changes

40 A Protocorinthian perfume-flask (*aryballos*) with the new outline-drawn repertory of animals and florals including a stylized Eastern Tree of Life. About 700 BC. Height 6.8 cm. (London 1969.12–15.1)

in the varieties of background filling motifs used in figure scenes suggest that foreign textiles too might have been influential. These new styles had their effect in different ways in the various pottery-producing centres of Greece, as in the other arts. The animals may have done little more than enliven or even energize what they decorated though the monsters soon found a role in Greek myth; the human figures allowed more implicit narrative than had the Geometric; while the floral carried both a message of fertility and provided near-abstract motifs in which the artist could build essays in design–symmetry and create framing patterns which were to become an integral element in Greek art.

In Corinth, a powerful state guarding the landward approach to the Peloponnese from the north as well as the east-west passage across a narrow isthmus, the Geometric styles of Athens had been matched, as in other Greek states, but figure scenes were generally avoided and instead we see a fondness for precise drawing of simple Geometric patterns. This meant that without a strong tradition in Geometric figure drawing, like the Athenian, Corinthian artists were perhaps the more prepared to accept the new figure styles, and the intricate floral friezes. These they adapted in various ways [40]. The silhouette style of Geometric figure painting was also inadequate when it came to the

detailing of eyes, manes and muscles and to showing overlapping figures in vigorous action. The Corinthian painters invented a new technique in which the figures are drawn still in silhouette but details are incised, to show the pale clay beneath in thin clear lines. Red and white paint came to be used also to pick out odd features, like ribs or hair [41]. This new technique we call black figure, and it is practised first on vases called Protocorinthian by archaeologists (to distinguish them from the later Archaic Corinthian series). It could have been inspired by the incised decoration of Eastern bronzes and ivories; the only alternative technique, as we shall see, could have been outline drawing or a greater disposition of colour than was available to simple vase painting. At its very best the style is miniaturist, and tiny figures barely one inch high are painted – etched, rather – on the small perfume-flasks (*aryballoi*) which seem to have been one of the most important products of Corinth's potters' quarter [43]. Larger figures are rarely attempted, but a version without the incision was used to decorate with figures the clay metopes on some 7th-century architecture in central Greece (e.g., at Thermon).

41 A Protocorinthian jug (*olpe*) with friezes of sphinxes and animals, including dogs chasing a hare, in the black figure technique with the characteristic dot-rosettes. About 640 BC. Height 32 cm. (Munich 8964)

42 Fragment of a Protoattic clay plaque dedicated to Athena at Sunium, showing marines on a ship, with a steersman. By the Analatos Painter. About 700 BC. Length 16 cm. (Athens)

The decoration is set in friezes round the vase, as it had been in the preceding period. Animals are the main subjects (lions, goats, bulls and birds), but there are some new monsters too, re-introduced from the East – sphinxes, griffins and similar creatures. These, and the lions, had already appeared on some Geometric vases but then their forms had been geometricized by the artists [20]. Now the new conventions are observed; their bodies fill out, jaws gape, tongues loll, ribs and muscles bulge. Some Eastern models are still closely observed, and the Syrian type of lion gives place to the pointed-nose Assyrian. The background is filled with small dot rosettes or abstract motifs just as on the Geometric vases where linear patterns were used to fill the gaps which the painter would not leave empty. The creatures generally pace aimlessly round the vase, but sometimes they are posed heraldically facing each other over a floral, itself a version of the Eastern Tree of Life. There are very few scenes with human figures but towards the middle of the 7th century we find more heroic episodes as well as a number of battle scenes showing the latest hoplite tactics with disciplined ranks of bronze-clad soldiers [44]. Floral friezes – the Eastern lotus and bud or palmette – appear on the shoulders of the vases, while below the main frieze there may often be a smaller one with a row of animals or a hare-

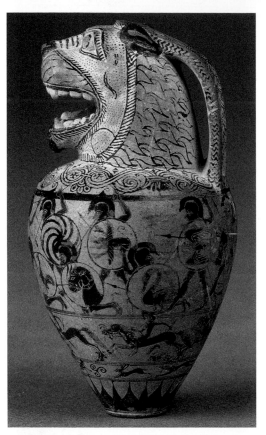

43 A Protocorinthian perfume-flask (the Macmillan *aryballos*) with its neck moulded as a lion's head. The friezes have florals, a fight, riders, a hare-hunt and rays – all on a vase barely 7 cm high. From Thebes. About 650 BC. (London 89.4–18.1)

44 A detail from the Protocorinthian 'Chigi vase' in Rome showing hoplite soldiers closing in battle to the music of flutes. There is freer use of colour here (reds, browns and white) and the usual animal friezes are suppressed. About 650 BC by the same painter as [43]. Found at Veii. Height of frieze 5 cm. (Rome, Villa Giulia)

45 A Protoattic vase with sphinxes, a piper with dancers, and chariots. For patterning the Athenian artist used stippling and scales, with outline drawing and very little incision (on the horses). By the Analatos Painter. About 690 BC. Height 80 cm. (Louvre CA 2985)

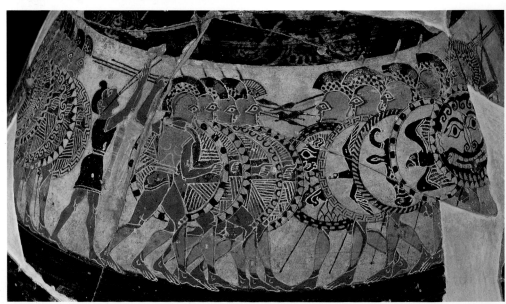

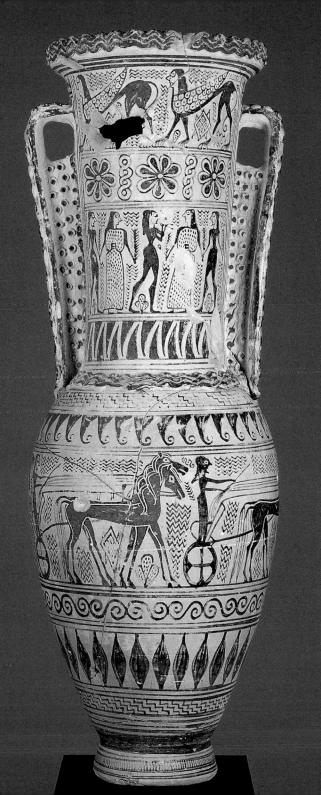

hunt. At the base upward-pointing rays recall the spiky lotus blossoms which decorate the rounded bases of many Eastern and Egyptian vases.

The Orientalizing vase painting of Athens presents far less of a contrast with what went before. The new patterns and subjects are admitted, but more slowly. The black figure technique is not adopted, and the details of figures are rendered by line drawing instead of silhouette for heads [42], and eventually for whole figures. White paint is sometimes used for details (Corinth at this time preferred red) and even a spot of incision here and there. The figures themselves – even of the Eastern sphinxes and the Greek centaur – are still rendered very much in the Geometric manner with angular features and bodies [45]. The filling ornament is still largely Geometric and the floral patterns are translated into geometrical structures rather than simply copied as at Corinth.

At first sight these Athenian vases (called Protoattic) look more primitive and outdated beside the Protocorinthian, and they certainly did not travel so far in the Greek world or have the same influence. But they have significant and important redeeming features. Firstly, the monumental character of the Geometric grave-marking vases is not forgot-

46 The upper part of a 'Melian' (probably Parian) vase. On the neck women watch a duel over armour. From the body we see part of a lyre-playing Apollo, probably with Artemis and Leto, in a divine chariot with winged horses. A brown wash is used on male flesh. About 620 BC. Height of neck 22 cm. (Athens 3961)

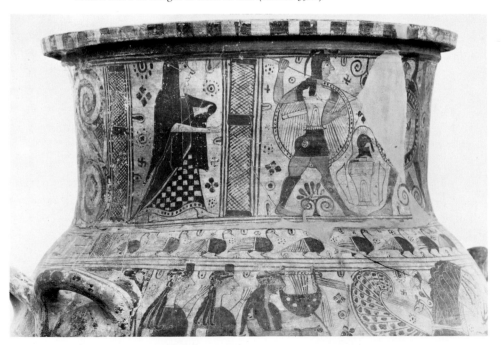

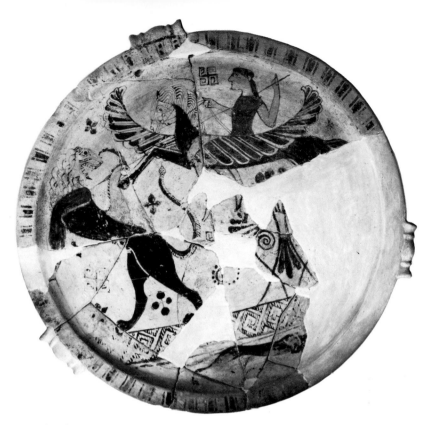

47 A plate from the north Greek island of Thasos, probably made in Naxos. Bellerophon, on the winged horse Pegasus, attacks the Chimaera, which has a lion's body, a goat's head on its back, and a serpent tail. About 650 BC. Diameter 28 cm. (Thasos)

ten. On the new vases the figures sometimes stand over half a metre tall and they present problems of drawing which the miniaturist Protocorinthian painters never had to face. Secondly, the tradition of human figure drawing ensured the continued appearance of narrative or genre scenes as well as the inevitable incursions of Orientalizing animals and monsters. Thirdly, the technique allowed a far more pictorial treatment and balance of the dark and light masses both in the general composition and the individual figures. This is enhanced by the mid-7th century by the use of white paint in the so-called Black and White Style [48]. It leads naturally to experiments with broad masses of other colours, or colour washes to cover flesh parts or drapery. This measure

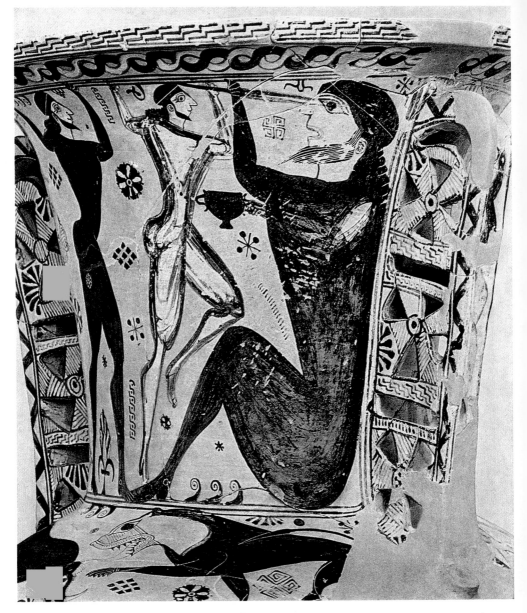

48 The one-eyed giant Polyphemus (Cyclops) is blinded by Odysseus and his companions in his cave having been reduced to a drunken stupor (whence the cup he clutches). On the neck of a Protoattic grave vase found at Eleusis. Odysseus is differentiated by the colour of his body. There is a little incision for hair, beards and fingers but the basic colour scheme is black and white. About 650 BC. Height of figures about 42 cm. (Eleusis)

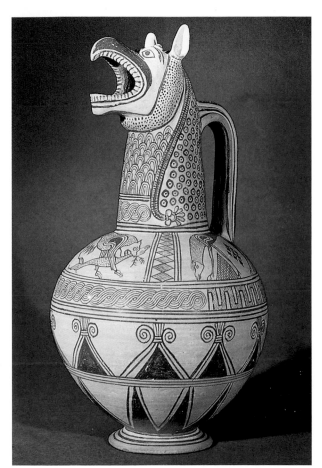

49 The griffin jug from Aegina was painted on one of the Cycladic islands. The lion with its prey is an Eastern motif but the grazing horses go back to Greek Geometric. The griffin is inspired by bronzes such as [34]. Notice the floral attachments to the Geometric triangles at the base. About 675 BC. Height 39 cm. (London 73.8–20.385)

of polychromy is something new on Greek vases, but resembles the Thermon metopes already mentioned. It is also short-lived since it presented technical difficulties. In the 7th and early 6th centuries it was exploited less in Athens than in the Greek islands, where vases of a style and technique analogous to the Athenian were being made. In Crete and occasionally in the islands there was a vogue for vases modelled partly as animals or as human heads. The griffin top to the jug from Aegina [49] follows a type more familiar to us in bronze. The outline style was practised also in parts of the Peloponnese, despite the proximity of Corinth, as at Argos. It may have been emigrant Argive artists who introduced the style to the Greek colonies in Sicily. On some island

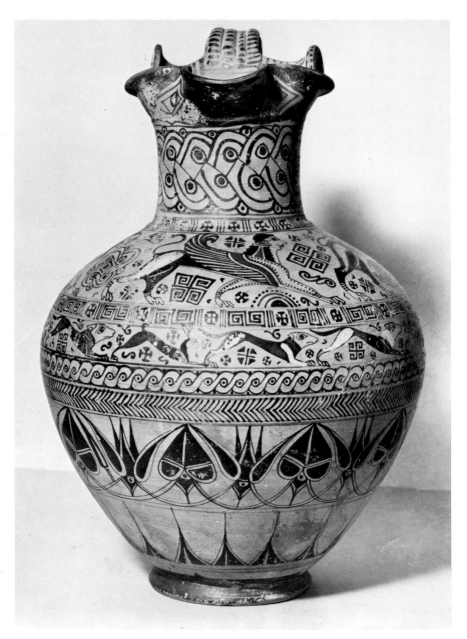

50 A Wild Goat vase (though without the goats!) from East Greece. The Orientalizing lotus and bud frieze is typical but there is more colour than usual on the animals. About 580 BC. (Vienna IV.1622)

vases we can follow the outline, polychrome style until well into the 6th century [46, 47].

The simpler outline drawn styles were affected by the East Greek cities, who were even slower to abandon Geometric patterns and figures. A decorative animal frieze style – the Wild Goat Style, named after its most popular beast – is adopted in about the middle of the 7th century, probably first in Ionia though it was long called Rhodian. It is unpretentious, but in general effect very different from the styles of mainland Greece and has been thought to owe something to Eastern tapestry patterns. It too survives well into the 6th century [50].

OTHER ARTS

The conventions of Greek Orientalizing art, which we best observe on the vases, determine also the decoration of other objects and other materials. Besides the painted vases there are large clay jars with decoration in low relief. These are best known in Crete, Boeotia and in the Greek islands, and the scenes on them, freely modelled or impressed, introduce us to some new subjects in the artist's repertory, including the Trojan Horse [51]. Engaging small vases in the shape of animals or heads

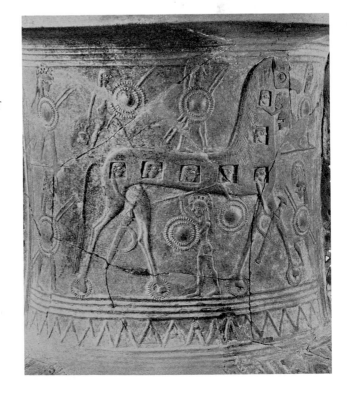

51 The neck of a clay relief vase found on Mykonos. The Trojan Horse, on wheels, the Greeks within it shown as through windows out of which they hold their weapons. Others have dismounted already. The body of the vase has panels showing the slaughter at Troy. About 650 BC. Height of frieze 35 cm. (Mykonos)

52 The monstrous Gorgon with her child, the winged horse Pegasus, on a clay relief which may
have decorated the end or side of an altar at Syracuse. Her kneeling pose is the Archaic conven-
tion for running or flying. Her face is that of a humanoid lion. About 600 B.C. Height 55 cm.
(Syracuse)

53 Cut-out bronze plaque in very low relief with incised details, of a type peculiar to Crete. Two huntsmen, one with a wild goat (ibex) on his shoulders. About 630 BC. Height 18 cm. (Louvre MNC 689)

54 Cut-out bronze plaque from Olympia, with incised details, showing a mother griffin with her young. This was probably the blazon from a wooden shield. About 600 BC. Height 77 cm. (Olympia)

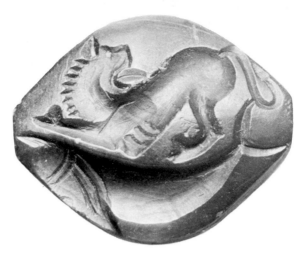

were made as perfume-flasks, and we have already seen the necks of vases moulded as griffins' or lions' heads. Clay and bronze figurines reflect the styles of larger works in stone, and painted clay revetments begin to appear, to protect the wooden parts of buildings, or as decoration on temples and altars [52]. Sheet-bronze is often used for the sheathing of parts of furniture or weapons. On it we find the early technique of hammering with beaten details, for floral or figure scenes. A different technique involves incision of detail lines and appears at its best on the decorative cut-out plaques made in Crete [53] and a number of shield blazons found at Olympia. One offers a characteristic Greek treatment of an Eastern monster, tamed and domesticated: a mother griffin suckling her young [54].

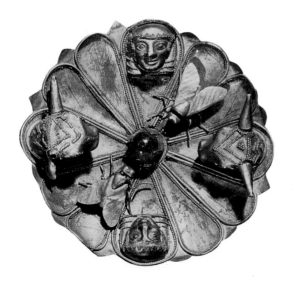

55 (*Above*) An Island Gem of serpentine showing a lion and a dolphin. About 600 BC. Length 2.2 cm. (Paris, BN N 6)

56 A gold roundel. On the petals are pairs of gold flies, human (Daedalic) heads and bulls' heads. Probably made in one of the Greek islands (Melos?) in about 625 BC. Width 4 cm. (Paris, BN)

The stone seals which were being cut at the end of the Geometric period were replaced in the Peloponnese by ivory. In the islands, however, an unexpected source inspired an important new school of stone-seal engravers. Fine Mycenaean and Minoan seals found in plundered tombs or in fields were studied by artists on Melos, who copied the shapes of the stones and, as soon as they had mastered the technique (on softer stones), some of the distinctive motifs. For the most part, however, they used the Orientalizing animal and monster devices which we see on island vases [55]. These Island Gems – once mistaken for prehistoric – provide a continuous tradition of engraving until well into the 6th century, when a new source introduces new shapes and initiates a more fruitful tradition. In the islands again, and East Greece, goldsmiths exploit to the full their newly mastered techniques in some of the finest decorative jewellery we have from antiquity [56].

SCULPTURE

Of larger works of art in this early period we know very little. Wall-paintings there may have been, but we can only guess about them from their hypothetical influence upon vase painting, and the influence might as easily have passed the other way. Wooden sculpture there must have been and there are literary references to early cult statues of wood (*xoana*) but they were probably very primitive in appearance, although they could have been large. Nothing wooden has been preserved except for a few statuettes from the waterlogged temple site on Samos [57]. The hammered bronze sheathing of wooden statuettes at Dreros, in Crete, displays forms akin to other early Orientalizing hammered work in bronze and gold, of 8th-century date.

Soft limestone can be carved almost as easily as wood, and there are stray examples of relief work in an early Orientalizing style, again from Crete. One of the new techniques introduced from the East had been the use of the mould for clay plaques and figures. This means of mass production helped to canonize and stereotype proportions for figures and, especially, the features of a facing head. The type is close to that of the Eastern naked goddess (Astarte) plaques, some of which reached the Greek world and were copied there, although the whole figure of the goddess was soon given clothes and identified as Aphrodite. But the face is still thoroughly Greek, alert and angular unlike the podgy Easterner. The type – we call it Daedalic after the mythical craftsman Daedalus –

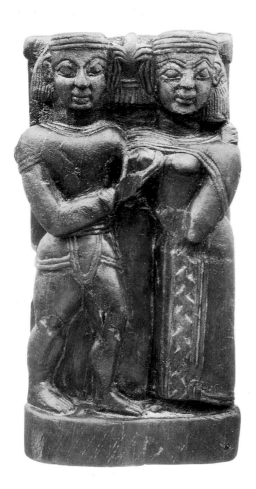
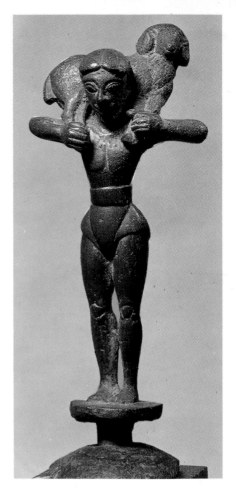

57 A wooden loving couple from the Heraeum of Samos showing a god and goddess, perhaps Zeus and Hera, with the eagle between their heads. A heavily orientalized Greek style of about 620 BC. Height 18 cm. (Samos)

58 Bronze statuette of a man carrying a ram, from Crete. The head is Daedalic, the dress Cretan. Late 7th century BC. Height 18 cm. (Berlin 7477)

59 Limestone statuette (the Auxerre Goddess) of typical Daedalic type with layered wig-like hair. The incised lines on the dress outlined areas of colour. The shawl is Cretan. About 630 BC. Height 62 cm. (Louvre 3098)

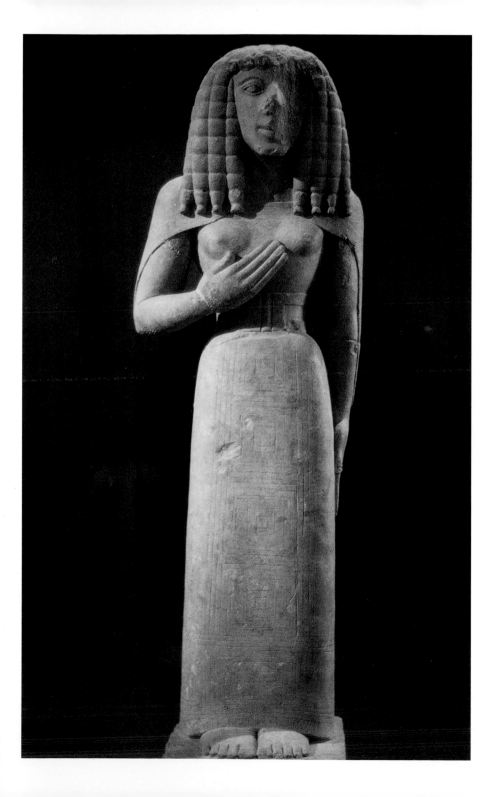

is most commonly met on the mould-made clay figures and plaques, but it is found also on other objects – bronzes [58], ivories, gold jewellery, stone lamps – and, more important, it is used for limestone statuettes. These are either independent figures [59], or they appear in the round, standing or seated, as the sculptural embellishment of temple buildings (as later at Prinias, in Crete) which at about this time began to attract this type of decoration.

This is the fashion of around and after the mid-7th century, but even the largest examples of figures carved in the Daedalic style are little more than decorative statuettes [59], until a new influence promotes a new scale. This brings us to Egypt and the common recognition that the next phase of Greek sculpture owed much to the arts of the Nile valley. Taken in isolation the innovations – scale, pose, technique – could be derived from Greek experience, but taken together, and with the well-recorded new Greek awareness of Egypt, it is clear that the prime source of inspiration lay there.

Greek mercenaries had been allowed to settle in the Nile delta after the mid-7th century and a trading town was soon established by the East Greeks and Aeginetans at Naucratis. This brought Greeks and Greek artists into closer contact with the arts of Egypt. There had been close contact in the Bronze Age, but thereafter there had been only minor import and some Greco-Egyptian production of bric-à-brac on Rhodes. They were likely to have been impressed by what was least familiar to them – the massive stone statuary and architecture – and this may have been enough to set sculptors on a new course. They had to face the challenge of both size and material, for the Egyptian figures were often of the hardest stones – porphyry and granite – and often far more than lifesize. The Greeks looked to the fine white marble which could be so easily quarried on their islands. The scale may have been less of a novelty. The main function of a temple had become to serve as the house (*oikos*) for the god – or at least for his cult image. It is likely that temple sizes and statue sizes were related, so there may have been many large wooden figures in Greek temples already. The Egyptian hardstone statues were always worked by abrasion and their sculptors had no iron tools; but the Greeks had hardened iron tools which could work marble. The early sculptors of the new style were remembered as being Cretan, and Crete had the tradition in stone statuary, but the island had no white marble so the new schools were naturally established on the marble islands, where there was also (on Naxos) supplies of abra-

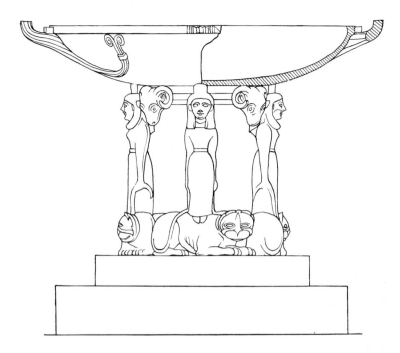

60 A *perirrhanterion* basin from Isthmia, the sanctuary of Poseidon near Corinth. The women, perhaps each an Artemis, stand on lions holding them by lead and tail. Late 7th century BC. Restored drawing, about 1.26 m high without base. (Corinth)

sive emery. The Egyptians laid out their statues according to a prepared grid drawn on the side of the stone block, establishing a fixed canon of proportion which was roughly realistic. Greeks may have for a while adopted the same system, but it is elusive.

The style of the new figures – of white marble and lifesize or more – is still Daedalic, for these were the only conventions for statuary which the Greek artists could at that time employ for statues of women. We have early marble examples from Samos and Delos (the dedication of Nikandre). But there is little more in the way of statuary of women for at least a generation, except for some small marble goddesses with lions who support water-basins (*perirrhanteria*) which are probably Peloponnesian in origin and inspiration [60]. The males too at first follow the Daedalic conventions for the head, but the body is shown naked (except for a belt), long-limbed, one foot set just before the other

in a pose which lent stability, and had been used before in bronze statuettes. In this it owes nothing to the Egyptian stone figures which stand rigid with vertical back and rear leg, with a supporting pillar, and only stand free if small and in softer material, as wood. The earliest of these statues of youths – *kouroi* – are from the islands and there is a distinguished group from Attica from about and after 600 BC [61]. At this early date the anatomical detail is translated into pure pattern – ears, knee-caps, ribs – not related organically to the body, which is itself foursquare, perceptibly newly released from the rectangular block from which it had been painstakingly chipped. Some are truly colossal, several at three metres, and a Naxian dedication on Delos at eight metres.

Monumental stone architecture in Greece may have owed the same source of inspiration as the sculpture – Egypt. The effect was felt at about the same time, but the development was slower and is best discussed in the next chapter. It must be mentioned here because these two phenomena mark an important stage in the progress of Greek art: the establishment of new crafts in which the Greek artist was to find his most fully satisfying media of expression.

The motley of 7th-century Greek art is as confusing as it is brilliant. Local schools flourish and propagate individual new styles. New techniques are learnt. The Greek artist took note of the exotic and grandiose works of those older civilizations with which his world was now in regular contact. He borrowed and adapted as he thought fit, imposing his native sense of pattern and standards of precision on foreign forms. These, in their countries of origin, were relatively stereotyped, serving palatial and priestly needs. The small-town life of Greece surely encouraged far more innovation in the crafts than would have been tolerated in more monolithic societies, and this must account for much of the innovation and speed of progress. But there were times in the early period when foreign stereotypes may have stifled even more rapid progress; I think of the tyranny of the mould, and uncompromising incising techniques of drawing. However, observation of the East and Egypt determined all progress. This is the period in which Greece was not the teacher, but the taught. But it is equally important to remember the strength of a tradition which had its beginnings far earlier than the perceptible influence of new ideas from overseas, and was able to translate the new ideas into forms in which we may try to recognize the origins of Classical art.

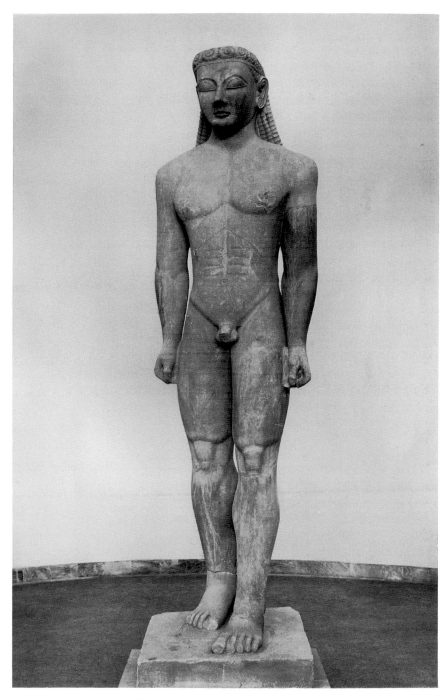

61 Marble *kouros* (part of face, including nose, the left arm and leg restored) dedicated to Poseidon at Sunium. About 590 BC. Height about 3 m. (Athens 2720)

Archaic Greek Art

The 6th century sees the consolidation of the prosperity of the states of mainland Greece with the rule of benevolent tyrants (or at least not 'tyrannical' in our sense of the word) giving place by the end of the century, though only in Athens, to something approaching a democratic constitution. Only the East Greeks suffered seriously, first from the Lydians, then the Persians, but this hardly diminished the activity of their artists, and the diaspora of many of them to the west, to Greece and Etruria, proved productive. Tyrants were good patrons of the arts: major projects enhanced their status and gave employment to the possibly discontented. The city-states remain independent of each other, and often at war, but there was a growing sense of nationality, of the difference between the Greeks and the rest – to them the bar-bar talkers, the barbarians. The new prosperity went hand-in-hand with vigorous trading round the shores of the Mediterranean, and the rapid growth of the colonies – in Sicily, Italy and on the shores of the Black Sea – which had been founded in past generations to ease problems of land at home. One result of all this was that the Greeks made some enemies overseas, as Greeks (although there were always fellow travellers) and not simply as individual states. In the west there were the Carthaginians and the Etruscans, their rivals and customers in trade, and in the east the new Empire of Persia. In the early 5th century they had to face these enemies with force of arms. They survived the encounters and made sure that for a while at least their troubles would be, as was usually the case, with their fellows rather than with foreigners. In the century or more leading up to this the arts of the Greek world and its different schools also moved closer to a common style, usually under the influence of the dominant cities in each craft – Athens for pottery, the Peloponnesian cities for metalwork. Regional differences are still readily perceptible, however, and one of the features of 6th-century art is the contribution made by East Greek artists working away from home, many no doubt as refugees from the Persians.

The new monumental arts of architecture and sculpture present the most striking remains of this, as of succeeding centuries; indeed the sheer size of some building projects in the East Greek cities remained unrivalled until after the Classical period.

ARCHITECTURE

The only public buildings of any importance, which might have encouraged elaboration of design and display, had been temples, and we cannot say whether other states emulated the palatial scale of the early Lefkandi building [13] for what was presumably a ruling family. Otherwise the Greeks had been used to fairly simple brick or stone structures with no decorative elaboration beyond the occasional use of a narrow sculptural frieze on walls, in the Eastern manner. In Egypt they saw massive stone architecture and stone columns with carved capitals.

In Greece already at least one temple (on Samos) had been given an encircling stone colonnade in the 7th century and the Greeks were not slow to take the hint about the elaboration of a feature which had emerged as an integral element in their architecture in the Lefkandi building. In origin it perhaps did no more than distinguish the building as a house of the god and provide a covered ambulatory round the walls of the one-roomed *cella* which held the cult statue. In practical terms it could support overhanging thatch or eaves and provide a covered area from which to watch processions, like later *stoai*. The Eastern contribution was in the patterns of stone bases and furniture which were copied by Ionian architects, and in the occasional use of figures in the place of columns in temple porches.

The beginnings of the major stone orders of architecture in Greece [62, 63] can be traced back to the 7th century. In mainland Greece the Doric order was evolved, with simple columns, reminiscent of both Mycenaean and Egyptian types, having cushion capitals, fluted shafts and no bases. The upper works were divided rhythmically into a frieze of triglyphs (the vertical bands) and metopes (at first painted, later sculptured) which were a free adaptation of the woodwork in these parts of earlier buildings. A triglyph was normally centred over a column below, which could prove awkward in designing the corners; I suspect the Greeks worried less about this 'triglyph problem' than modern scholars. In East Greece and the islands the other major order of stone architecture, the Ionic, borrowed its decorative forms from the repertory of

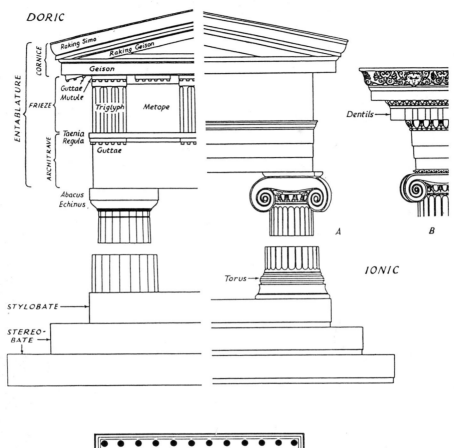

62 The Orders. The Doric order is as it was developed by about 600 BC. In Ionic, from the mid-6th century, the frieze is either sculpted (A) or a row of dentils over decorative mouldings (B). Both may appear in different places on one building (the Erechtheion) and from the 4th century on may be combined. Below is the plan of a typical Doric temple (that of Aphaea on Aegina)

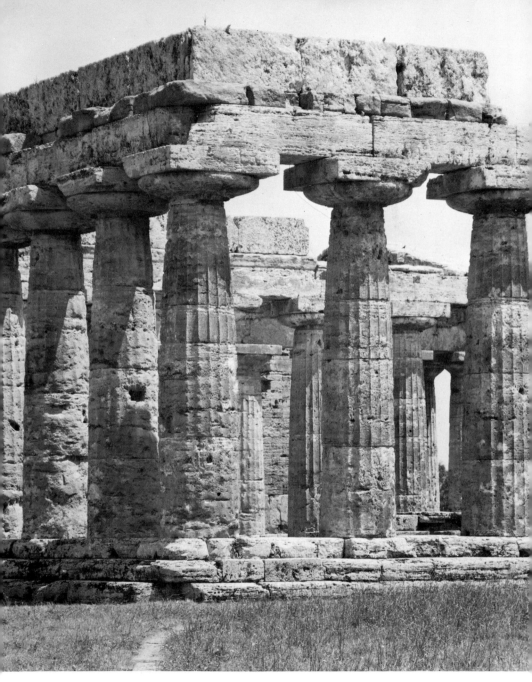

63 The Doric temple of Hera (the so-called **Basilica**) at Paestum in central Italy. A good example of the early cigar-shaped columns with bulging capitals. Mid-6th century BC

Orientalizing art, with volutes and florals which in the Near East had never graced anything larger than wooden or bronze furniture, or – like the volute capitals of Cyprus and Phoenicia – had never formed an element of any true architectural order. The first capitals (known at Smyrna [64] and Phocaea) are bell-shaped with lotus and overlapping leaf patterns in relief upon them. They are followed by the Aeolic capitals, with the volutes springing from the shafts [65], which give way to the broader Ionic, with the volutes eventually linked. The column shafts have more flutes than the Doric, with, in time, flat ridges between them. There are bases too – swelling *tori* and discs, elaborately fluted like the carefully turned wooden furniture which inspired them. Some of the earliest Ionic columns served as bases for votive statues, such as the sphinx dedications made by Naxians at Delphi [66] and on Delos. On Ionic buildings the upper works over the colonnades are simpler than the Doric, but an important feature is the continuous frieze, which is sometimes decorated with figures, or plain with carved beam-ends (dentils). Altogether there is much more variety in the Ionic order, more superficial ornament and decoration [67]. It seems ornate and fussy beside the Doric, and the contrast was one happily exploited by architects of the Classical period and in the Western colonies.

The overlapping leaf pattern of the early capitals was important. The rounded leaf with the tips of leaves between became the *ovolo* or egg-and-dart (nothing to do with eggs, *pace* Ruskin), the ivy-shaped leaves leaf-and-dart; and the profiles of these mouldings echoed the shape of the leaves – rounded for *ovolo*, S-shaped for leaf-and-dart (*cyma recta* or *reversa*, depending on whether the concave or convex element protrudes). The origins are Ionic but the mouldings invade Doric too, where the only regular straight mouldings were flat (decorated then in a rectilinear way, with meander) or the Egyptian overhanging *cavetto* (decorated with round-topped tongues).

The orders were applied to the exteriors of temples, which retained their simple plan, of porch and hall (*cella*), but were now regularly surrounded by a colonnade or at least a columnar façade. Smaller structures, the pavilions or treasuries set up by individual states at the national sanctuaries, have columns at the front only and on Ionic treasuries at Delphi we find statues of women replacing the columns in the porch. The largest buildings, on the other hand, might double the rows of columns at the sides and even treble those at the front (as at Samos and Ephesus). Inside the *cella* more columns helped to support the roof, at

64 Column capital from the
unfinished Temple of Athena at Old
Smyrna, overthrown by the Lydians
about 600 B C. Carved in leaf patterns
which appear still between the volutes
of later Ionic capitals. Height 62 cm.
(Izmir)

65 Aeolic capital from Lesbos. About
560 B C. Height 58 cm. (Istanbul 985)

66 The Naxian sphinx at Delphi.
Columns often support dedications in
the Archaic period, especially
sphinxes or *korai*. This has one of the
earliest Ionic capitals with wide set,
concave volutes. About 560 B C.
Height of sphinx 2.25 m. (Delphi)

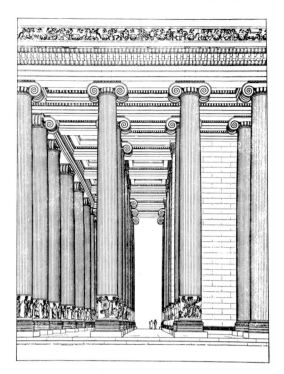

67 Restored drawing (by F. Krischen) of the side front of the Temple of Artemis at Ephesus. Designed in the 540s, completed a century later. The relief drums on the columns should probably be placed at their tops.

first axially down the centre, then in two rows to provide a nave-like approach to the cult statue. Altars stood outside the front door of the temple, normally to the east, and were either simple rectangular blocks with carved upper parts, or, in East Greece, monumental structures with broad flights of steps leading up to the sacrificial platform. Where wood was still used on the exterior of temples it was protected by painted clay revetments, and large clay roof tiles had been invented in the 7th century, but generally walls are all stone now, of precisely jointed rect-angular ashlars, or, for some house and terrace walls, of polygonal blocks, sometimes with curved edges (the so-called Lesbian), which are no less precisely fitted. Ionic buildings especially were decorated with elaborately carved mouldings round doors, along the tops of walls [68], on gutters and over the columns, sometimes even on the columns. Similar floral and volute mouldings are repeated in many minor works of bronze or clay, and in painting, and they are hellenized successors to the Orientalizing florals of the 7th century. The mouldings, and the orders, survived longer than the building types for which they had been designed – to the present day.

82

68 Carved frieze of leaf-and-dart, bead-and-reel, and lotus and palmette, from an Archaic Treasury at Delphi. Late 6th century BC. (Delphi)

The sculptural decoration of temples will be discussed later in this chapter. We have of necessity so far spoken only of temples. It was for these houses of the gods that the elaboration of the stone orders was reserved, and not for private houses, which probably boasted little more than painted wooden exteriors. Some tyrants may have fared better. The colonnade shelters (*stoai*) and entrance gates to sanctuaries were also treated in the grand manner, but only in the succeeding period do public buildings, law courts and theatres, regularly attract this attention.

SCULPTURE

Of the statuary in the round the *kouros* figures of naked youths, with their set, symmetrical stance, hands clenched at the sides, one foot advanced, remain unchanged in pose throughout our period [*69, 70*], and so serve as a useful standard on which to observe the advances in technique and treatment which are registered in different ways on other figures.

They were long known as Apollos, but few can represent this or any other deity; most are dedicated as attendants to a god, and early ones can be of colossal size, while others stand as memorials – not portraits – over graves. Their individuality is expressed in the inscriptions on them or on their bases, so that these are in their way idealized figures, undifferentiated by age or profession. Through the 6th century we can observe that a growing confidence in the carving of marble led to the disappearance of the block-like character of the earliest in the series.

83

69 Marble *kouros* from Tenea in south Greece. About 550 BC. Height 1.35 m. (Munich 168)

70 Marble *kouros* from a cemetery near Athens (Anavysos). On the base was inscribed the verse – 'Stop and grieve at the tomb of the dead Kroisos, slain by wild Ares in the front rank of battle.' About 530 BC. Height 1.94 m. (Athens 3851)

71 Marble figure of a man carrying a calf, the dedication of one [Rh]ombos on the Athenian Acropolis. About 560 BC. Restored height of whole figure 1.65 m. (Acr. 62)

There were also new tools. The Egyptians had used copper claw-chisels on soft stone; made of Greek iron the chisels could work marble, and they were adopted some time after the other egyptianizing traits described in the last chapter, which are by now mainly abandoned except for some minor borrowed poses. Anatomical details become more realistically treated and are better related to the mass and structure of the body. The Archaic smile, which came into fashion in the second quarter of the century [69], is relaxed into a straighter, sometimes sulky

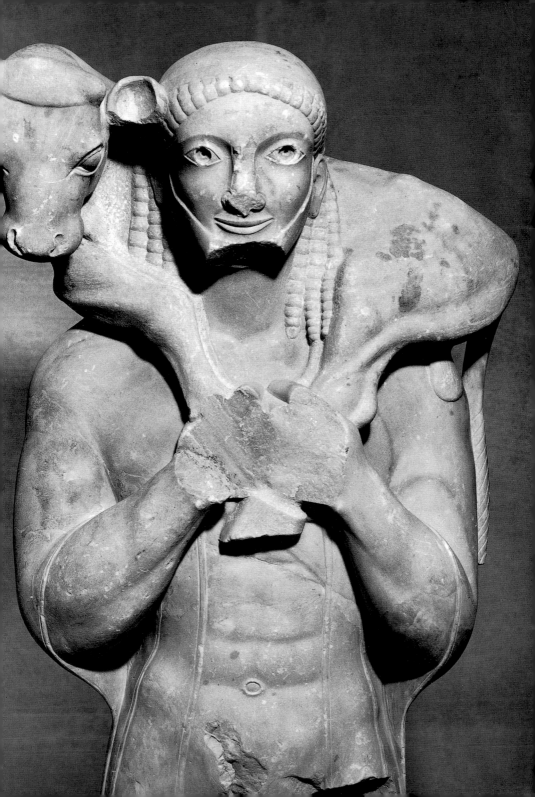

expression. The convention had given an impression of strained cheerfulness which the artist may have appreciated, but which was usually quite alien to what we expect of Greek funerary or votive art, and which cannot fairly be added to the few instances of emotion expressed in the features of Archaic statues. Progress was not deliberate but by a form of natural selection of those forms which seemed better to express the function of the figures; the selection naturally tended to the more realistic [70] and by the end of the period the live model was being more closely observed. Life was beginning to be as important a factor as geometry. The figure was at last conceived as a whole and not as a sum of parts, which was an approach imposed by the cutting-back techniques. The new manner could only be developed by modelling techniques, creating the figures from the inside out, not from the outside in. These were encouraged by the desire to cast large figures in bronze, which start as modelled figures in clay, and models created in the same way could as readily be translated into stone, by various measuring techniques, producing a dramatically different effect from that of earlier works in stone. The casting technique will be remarked on later in this chapter. This is where the Classical revolution begins, but we have first to chart the century that led to it in works other than the *kouroi*.

There are other free-standing statues of men which do not observe the *kouros* pose: from the Acropolis at Athens comes the famous calf-bearer [71] and a series of horsemen. In the head of one of these – the Rampin Horseman [74] – we observe the Archaic smile and the exquisitely precise carving of the marble in curving planes meeting in sharp ridges which would have been picked out even more dramatically with colour and in brilliant sunshine. The meticulous treatment of the curls and locks of this young Athenian cavalier dandy adds to the effect. His oak wreath tells of his success in the games. Here too strict frontality is relaxed. The head is inclined down and to one side, towards the spectator who would be passing across the front of the horse.

We have seen the way in which the artist treated the male body almost as an exercise in pattern and composition. In a country and society in which women were not seen in public as much undressed as many are today, it is not wholly surprising that female figure studies were not common in statuary until command of technique allowed a successful suggestion of more sensuous qualities. In vase painting it is otherwise, as we shall see. To the Archaic sculptor, however, women were little more than clothes-hangers. Faces are rarely any prettier or more appeal-

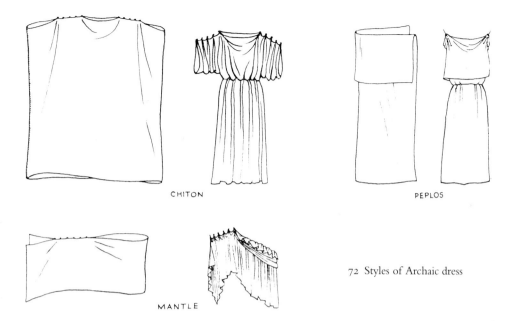

CHITON PEPLOS

MANTLE

72 Styles of Archaic dress

ing than those of the men, the hair not always more ornate. Patterns of folds, heavy and straight, fanning out across the body, or gathering into a zigzag hemline, exercised the sculptor's imagination and taste for variety of pattern, answering his other interest in the patterns of male anatomy. Breasts are admitted to exist, but not much admired. On later *korai* (maidens) the material is drawn tightly round the legs to show them and the buttocks as though bare, but the gesture and motif were designed at first simply to offer a pattern of diagonal folds across the lower half of the figure. One early statue from Attica [73] is, as a statue of a woman, gaunt and clumsy, redeemed only by the bold carving and simple drapery. The outer garment is the heavy *peplos* [72]. This is the dress of what is perhaps the finest of the ladies from Athens, the *Peplos Kore* [76], but it was not a garment which fully satisfied the Archaic artist's love of pattern. A new fashion and a new sculptural treatment of dress had arrived together from overseas. At this time in East Greece sculptors were experimenting with ways of diversifying the surface of the carved drapery, suggesting the folds by incised wavy lines or close-set, shallowly carved grooves. The lighter and more voluminous *chiton*, which Athenian *korai* had sometimes worn as an undershift, lent itself

87

more to this sort of treatment, offering full sleeves and skirts which could be gathered into a multiplicity of folds. These were further varied by drawing aside the skirt, in the manner which later showed off the legs, by slinging the *himation* cloak diagonally across the upper body to answer the folds across the legs, and by painting the elaborate patterns of embroidered hems. These new *chiton-korai* have their effect on the series known to us from the finds on the Athenian Acropolis from about the mid-6th century on [77], and there is evidence from signed bases and the style of some pieces that East Greek artists (such as Archermos of Chios) were at work in the city. Under the influence of these men (mainly Ionians and islanders) some of the *kore* heads even begin to look

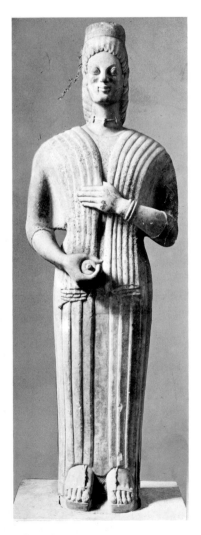

73 The Berlin Goddess from an Attic countryside cemetery (Keratea). She holds a pomegranate and wears the *polos* headdress. About 570–560 BC. Height 1.9 m. (Berlin 1800)

74 The Rampin Horseman, a dedication (one of a pair) on the Athenian Acropolis. The head was removed from Athens to Paris before the excavations which yielded the horseman's body. Mid-6th century BC. Height of head 29 cm. (Louvre 3104, Acr. 590)

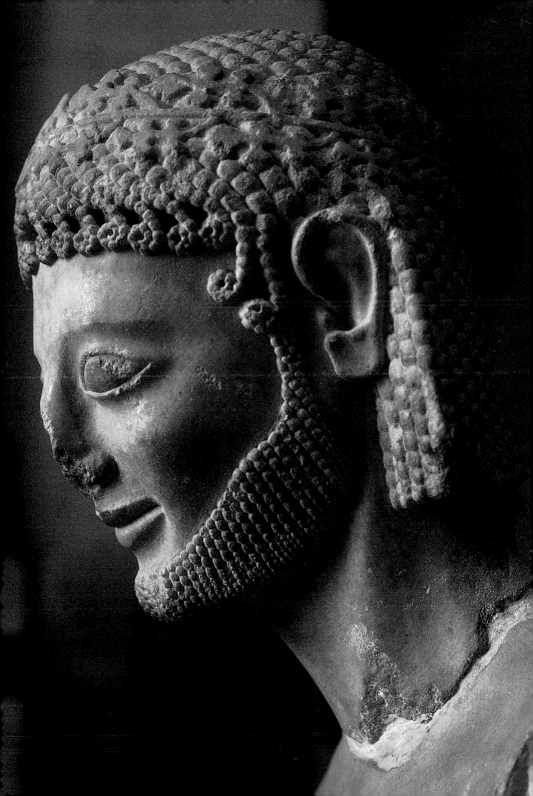

feminine. Towards the end of the Archaic period more attention is paid to the form of the body beneath the drapery and the features change, as did those of the *kouroi*. The only female type apart from the *kore* is the novel winged Victory (Nike) [75] which proves a popular subject for commemorative monuments for centuries to come.

All these statues in the round are very much set-pieces offering no variety of pose. There were many active regional schools making such figures, not necessarily determined by the styles of East Greeks or Athenians. The role of the former has been remarked. Their penchant for dressed *kouroi* and spherical heads was not one that travelled, but they were otherwise more influential than Athens from the mid-6th century on.

For more ambitious sculptural compositions we have to look for work in relief, especially on buildings. The arts of sculpture and architecture in Greece were inspired by the same source and always went hand-in-hand. The architecture was never simply the vehicle for the sculpture, nor was the sculpture merely decoration: its position enhanced and helped to articulate parts of the building and its themes added something to the sanctity of the temple, sometimes carrying profound religious and political messages. On Doric buildings the sculptor filled the rectangular metopes with individual groups of two or more figures. Fights are a natural choice but pursuits are found too, and occasionally the action is carried across from one metope to the next. Series of metopes may be linked by a theme like the Argonaut stories on the Sicyonian building at Delphi [78], or the deeds of Theseus and Heracles on the Athenian Treasury there. Some of the early metope compositions are the most bold, with frontal views of horsemen, the proud march of the heroes turned cattle-rustlers, and the duels of men, or man and monster.

The low triangles at the ends of gabled roofs – pediments – offered an awkward field. At first they are filled by an imposing central figure, flanked by other figures or groups at different scales, out towards the corners. Our earliest complete example is from the Temple of Artemis in Corfu, with a big central Gorgon. Sometimes a single theme or story occupies the composition, but the diminishing scale away from the centre does not make for unity, and in some instances looks rather ridiculous. Prostrate bodies, or fish- and snake-tailed monsters were favourites for corners, such as the entwined heroes or demons with snake tails from Athena's Temple on the Acropolis at Athens [82]. These,

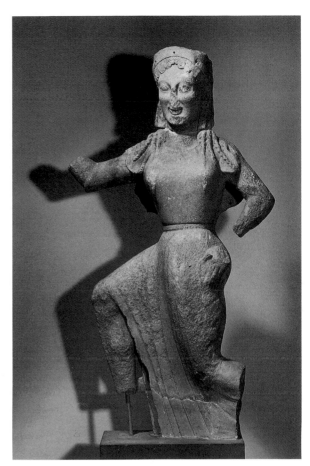

75 Nike from Delos, the earliest of the winged Victories. She had wings at her back and heels, wears a *peplos* and *chiton* fastened by disc brooches. The inscribed base reads – 'Farshooter [Apollo, receive this] fine figure [. . . worked by] the skills of Archermos, from the Chian Mikkiades . . .'. Archermos was a Chian sculptor who also worked in Athens. About 550 BC. Height 90 cm. (Athens 21)

like many other early architectural sculptures, are carved in limestone, which was, if necessary, covered with a coat of stucco to provide a smooth surface, and was brilliantly painted. The backgrounds were painted deep blue or red to help the lighter figures stand out from the shadows of the gables. By the end of the Archaic period unity of scale was observed for all the figures in the pediment, except the central divinity, and battle scenes (at Aegina and Athens) provided the sort of stooping, falling or recumbent figures which could fill the awkward frame [*79, 80*].

The sculptures on Ionic buildings are applied according to less rigid rules – or rather, individual and local tastes were given free expression.

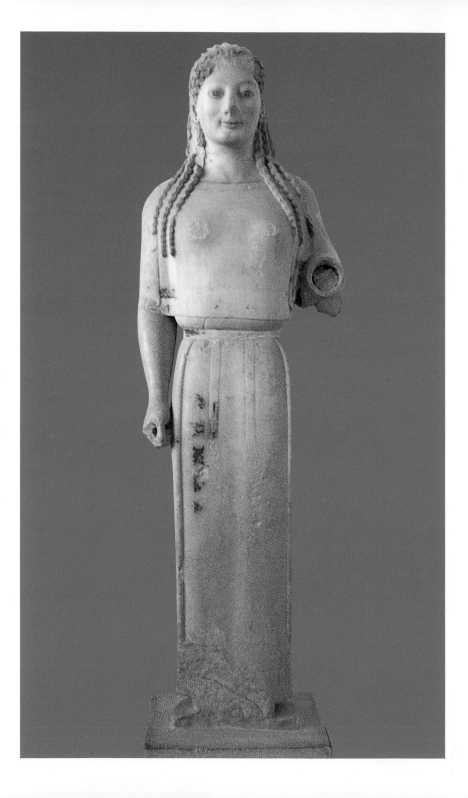

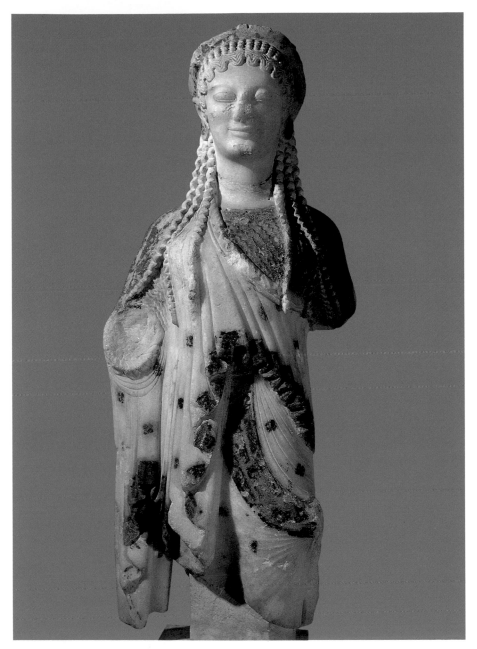

76 (*Left*) The *Peplos Kore* from the Athenian Acropolis. A bronze wreath and earrings had been added separately. Her hair and lips are painted red, lashes and brows black, and the pattern on her dress green. About 530 BC. Three-quarters lifesize. (Acr. 679) See p 87

77 (*Above*) A *kore* from the Athenian Acropolis, the work of an Ionian artist, probably from Chios. She wears a *chiton* and *himation*. The *chiton* was blue, and red and blue were used on dress patterns, earrings and necklet. About 525 BC. Half lifesize. (Acr. 675)

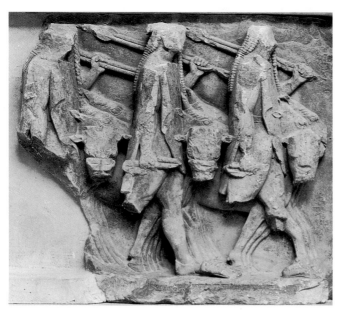

78 A metope from a Sicyonian building at Delphi. Castor and Polydeuces (the Dioscuri), Idas and Lynceus (missing here), stole cattle in the course of the Argonaut expedition. Heroes and cattle march in step, the beasts penned in by the spears. Names were painted on the background. About 560 BC. Height 62 cm. (Delphi)

From the massive Temple of Artemis at Ephesus we have only scraps of relief figures which decorated drums of the columns and friezes from the gutter and, perhaps, the *cella* wall. A better example is afforded by the Treasury dedicated by the islanders of Siphnos at Delphi in about 525 BC. Here the porch columns are replaced by *korai*, there are rich floral carvings round the door and at the gutter, and figure friezes run on all sides just below the roof. They offer very different answers to the problem of composing a narrative frieze; and the hands of two artists of strongly differing temperament can be detected (east and north by one; west and south by the other). On the north there is the battle of gods and giants [81], surging across the frieze in such a way as to obscure the divisions between individual duels and encounters; on the west there is the tripartite treatment of the Judgement of Paris (answering the three gaps on the building's façade), each goddess with her chariot, in which the story is conveyed by telling details of gesture; on the east a Trojan episode, where on one half we see the gods sitting in council on Olympus to judge the duel of heroes on the Trojan plain that appears in the other half; on the south a fragmentary processional which may include a mythical occasion.

94

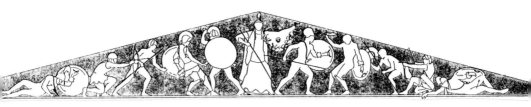

79 Restored east pediment from the
Temple of Aphaea on Aegina. Athena at
the centre supervises a battle at Troy,
perhaps the earlier encounter where
Heracles took part. The fighting figures
are carved in the round and their
struggling poses well suit the awkward
field. About 490–480 BC. Height at
centre 4.2 m. (Munich)

80 Heracles, wearing a lion-head
helmet, from the east pediment at Aegina
(see [79]) Height 79 cm. (Munich)

81 (*Below*) From the north frieze of the
Siphnian Treasury at Delphi. Battle of
gods and giants. The gods fight from the
left (the usual Greek convention for
victors). The figures were named. At the
left is Hephaistos, plying his bellows to
heat coals. The figure with an animal
skin is Dionysus, then Themis in her
lion-chariot with Apollo and Artemis
before it. About 525 BC. Height 63 cm.
(Delphi)

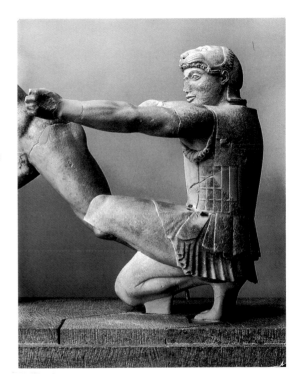

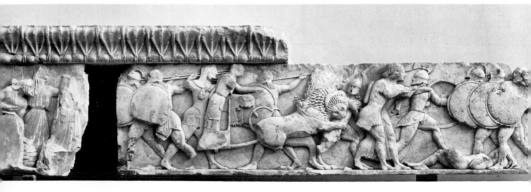

82 A limestone group in the corner of the pediment of the Temple of Athena on the Athenian Acropolis. Three male torsos, winged and with entwined serpent bodies. They have been variously interpreted in the light of the symbols they hold – water, corn, a bird. Hair and beards are blue, eyes black, skin yellow, and there is red and black on the feathers and scaly stripes. About 550–540 BC. Height of foremost figure 71 cm. (Acr.)

Finally, there are the acroteria which appear on both Doric and Ionic buildings – figures in the round at gable corners and crown, generally of monsters, sphinxes, griffins or gorgons, sometimes simply massive floral complexes.

The sculpture on these buildings is almost in the round, wholly so in pediments by the end of the period, but the poses and groups are far more ambitious than any for free-standing statuary. There are a few free-standing groups of Archaic figures, mainly East Greek; they stand shoulder-to-shoulder, like football teams, and do not interact. We have rather to compare the figure drawing on vases, and in fact most Archaic relief sculpture is readily explained in terms of the line drawing on the uncut block, from which the sculptor started. Where the relief was shallow it meant that all the detail was brought to the front plane, even though the figures were shown as overlapping. Only on the very high relief of some

metopes and pediments, where the figures are mainly or wholly detached from the background, do we have works carved properly in the round, allowing intelligible three-quarter views. But the compositions remain the same, uninhibited by the greater difficulties presented by the carving.

Shallow relief, picked out in colour, was used for another class of monuments – gravestones. We know best those in Athens and the countryside. At the start of the 6th century the gravestones were tall shafts (*stelai*) topped by sphinxes [*83*], but soon the shaft was carved in relief with a representation of the dead. Youths are shown as athletes, shouldering a discus or holding their oil-bottles, men as warriors [*84*]: all in an upright stance, like profile views of the *kouroi* they so much resemble in the detail of their carving. A youth is once shown with his young sister, another fragmentary stone has a mother holding her child, but it is unusual for the tall thin shafts to carry more than one figure. These reliefs represent the dead without being real portraits, but they do admit more differentiation of age and profession than did the grave *kouroi*. The distinctions between adolescence (athletes), maturity (warriors) and advanced age (leaning on a staff, with a dog) come to be observed and what might be called generalized portraiture is seen in the puffy features of a boxer [*85*].

After about 530 the sphinxes on gravestones had been replaced by simpler palmette finials. This is another example of East Greek influence in Athens, for the type had been known in Ionia for a generation already, although the shafts there were not normally carved. The type with the slim tall shaft was abandoned in Athens before the Persian Wars, but persisted in the islands.

Reliefs appear on other monuments as well. Statue and *stele* bases may be so decorated. Several of these have been found in Athens' main cemetery, carved with scenes of athletes [*87*] or young men taking their ease. They also served as votive offerings in sanctuaries. These votive reliefs may be carved with representations of the deity, or of an act of worship in which the dedicator may be thought to figure among the worshippers and some show the dedicator alone. The best of these reliefs were set in the rock or stood upon pillars. Indeed, apart from the temple itself, the greater part of the decoration of a Greek sanctuary was made up of private dedications set in positions of honour or obscurity according to their size or merit, or to the relative importance and popularity of the dedicator. A special class of votive is represented by

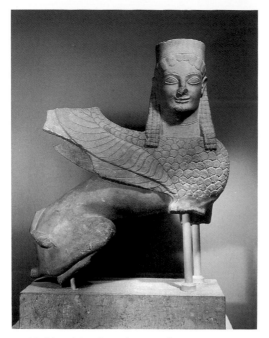

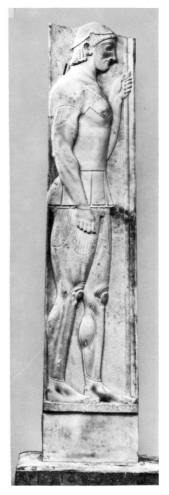

83 Marble sphinx from the top of a gravestone in a cemetery near Athens (Spata). She wears a *polos*. About 550 BC. Height 46 cm. (Athens 28)

84 Gravestone of Aristion from Attica (Velanideza), signed by the artist Aristocles. The background was painted red and there are traces of red and blue on the figure, while patterns on the corselet show where colour had been. About 510 BC. Height without base 2.4 m. (Athens 29)

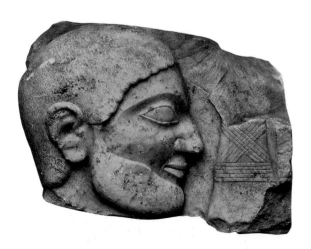

85 Fragment of a gravestone from Athens with the head of a boxer, his ears bruised, his hands bound. About 540 BC. Height 23 cm. (Athens, Ker.)

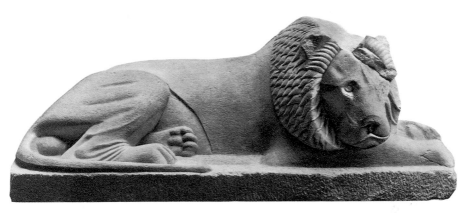

86 A marble lion from the cemetery at Miletus. Lions served as grave-markers from the late 7th century on. About 550 BC. Length 1.76 m. (Berlin 1790)

the figures of lions (Delos) or seated figures (Didyma) which flanked processional ways in the Egyptian manner. Lions too could serve as tomb-markers, and, as a change from the threatening Eastern type, the more domestic Egyptian beast is copied by some East Greek artists, with fine regard for the quality of heavy pelt and pattern of mane [86]. It is easy to forget how good Greek artists can be at animals. Such personal or state commissions to architects and sculptors are an important feature of Archaic Greece. The artist is hired to do a job, to please or impress mortals or divinities.

With these monumental arts already so well established in Greece in the Archaic period it is inevitable that they take pride of place over what is still our most bountiful source of information about Greek art and taste – vase painting.

87 Relief on the base of a statue marking a grave in Athens. It had been built into Athens' walls in the hurried refortification after the Persian Wars. Athletes are training: a runner in the starting position; wrestlers; a youth testing the point of his javelin. About 510 BC. Length 82 cm. (Athens 3476)

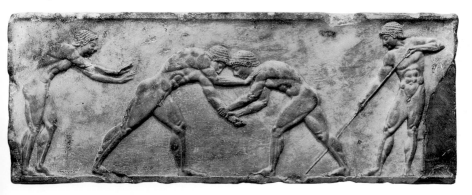

Decorating clay vases seldom called for high art, though some of the artists so occupied were consummate draughtsmen. Their wares were not expensive (a day's wage for a decent small vase) but some specialist production, first in Corinth and later in Athens, won markets all over and beyond the Greek world. It must have looked as unusual and desirable to many as Chinese porcelain did at first to Europeans. It was not quite as novel everywhere, and regional schools in Greece are busy through much of the 6th century, but Athenian potters won rich markets in Etruria and the Western Greek colonies, and held them until local competition in South Italy provided a real alternative. What attracted must have been the quality of the potting, with its fine black gloss paint, and the narrative entertainment of the figure decoration. Such a massive trade in breakables must have made a lot of money for the middlemen. Its survival qualities make it important for us as a field for study in its own right and for what it may teach about other and senior crafts.

By the end of the 7th century the Athenian vase painter had adopted wholeheartedly the black figure technique, which had already been practised at Corinth for a century. With it came also the animal frieze style of Corinth, and for a generation or more the greater part of Athens' vases is covered with rows of animals – lions, goats, boars, sphinxes. But the monumental character of Athens' pottery had not been forgotten, and while at Corinth the gross creatures wandered lost in a maze of filling rosettes in a repetitive, mass-produced style, the Athenian beasts were better managed. The Nessos Painter was one of the first to use black figure in Athens. He still painted large funeral vases, and beasts upon them are commensurately massive, precisely and boldly drawn in a manner not matched in Corinth. And the narrative scenes persist beside the animals on many vases, generally taking the prior position. The success of this new style in Athenian black figure pottery is shown by the way it penetrates markets hitherto served only by Corinth.

I called the artist the Nessos Painter. A few ancient painters and potters signed a small proportion of their work, but the nature of the drawing, highly stylized and surviving in significant quantity, makes it possible to attribute groups to individual hands on the basis of their 'handwriting', usually the rendering of trivial details, and the correctness of the exercise can be proved by those few already signed. This adds

88 Detail of an Athenian *amphora* by the Gorgon Painter, pupil of the Nessos Painter. Early 6th century BC. (Louvre E 187)

an important dimension to the study, but we have often to use sobriquets, like the Nessos Painter, not real names.

The Nessos Painter was succeeded, early in the 6th century, by others who worked in the animal frieze style as well as with narrative scenes [88], but by about 570 Athenian interest in figure scenes rather than animals is beginning to win the day. The François Vase [89, 90], a wine-mixing-bowl (crater) found in an Etruscan grave, carries six figured friezes on either side, of which only one is occupied by animals – fighting and posed heraldically over florals, while on the rest and on the handles more than two hundred figures act out mythological scenes. Almost all the figures, and some objects, are labelled with their names and both potter and painter, Ergotimos and Kleitias, signed their work, twice. From now on animal friezes and florals are suppressed to subsidiary positions and the painter increases his repertory of mythological themes. Even the gorgoneion which serves to fill many circular fields in cups or on plates in the 6th century is the product of a mythical adventure, also shown on vases – Perseus' encounter with the Gorgon-Medusa and his removal of her (literally) petrifying head. The same head appears often as an appropriate device on shields. The new dedication to the depiction of myth leads to massive Athenian production, much of it, it seems, in a lively style for the export market [91].

89, 90 The François Vase, a volute *crater*, the earliest well-preserved example of an Athenian vase almost wholly devoted to myth scenes. From Chiusi. About 570 BC. Height 66 cm. Detail (*below*) shows the ship coming to pick up Theseus and the Athenians he had rescued from the Minotaur. One eager sailor swims ashore and at the right the victory dance begins. The figures are unusually animated for the period. (Florence 4209)

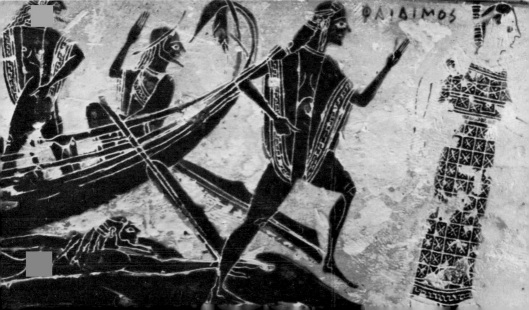

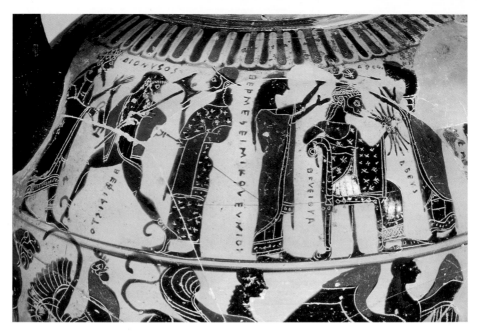

91 Athenian black figure *amphora*, the so-called Tyrrhenian type which seems to have been an export model for Etruria. Zeus, seated right, bears Athena, emerging from his head, attended by goddesses of childbirth. Behind are Hermes, Hephaistos who had cleaved Zeus' head with his axe, and Dionysus; all named. (Berlin F 1704)

92 Athenian *amphora* by the Amasis Painter. Dionysus with dancing nymphs and youths. About 530 B C. Height 44 cm. (Basel)

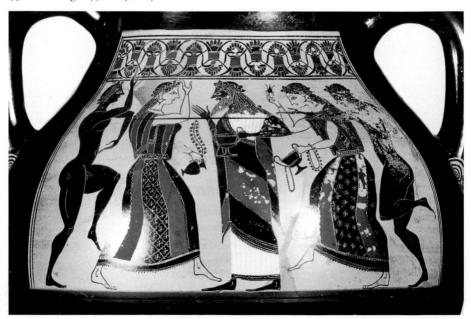

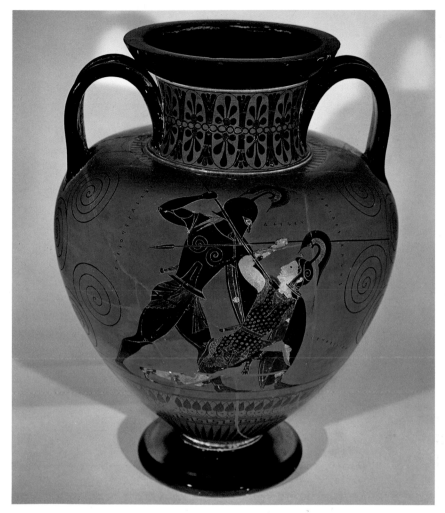

93 An Athenian black figure *amphora* by Exekias showing Achilles killing the Amazon queen Penthesilea at Troy. From Vulci. About 540 B C. (London B 210)

94 Athenian Little Master band cup detail, with lions and leopards attacking a bull and a mule. About 540 B C. (Oxford)

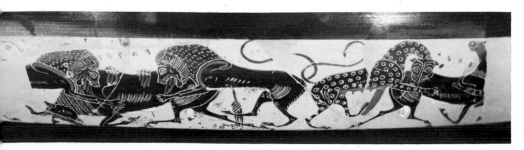

New artists set high standards in painting table vases (the big funeral vases had gone out of fashion). The Amasis Painter's lithe figures [92] show an unexpected, vivid humour. His potter-work is equally individual and it is likely that we have here to deal with a painter-potter of rare distinction. His contemporary (of the mid-century and after) Exekias offers a strong contrast in an almost Classical style with figures of dignity and presence [93]. The vases these artists decorate are wine- or olive-oil-jars (*amphorae*), water-jars (*hydriae*) or wine-mixing-bowls (*craters*). On cups we find a more miniaturist style reminiscent of Protocorinthian. Greek cups generally have two horizontal side handles. The Corinthian type, with a deep bowl, was replaced in Athens by varieties with a broad shallow bowl set on a high splaying stem, like that of a wine-glass. These may have their lips plain (lip cups) with small figures or groups decorating them, or black (band cups) with figures in the band between the handles. Inside there may be a figure or group within a circle, and the rest of the vase is painted with the fine, lustrous black paint which is one of the most appealing features of all good Athenian vases. Their artists are the so-called Little Masters [94].

The painters of the later part of the 6th century offer a somewhat racier, sometimes sketchy, style. It occasionally succeeds in combining the precision of Exekias with the new verve, but the influence is now that of another vase painting technique, red figure, to which we must turn in a moment. Before we do, it should be admitted that not all the fine black figure vases of the 6th century are Athenian. The Corinthians continued in brisk competition to around 550, emulating and in some respects still even inspiring the figure scenes and shapes of Athenian vases. They achieve a decorative effect in colour which the Athenian seldom looked for, preferring detailed drawing by incision and freer composition. But the output of painted pottery for export seems to have been an important factor in Corinth's potters' quarter, especially the colourful *craters* which were sent west to Etruria [96]. Why the Corinthians stopped decorating vases in this manner is rather a mystery; their quality was as good as ever and it cannot all be a matter of Athenian competition. Soon, however, Athenian potters (such as Nikosthenes) sought out the new markets with export models especially designed for them, copying shapes familiar to the Etruscan customers.

Other schools, dependent in varying degrees upon Corinth and Athens, produced black figure vases for their local markets. Spartan cups had some success overseas but their figures are stiff and lifeless though

95 A chalice, made in Chios. The shape, thin walls and fine surface are distinctive of the class, which was widely exported. This is from a Greek colony (Taucheira) in Libya. About 560 BC. Height 18 cm. (Tocra)

often very precisely drawn. Such East Greek schools as were not ringing the changes on the old outline style of the Wild Goats also produced black figure, generally fussy and highly coloured, but also some delicate cups of great charm and originality [95, 97]. On these, and the Spartan cups, we often see whirling compositions, or scenes which own no top or bottom, such as the Athenian artists generally eschewed, and more of the interior is filled with the scene [98]. In South Italy Chalcidian potters had set up shop perhaps in Rhegium (Reggio) and had some success in Italy and Sicily with vases on which the finer motifs of the other schools were combined with a superb decorative sensibility and telling economy of line [99]. Emigrant artists from East Greece had some success in Etruria and promoted distinguished local schools of black figure. An Ionian artist working in Caere (Cerveteri) made a series of superbly colourful *hydriae* which were in some demand locally. He shows a rare sense of humour as well as imagination in his treatment of myth [100], and sometimes the story is outside the usual vase painters' repertory: perhaps more dependent on painting traditions in his eastern home which were not expressed on pottery.

96 Corinthian *crater* showing a married couple in a chariot. Red and white are used freely and the detail on the white is painted, not incised. The background has been reddened to heighten the polychrome effect. By the Three Maidens Painter. From Cerveteri. About 560 BC. Height 42.5 cm. (Vatican MGE 126)

97 An East Greek Little Master cup, probably made in Samos, but found in Etruria. The detail is not incised but reserved. A man dances between trees; to the left a bird brings food to fledgelings, approached by a snake and a locust. About 550 BC. Diameter 23 cm. (Louvre F 68)

98 Spartan black figure cup. Bellerophon attacks the Chimaera which is posed over him opposite the hero's mount, Pegasus. About 550 BC. Diameter 14 cm. (Malibu 85.AE.121)

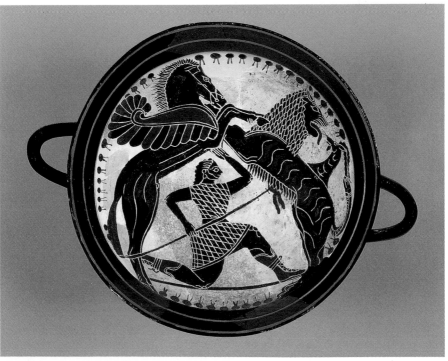

Although the individuality of these schools, and of the different artists in Athens, can be appreciated at a glance, there were fairly rigidly observed conventions in black figure, and an overall unity of style which developed slowly. The black silhouette with incised detail remained the basic element. Red was used more often than in the 7th century – for hair and beards, on drapery, and for a while in early black figure to show masculine sunburnt faces. Women's faces and bodies are in white, painted over the black silhouette which showed through the incised details, and white appears on drapery patterns. The male-red, female-white convention was observed in Egyptian art, and is, after all, an approximation to life. The figures are shown in a strictly profile view although it was usually found easier to show the chest frontal, especially in moving figures. For running or flying the figures appear as kneeling with elbows thrown high. The eye too is frontal even in a profile head, a disc for men, almond shape for women, on Athenian vases. Frontal heads and bodies are rare except for grotesque or horrific creatures like satyrs, centaurs and gorgons, or human figures who seem to be appealing to the viewer for sympathy. The representation of drapery changes from flat enveloping folds to elaborately patterned pleats and zigzag hems, exactly like the carving of the marble *korai* after the mid-century. Emotion is expressed by gesture – hands tearing hair in grief, gestures of farewell, of animated conversation, of abandoned joy; rarely a facial detail like a furrowed brow or clenched teeth. The women are ageless, with an occasional matron. For the men a beard marks maturity or status, and white hair or partial baldness and bent shoulders old age.

Conventions, too, govern the way in which the more popular scenes are shown, and the accepted way of depicting, for instance, the Judgement of Paris or the departure of a warrior, is rarely changed or abandoned by artists. The formulae in fact help to tell the story. The composition of a scene need not be bound by time or space. By expressing the roles of the actors through attribute or pose something more than an event can be expressed, and the viewer may be reminded of earlier events and the outcome. This technique is often called 'synoptic' but this implies a deliberate choice of significant detail by the artist, which was probably seldom the case. It is common to many places and periods; even film has not rendered it altogether obsolete. Sometimes even a seemingly non-narrative symmetrical or heraldic composition reveals a deeper intention. Thus, a bronze plaque from Olympia shows a warrior between centaurs, but is resolved into Kaineus being beaten

99 Chalcidian black figure column *crater* with cocks and snakes and a characteristically plump bud frieze. From Vulci. About 530 BC. Height 37 cm. (Würzburg 147)

into the ground by them; or a Spartan vase where two monsters rear over a hero, which becomes a Bellerophon with Pegasus fighting the Chimaera [98], an alternative to the more natural confrontation. But within these conventions individual skill and imagination could still be expressed. Scenes of myth predominate, especially the deeds of popular heroes like Heracles [101]. There are also more formal studies of the gods, alone or in groups. Many of the vases are designed to serve a drinking-party, and scenes with the god of wine, Dionysus, are naturally common. In his entourage is one of the most engaging figures of Archaic art – the satyr. An earlier poet had called satyrs 'unemployable layabouts'. Not until the 6th century did artists look for a way to

100 A Caeretan *hydria*, made by a Greek artist in Etruria. Heracles delivers the hound of Hades, Cerberus, to Eurystheus, who has jumped terrified into a storage jar. About 510 BC. Height 43 cm. (Louvre E 701)

showing these creatures, and decided to use them both in the service of the wine god Dionysus and to demonstrate embarrassingly human weaknesses and some uninhibited wish-fulfillment. This is a characteristically Greek way of expressing through the supernatural some of the less admirable aspects of contemporary behaviour, and especially male problems in the sex war. The satyrs' role becomes a subtle commentary on the human, a means of expressing views about behaviour, sex, and even religion that did not come easily to media other than images [*102, 107–109*]. The centaur type, part man, part horse, may have suggested their physical form, since the satyr is little more than an abbreviated centaur, with shaggy head, horse's ears and tail, and two human or horse's legs. The centaurs had shown a fondness for wine and women; the satyrs added song, and in Dionysus' service they even play a part in the early development of the Greek theatre.

It is easy to interpret all these mythological scenes as expressions of no more than Greek love of colourful narrative. Certainly, few seem to express any deeper religious feeling. But in other ancient cultures, and in later Classical art and literature, myth is freely used metaphorically to comment on contemporary problems of life or politics. In the absence of explicit references in texts it is not possible to be sure that this was also true of the Archaic period, but we may suspect that Heracles, as favourite of Athena, was exploited by Athens' rulers, who naturally claimed Athena's patronage, and could use or even invent mythical (but to the Greeks, historical) occasions to illustrate events, or justify new policies. Pisistratus once returned to power with a charade in which he was driven in a chariot by a mock–Athena back to the Acropolis, an

101 Detail of an Athenian black figure *amphora*, by Psiax (who also painted red figure). Heracles has to wrestle the Nemean lion which cannot be hurt by weapons. From Vulci. About 520 BC. (Brescia)

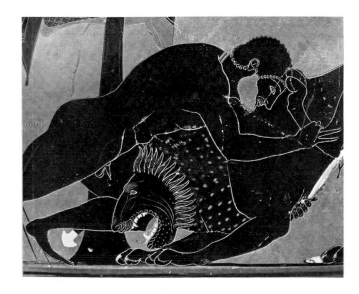

event surely inspired by scenes of Athena's introduction of Heracles to Olympus by chariot. And after the 6th century, although Heracles was bound to remain popular, he had to yield to a new and rather more overtly political interest in a rival, local hero Theseus, who symbolized the new democracy. All these contemporary messages can be read in the vase painting of the day.

Besides these scenes of myth everyday life was not neglected – weddings, burials, gossip at the fountain, courtship and love, and, of course, the drinking-party; but some of the finest examples of these subjects, and an even greater range of them, are to be found on Athenian vases painted in the new technique which was to oust black figure – red figure.

The black figure vases were still being made in the 5th century but in their last phase they take second place – except for some traditional prize vases which perpetuate the old technique (the Panathenaic *amphorae*) – to vases painted in what we call the red figure style. This had been introduced in Athens about 530 BC. It is an exact reversal of black figure. The background now, and not the figure, is painted black, and so the figures appear in the red of the clay ground (the colour may be heightened), and the details are painted upon them in line detail where before they had been incised. In fact we are back with the outline drawings of the Orientalizing period, which had never been quite forgotten, even by some black figure artists (such as Sophilos and the

102 Red figure cup signed by Phintias. A large satyr is being assaulted by a small naked woman. About 510 BC. (Karlsruhe 63.104)

103 Detail from an Athenian red figure *amphora* by the Andocides Painter, with the goddess Artemis wearing *chiton*, *himation*, wreath and earrings. Incision is still used, round her hair. She holds a formal flower while watching, unconcerned, a contest between her brother Apollo and Heracles. From Vulci. About 525 BC. (Berlin F 2159)

104 Red figure calyx *crater* by Euphronios. Athletes: one binds up his penis, another prac-
tises with a discus before a trainer, another folds clothes. About 510 BC. Width 44.4 cm.
(Berlin 2180)

Amasis Painter). The brush is a more subtle implement than the incis-
ing point, and although at first treatment of figures and detail is not
much different from black figure, in time the more flowing line assists
a more realistic rendering of anatomy and drapery. The fact that the
outline of the figure is limited by a line, and not the outer edge of the
silhouette mass, also has its effect. Colour now plays virtually no part,
and only the lightest touches of red and white – even occasionally
gilding – appear, but variety is admitted by the use of thinned paint for
light anatomical detail, fine drapery or hair, and a relief line of brilliance
and body for more important outlines and strokes. Men and women
have to be distinguished by features, dress and anatomy now, not colour.
The line of the body is sketched through the intricate drapery patterns
and there are plenty of brilliant and perceptive studies of the female
nude which we look for in vain in sculpture of this date. The muscula-
ture of the male body is more accurately observed, the abrupt transition
between frontal chest and profile hips is managed plausibly, and even

105 Clay plaque from the Athenian Acropolis, probably painted by Euthymides, a known vase painter. It bore the motto 'Megacles is handsome' but the name was erased and Glaucytes substituted, probably after Megacles was ostracised. About 500 BC. Width 50 cm. (Acr. 1037)

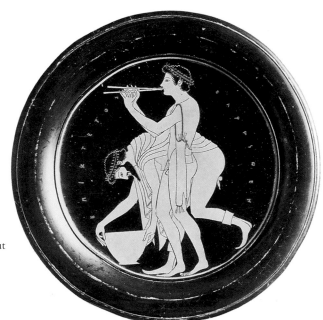

106 Red figure plate by Epiktetos. From Vulci. About 510 BC. Diameter 18.7 cm. (London E 137)

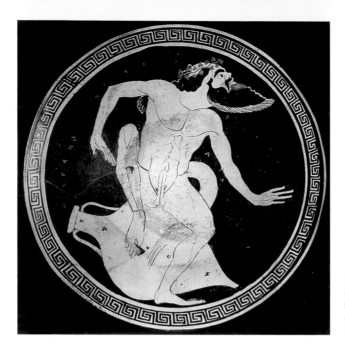

107 Interior of a red figure cup by Onesimos. An excited satyr squats on a pointed wine *amphora*. From Orvieto. About 500 BC. (Boston 10. 179)

back three-quarter views and bold foreshortening of limbs are soon brought off. The eye is gradually shown in a proper profile view, but frontal heads are still avoided, and three-quarter views of heads seldom attempted. There are even a few examples of light shading which helps to lend an illusion of mass to the linear drawing of objects. Within a generation the new technique effected greater advances in the graphic arts than black figure had achieved in over a century.

The earliest of the red figure artists, the Andocides Painter [103], decorated vases which also carried scenes in the old black figure technique (done by him or a companion) and other artists produced these bilinguals. The new style had its effect on the old – quite apart from the way in which it gradually stifled it. For example, the silhouette is more often now defined by a line, incised [101]. Subjects and stories remain unchanged but there is a shift of emphasis in the representations of some myths, many more genre scenes of athletics or drinking parties, and we see rather more specialization among the painters, who are attracted to work on either large or small vases (usually cups). The first half-century of red figure produced most of its great masters. Artists like Euphronios [104] and Euthymides were working before 500 in a classic style which

118

108 A red figure *psykter* (wine-cooler) by Douris. Satyrs at a party. From Cerveteri. About 480 BC. Height 29 cm. (London E 768)

109 Red figure cup by the Brygos Painter. Satyrs move to assault the goddess Hera. Hermes intervenes cautiously but Heracles threatens them with force. From Capua. About 480 BC. Diameter 27.5 cm. (London E 65)

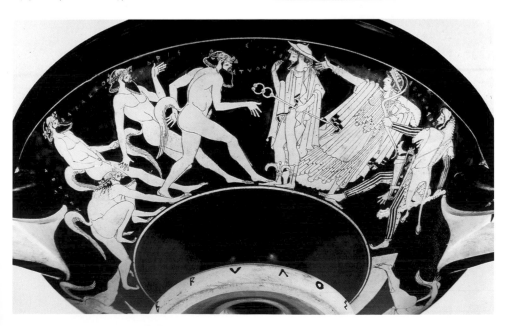

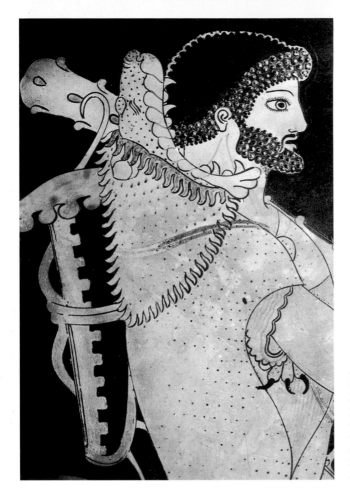

110 Detail from an *amphora* by the Berlin Painter with Heracles wearing lionskin, with club, bow and quiver. Notice the difference between the strong relief line and thinned lines for anatomy and on dress, and the relief ringlets in hair and beard. About 480 BC. (Basel BS 456)

owed something to the work of Exekias and for its precision and command of line can compare with the very best in contemporary statuary. These so-called Pioneers specialized in larger vases. Euthymides is probably also the master of a larger work, a clay plaque from the Acropolis, with a warrior painted part in outline, part in black figure [105]. Among contemporaries, working on smaller vases generally, are Oltos, a robust, economical draughtsman, and Epiktetos, whose figures are closer to those on the large vases but more delicately conceived [106]. At the end of our period the greatest names (or pseudonyms) are the Berlin Painter and the Kleophrades Painter. The Berlin Painter appre-

111 The head of a dancing maenad from an *amphora* by the Kleophrades Painter. She wears an animal skin, painted in a pale wash, over *chiton* and shawl. A snake winds up one arm and she holds a *thyrsos*, a reed with cluster of ivy leaves at the top. From Vulci. About 490 BC. (Munich 2344)

112 Painted wooden votive plaque from a cave at Pitsa, near Corinth, in Corinthian style and with Corinthian inscriptions. A scene of sacrifice. About 530 BC. Length 30 cm. (Athens)

ciated the effect that could be made with single figure studies or small groups. His is perhaps the most skilful use of this strange technique which forces all the figures to the foreground, before an inky backdrop [*110*]. The Kleophrades Painter, more an intellectual to judge from his themes, lacked nothing in sober strength, but many of his subjects are treated with an originality and verve [*111*] that we associate more with the cup-painters. Of these there are several artists of the first rank working in Athens in the opening years of the 5th century. Their cups are the new, high-stemmed *kylikes*, with a shallow open bowl which offered a circular field for decoration within (appearing to the drinker through his wine), and two broad arcs on the outside for frieze compositions which were best appreciated when the cup was hanging on the wall (the foot carefully sized so as not to obscure the drawing). Onesimos delicately ranged from residual Archaic vigour [*107*] to the dignity which is to typify the succeeding period, and which is especially characteristic of his later work. Douris, a rather finicky but expressive artist, also had a long career. His vase shown here is a *psykter* or cooler [*108*]. Filled with wine it would stand in a bigger bowl full of ice-cold water or snow. The Brygos Painter's notable output included a magnificently full series of Dionysiac [*109*] and drinking-party scenes with

122

113 Tomb painting at Elmali, in Persian-dominated Lycia (SW Turkey). The subjects are part eastern, part Greek, and the style must be that of other major painting in the East Greek world, not otherwise well preserved. About 500 BC.

shrewd characterizations of drunkenness, excitement or lassitude, as well as more formal mythological scenes in the grand manner.

It will be realized that painting is a misnomer for the art of red figure. There is hardly any colour, and no more variety of intensity in the painting than can be copied in line drawing with a pencil. Euthymides' plaque [105] shows what work on a larger scale might have looked like. The light background would have been the rule for any painting on walls or wooden panels, of which hardly any have survived [112] and we have to look to work on the periphery of the Greek world – in Italy and Anatolia [113] – to get some idea of what contemporary major painting must have looked like. For its conventions it seems likely that it was little different from vase painting writ large but enjoying the added realism of the light background and a greater range of colour.

114 Clay antefix for a roof from Gela in Sicily. Satyrs are by this time often shown with human ears, but these are still animal. Early 5th century BC. Height 19.5 cm. (Gela)

115 Clay figure-vase of a youth binding his hair. Probably Athenian, and from Athens. About 530 BC. Height 25.5 cm. (Agora P 1231)

OTHER ARTS

There are countless smaller objects, in clay, bronze or more precious materials, upon which the artists lavished their skills. Generally the style and subject-matter of the decoration is as that of the major or better documented arts such as sculpture and vase painting, but occasionally the special demands of material, technique or purpose, or the inspiration of different foreign models, produced original and new art forms. The customers were not always the very rich, it seems.

Figurines in clay, mass-produced from a mould and generally painted before being fired, are common dedications in sanctuaries, but they were naturally not accorded any place of honour and were from time to time swept out or buried to make way for more. The same figures, of men, women, gods or animals, could serve as offerings in a grave,

116 Drawing of a bronze shield-band relief, an important field for myth scenes in the 6th century, representing subjects current in south Greece, not always quite the same as those familiar from Athenian vases. Clytemnestra and Aegisthus are murdering Agamemnon. From Olympia. About 560 BC. Width 7.2 cm. (Olympia)

117 (*Below*) Bronze pectoral from Samos showing Heracles fighting the three-bodied Geryon. East Greek artists were freer with myth scenes on their bronzes (few preserved) than on their vases. About 610 BC. (Samos 2518)

toys for children or household decoration. The original models, from which the moulds were made, were often fine works of miniature sculpture, to which the decorative figurines which abound on sites and in museums rarely do justice. A different class is the hollow figure-vase serving as a perfume-flask [*115*]. The type had been known in the 7th century and is further elaborated in the 6th. Clay figures in the round or in relief also serve as revetments, acroteria or gutter terminals on the smaller buildings, and some of these are notable works of art, especially those from Western Greek sites (in Sicily and South Italy) [*114*]. Here there was no fine white marble and techniques of minor and major clay statuary were soon highly developed.

Sheet bronze with incised or hammered detail was an important medium for figure decoration on a variety of objects: on the bands fastening the handles inside hoplite shields – a southern Greek speciality [*116*], or the pectoral from Samos [*117*] which preserves precious evidence for East Greek narrative styles.

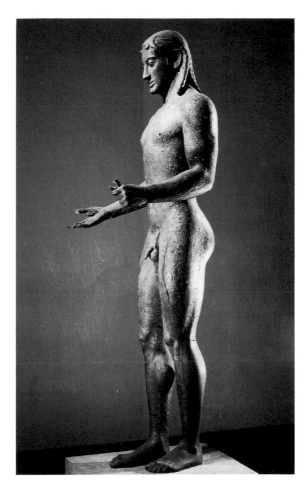

Archaic.

118 Hollow-cast (direct method) bronze Apollo from Piraeus, found with a cache of later statues, probably en route to Italy but overtaken by Sulla's sack of the town in 86 BC. He held a bow in his left hand, a *phiale* in his right. About 520 BC. Height 1.92 m. (Piraeus)

Figurines in bronze are cast solid from models similar to those from which moulds for clay figures were made, but finer (of wax, not clay) and, except in rare instances where moulds were kept for re-use, they were singletons which were destroyed in the casting. Larger statuary up to lifesize was being made in bronze by the end of the Archaic period [*118*], using the *cire perdue* method which also required a finished full-size model in clay. This model was lost when the figure was cast direct onto it, but by the indirect method moulds were made and could be re-used for repairs or for other, adjusted figures. The method produced light, hollow figures with a thin fabric. The casting replaced the wax which had coated the inside of the moulds (not the outside of the

127

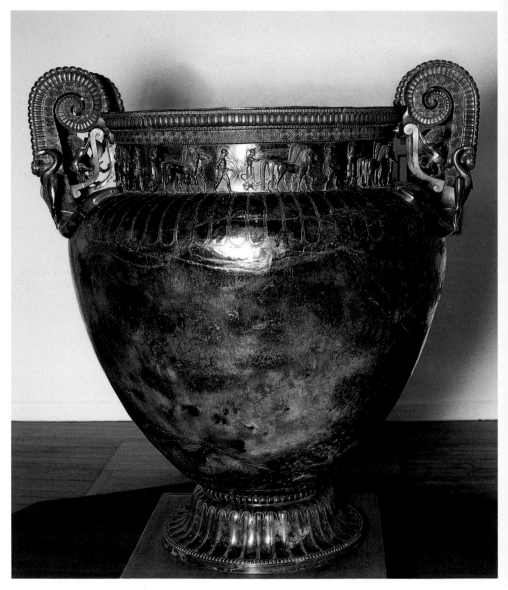

119 Bronze *crater* from Vix (France). The handles, rim, foot and figures on the neck were cast separately and labelled for assembly on arrival. The style is Spartan. About 530 BC. Height 1.64 m. (Châtillon-sur-Seine)

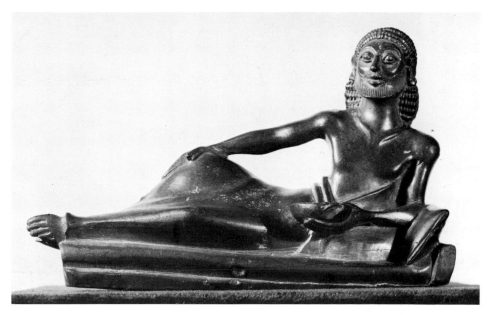

120 Bronze solid cast figure of a man at a feast, from the rim of a bronze vessel. About 520 BC. Length 10 cm. (London 1954.10–18.1)

model) with bronze, the body of the figure being filled with a core which could be chipped out. We have already noticed the importance of this major modelling technique in the history of Greek art, and the flexibility of design that it allowed.

The bronze figurines are sometimes independent works – votive or decorative – but more often were applied to other objects, especially bronze vases [120]. These were naturally more valuable than the clay vessels, but few have survived. The great mixing-bowls (craters) had hammered bowls to which were applied cast-bronze figures – the volute handles fashioned with gorgons at the point of attachment to the bowl, elaborately moulded hoops for the lip and foot, and sometimes relief figures of animals, warriors or horsemen round the neck but no decoration on the body where the clay vases have their figure scenes. The finest of these bronzes are found in the export market; the largest complete being from as far away as Vix, on the Seine, where the nearly six-foot high vessel lay in the grave of a Celtic princess [119]. Smaller bronze vessels may have patterns incised on their bodies, but their handles are

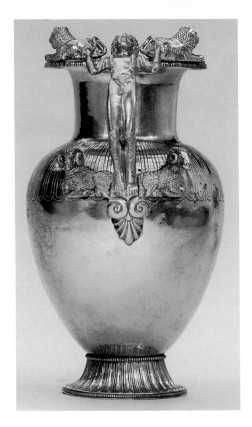

121 Silver jug with cast handle from a Lydian tomb in Turkey. About 525 BC. Height 18 cm. (Ankara, returned from New York)

cast, with heads, animals or palmettes at either end, sometimes the whole body of an animal or of a youth serving as the handle of a jug. From Egypt came the idea of using a human figure as the handle for a mirror or dish. The ladies supporting the Greek mirrors (the reflecting discs were burnished or silvered bronze) are sometimes naked, like their Egyptian kin. The style and shapes of this bronzework were as readily rendered in silver [121], which has naturally survived less well. With the advent of coinage silver acquired a bullion role, but also became more familiar on the tables of the rich to the point of being disparaged for its hubristic display in the Classical period.

In the art of gem-engraving there are striking innovations in materials and technique. Harder stones – carnelian, chalcedony and agate – are introduced from the Near East, and with them the use of a cutting-wheel on a lathe which managed tougher material more easily and had not been used in Greece since the Bronze Age. Scarab seals become the

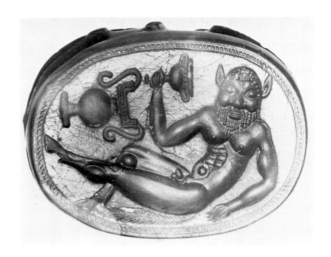

122 Intaglio from an agate scarab with a reclining satyr with cup and bowl. About 530 BC. Length 2.2 cm. (London 465)

most popular shape, the Egyptian form with a beetle carved on the back, the stone being set in a pendant or on a swivel as a finger ring. This new phase in Greek gem-engraving seems to have been initiated by East Greek artists, probably in Cyprus where the Phoenicians and Phoenician art were to be found. The Eastern influence, beyond the material and technique, was minimal, and very soon local schools can be distinguished in East Greece producing exquisite intaglio devices in the purest Late Archaic styles [122]. The cutting of dies for coins is a craft akin to that of the gem-engraver [123]. Electrum (white gold) coins were struck first in Asia Minor and East Greece, probably by the early 6th century, and by the end of the Archaic period most Greek cities of importance (except Sparta who abjured this root of all evil) had their

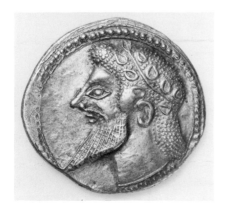
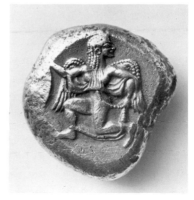

123 Silver coin from Naxos in Sicily with a head of Dionysus; and an electrum coin with a winged woman from Cyzicus in the Propontis. Late 6th century BC.

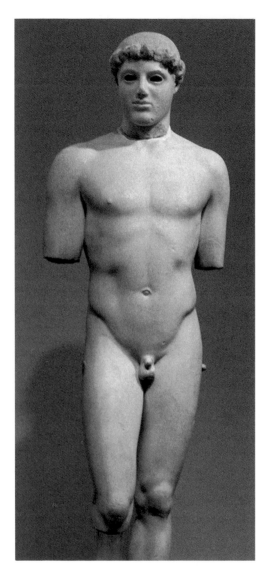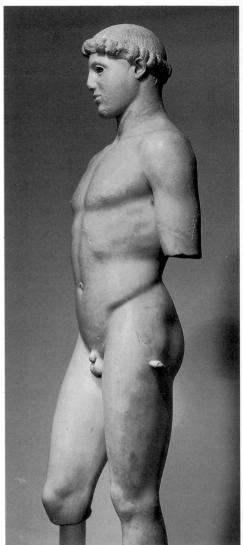

124 The Critian Boy, so named for the similarity of the head to that of the Tyrannicide Harmodius in the group by Critios and Nesiotes [*163*]. From the Athenian Acropolis. About 480 BC. Height 86 cm. (Acr. 698)

own issues of silver coinage. Some of the types are as delicately conceived as those on the best gems, though they lack the miniaturist detail, and once a coin device is established for a city a natural conservative tendency made against rapid changes of style or type. In this respect smaller states were often able to afford greater variety and originality in their coin design. As on the scarabs, with their oval fields, so the circular field of a coin presented special difficulties of composition which the Greek artist triumphantly faced, as he had done in the *tondo* centrepieces of painted cups. These miniaturist arts can sometimes offer works of major importance, although they are frequently ignored in favour of the more traditional or spectacular subjects.

By the early 5th century all the major arts which are to characterize Classical Greece had been established and the techniques mastered. Indeed, a great many of the special features of Classical art, its peculiar blend of idealism and realism, are anticipated. If the main breakthrough in sculpture is the rejection of the *kouros'* fearful symmetry, then this had happened already by the time of the Persian Wars; not in the lively poses of relief and architectural sculpture, but in figures like the Critian Boy from the Athenian Acropolis [*124*], who is still a standing frontal youth – similar to a *kouros* – but relaxed, with his weight shifted onto one leg, head inclined, hip raised, body gently curved: the work of a sculptor who could now express his understanding of the human body as a structure of bones and flesh, rather than a stiff-limbed puppet.

When the Persian generals left their treasures behind in their tents after defeat on the battlefield of Plataea (479 BC), the Eastern *objets de luxe* offered bullion, but few new art forms to excite Greek artists, and soon Greece was to repay in full, and more, its debt to those Eastern crafts whose effect we have observed in the last two chapters.

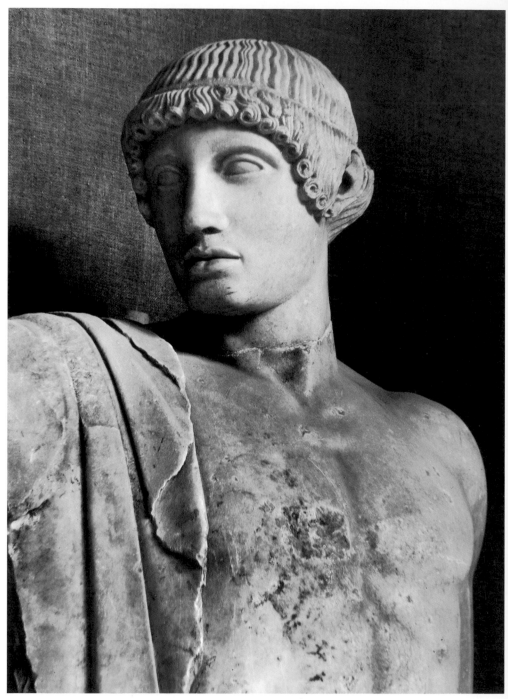

125 Detail of Apollo from the centre of the west pediment of the Temple of Zeus at Olympia. (Olympia)

Classical Sculpture and Architecture

The Persian Wars left Athens devastated, her temples burnt and monuments overthrown by the invader, and although she soon won back prosperity and an ascendancy over part of the Greek world, which she had earned by her stand against the barbarian, the city had for a while no time or money to lavish on monumental art rather than armaments. There was, moreover, an agreement (the Oath of Plataea) to leave ruins unrepaired as a memorial of the invasion, though this would be annulled once the Persian was finally repelled from all Greek soil.

For the first-fruits of the break with Archaic conventions in art which had already occurred before the Persian Wars we have to look elsewhere. The great national sanctuary of Zeus at Olympia, unscathed by Persian attack, is the natural place to look for examples of the new, incipient Classical style, and the accidents of survival have preserved

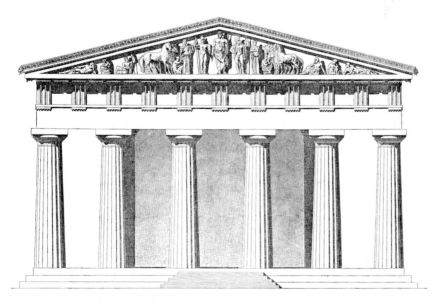

126 Restored drawing of the east end of the Temple of Zeus at Olympia. 450s BC

here many fine works of the generation after the Battle of Salamis. After a flood in late antiquity, which covered the site with a deep layer of sand, Olympia was barely visited, rarely robbed and for a long time lost. From beneath the sand and from a rough, late fortification wall has been recovered the greater part of the sculpture from the Temple of Zeus, and enough of its architecture to admit almost certain restoration on paper.

OLYMPIA AND THE EARLY CLASSICAL

The temple was in the Doric order, and the largest completed in mainland Greece (over twenty-seven metres long) before the Parthenon, which is some three metres longer. The coarse local limestone of which it is built is covered with stucco, but fine Parian marble was brought in for the roof-tiles and sculptures. The exterior had sculptural embellishment only for the acroteria on the roof and in the pediments – the metopes were left bare [*126*]. In the pediment over the main entrance in the east the line up of contestants and chariots before the fateful race between Pelops and Oenomaos is shown. Zeus himself towers in the centre, and the corners are filled by reclining figures. This is a static but impressive composition, only fraught with deeper meaning for those who knew the history of the sanctuary, of broken oaths and relentless punishment by Zeus of impious families. The other pediment has Apollo at the centre [*125*], in control but not physically involved in the wedding brawl between the Lapiths of Thessaly and the drunken centaurs who tried to carry off the bride and women. Here all is action, like the earlier pedimental compositions of fights, and the message of divine authority lies in the Apollo, symbolizing the Rule of Law.

Passing through the outer ring of columns and looking up over the inner porches the visitor saw at either end six sculptured metopes. These showed the Labours of Heracles, starting with his triumph over the lion, ending with the local episode of his breaching the walls of the stables of Augeas, to flood and cleanse them. His patron Athena is shown helping him on four of them, and both he and she seem to mature as they progress [*128*]. Within the main hall (*cella*) a central nave was formed by two tiers of superimposed Doric columns on either side, and filling the end was Phidias' great gold and ivory statue of Zeus himself, seated, with a figure of Victory on his outstretched right hand. The statue, which was said to have 'added something to accepted religion'

127 Clay group of Zeus carrying off Ganymede to be his cup-bearer in Olympus. The boy holds a cock, a common love-gift. The bright colours are well preserved in the fired clay. About 470 BC. Half lifesize. (Olympia)

(Quintilian), towered to the roof. It was eventually taken to Constantinople and burnt in a palace fire in AD 475. All that we can know of it is gleaned from later reduced copies or free adaptations, and from some of the clay moulds on which drapery was formed, which were excavated in recent years in Phidias' workshop at Olympia (see [10]). The marble statuary on the temple was in position by 456 BC, but the cult statue was supplied some twenty years later.

It is naturally the style of the pediments and metopes at Olympia that occupy our attention, and can give the measure of how far the arts had progressed since the Archaic period. Set high on a building, sculpture of this sort is most effective if carved in fairly simple and bold planes. But at Olympia, as on the Parthenon where the work is far more detailed, much of the subtlety of the sculpture was lost at the height at which it was displayed. Here there is considerable individuality in the treatment of bodies and features. Heracles' expression reflects his feel-

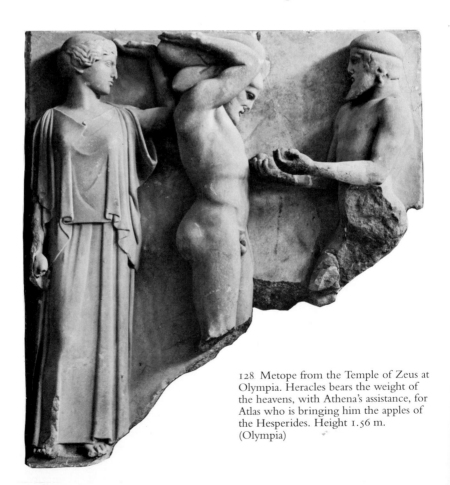

128 Metope from the Temple of Zeus at Olympia. Heracles bears the weight of the heavens, with Athena's assistance, for Atlas who is bringing him the apples of the Hesperides. Height 1.56 m. (Olympia)

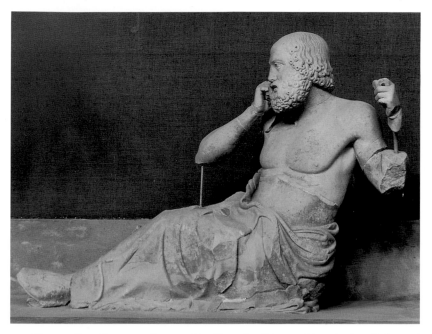

129 The seer from the east pediment of the Temple of Zeus at Olympia. A well observed study of an ageing body and mental distress. (Olympia)

ings in the face of his various labours, and in the fights pain and bestiality are vividly portrayed. This is novel, but has no immediate following, as we shall see.

The male figures stand in the new, easy pose, with one leg relaxed and the weight of the body lightly shifted onto the other; a pose which marks them off so clearly from the Archaic. Nude bodies of all ages are strongly and accurately modelled and seem able to convey mood no less effectively than do the heads [*129*]. A clay group of Zeus and Ganymede at Olympia shows the new style well [*127*], the heads still slightly Archaic, especially in the treatment of hair, but the features cast in a new mould. Another Zeus (or Poseidon) is the fine bronze from the wreck off Cape Artemisium [*130*], more than lifesize, and certainly the most vigorous surviving example of Early Classical statuary. This is nearer in date to the Olympia sculptures and shows an advance in the freer treatment of hair and build. Full-size bronze statues and groups must have

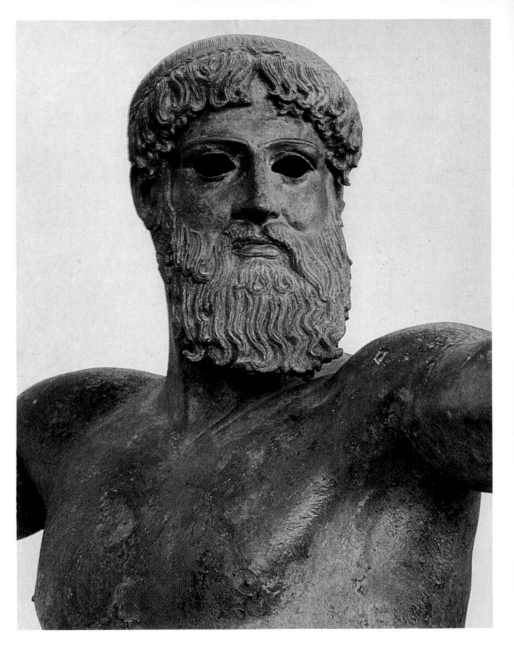

130 Detail of bronze figure from the Artemisium wreck; more probably a Zeus with a thunder-bolt than Poseidon with a trident. The brows and lips were inlaid in copper and the eyes inset. About 460 BC. Just over lifesize. (Athens)

131 Bronze charioteer from Delphi. He stood in a four-horse chariot led by a groom. The group was dedicated by Polyzalos, tyrant of Gela in Sicily, celebrating a victory in the Games of either 478 or 474 BC. The eyes are inlaid with glass and stone, copper for the lips, silver for the headband pattern. Height 1.8 m. (Delphi)

been far more common at this time and parts of others have survived. The famous charioteer from a group at Delphi is an obvious example [*131*], and now we can add the remarkable bronze warriors from Riace [*4*] which outdo even the charioteer and the Artemisium Zeus for their presence and quality. This is the best of Greek sculpture of the period, and we have so little of it!

ATHENS

The gaudy pleated *chiton* in which the Archaic *korai* were dressed is generally replaced now by the heavier *peplos*, which leaves the arms bare and has a heavy, straight overfall to the waist [*72*]. The change in fashion also offered a style of dress which seems more in keeping with the new spirit and has helped characterize the Early Classical in Greece as the Severe Style. The simple broad folds hang naturally and acknowledge realistically the shape of the body beneath. The *peplos* figures sometimes seem heavy and dull. There is little to show for the style in Athens [*132*] where there are no carved tombstones of this date to display the new dignity which would have suited them so well, but we may look for examples on tombstones from the Greek islands [*133*]. Here the narrow type of *stele* with a palmette finial, which had been invented in the islands of East Greece and had been copied by Athens in the 6th

century, was still being made. The islands, a source of fine statuary marble even after the resources of Athens' Mount Pentelikon had been realized and exploited, always had important studios, and the sanctuary island of Delos in their midst attracted rich offerings. East Greece, too, despite the even more imminent and continuing Persian threat, still had an active sculptural tradition, more often now turned to the service of their Persian-dominated neighbours in Lydia, Lycia or Caria. It was East Greek masons whom the Persians had taken to work on their homeland palaces.

By the middle of the 5th century Athens was secure in her position at the head of a large tribute-paying confederacy which she had created to defend Greek liberty against the Persians. The treasury of the confederacy was transferred to Athens itself in 454 BC and the statesman Pericles set aside part of the revenue for a programme of rebuilding

132 (*Left*) Votive relief from the Athenian Acropolis showing Athena reading a decree or list of citizens fallen in battle, whence the pensive pose. Her *peplos* has a long belted overfall in the Athenian manner. About 470 BC. Height 48 cm. (Acr. 1707)

133 Gravestone of a girl from one of the Greek islands, probably Paros. The lid of the box she holds is on the floor. Her loose *peplos* is open all down the side. About 450 BC. Height 1.39 m. (Berlin 1482)

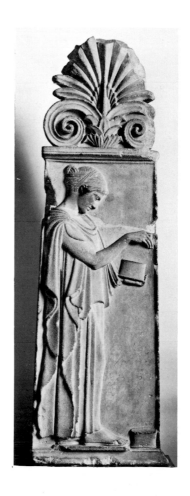

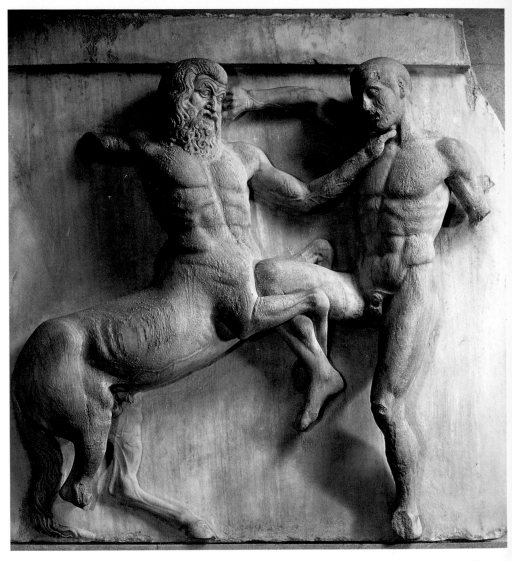

134 A metope from the south side of the Parthenon with a centaur struggling with a Lapith. Notice the almost Archaic masklike treatment of the centaur's face. About 440 BC. Height of metope 1.2 m. (London)

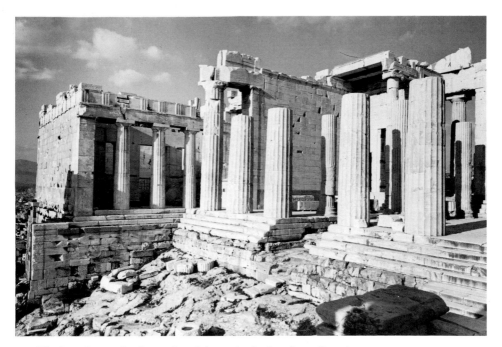

135 The Propylaea to the Acropolis at Athens. An Ionic column from the centre passage-way can be seen centre right; the rest is Doric. Built to the plans of Mnesicles, 437–432 BC. Width of front 18.5 m

which was to make the city the show–place of Greece. The construction of temples and public buildings on the Acropolis citadel, in the lower town and in the Attic countryside went on despite expensive wars in which Athens was not always victorious. By the end of the century she had been severely defeated by Sparta, but the visitor to Athens then would have seen the city at its architectural best.

The Acropolis, ravaged by the Persians, was completely replanned. Approaching from the west the visitor was faced by a monumental entrance way, in the Doric order, but with tall Ionic columns flanking the central passageway [135]. The Classical approach is still the one in use, beside an outer gateway and monument of the Roman period. There is no sculpture here but we can already appreciate the exquisite finish of the masonry, the fine joints, the precision of every moulding which is never merely mechanical, and the way in which the qualities of white marble, be it a plain surface or carved in gentle curves and sharp ridges, are exploited.

136 Drawing by J.J. Coulton expressing in exaggerated form the optical refinements in the design of a Doric temple of the Classical period

Within the entrance stood the colossal bronze Athena Promachos, a work of Phidias but wholly lost to us. The crowning glory of the citadel – the Temple of Athena Parthenos (the Maiden) or the Parthenon, as it is better known – was not revealed in its full height so quickly to the ancient visitor as it is today, but had to be approached through a second gate and court [1, 2]. The temple exterior, wholly of the Doric order, displays the same precision in the carving and fitting of all its parts as does all Greek architecture of the Classical period. Moreover, it reveals refinements of design which subtly correct the rather static matchbox effect of Doric temple architecture. The eight columns of the front, instead of the more usual six, give it an unfamiliar breadth and dignity. The refinements of detail had been practised on many other buildings; a crude early example is the *entasis* of Archaic column shafts [63]. The same feature, much refined, appears on the Parthenon, while the whole platform from which the columns rise sinks in a gentle curve away to the corners; the columns lean slightly in, the upper works slightly out [136]. These are refinements that can be measured and with care observed by the naked eye. It is only when we look at buildings in which they were not applied, or were applied less skilfully, that we can appreciate the effect their absence might have had on the Parthenon's forest of columns and heavy upper works. The satisfying effect of the building depends as much as anything on the regularity of the proportions (essentially 4:9) applied to everything from overall plan to detail of mouldings.

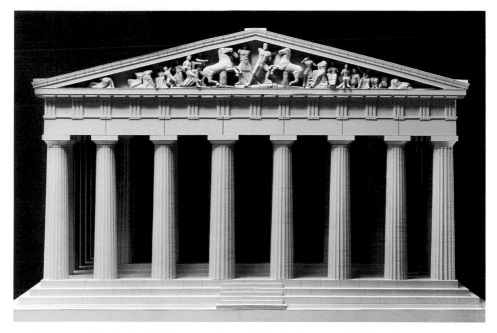

137 Reconstruction in Basel of the west front of the Parthenon, with the pediment showing the struggle between Athena and Poseidon, missing figures plausibly restored

The pediments, most of whose few surviving figures are in London, illustrated important moments in Athens' myth-history – the birth of the goddess Athena attended by the other gods, and the dispute between Athena and Poseidon for patronage of the city [137]. The massive figures from these pediments tell us how far the sculptors had progressed in their attitude to the figure and dress in the years since the Olympia pediments, but they are the latest of the carving on the building, of the 430s [138]. The restless swirl of massed cloth is shown by deep-cut folds which catch the shadows. The material now has a volume, almost a life of its own, but at the same time the forms of the body beneath are clearly understood and as firmly expressed. The totally relaxed poses of the reclining and seated figures show a new confidence, lacking in the Olympia sculptures. The figures are carved wholly in the round, and finished as carefully at the back (never seen once they were in position on the building) as at the front. This is not a feature of all Greek pediments, but here the gift to the goddess required perfection. The few

remaining heads are badly battered, and for an idea of the way heads were treated by this school of artists we must turn to the work in relief on the temple – the metopes and frieze.

The carved metopes, earlier than the pediments, stood all round the outside of the temple, not just over the inner porches, as at Olympia. There are simple groups of struggling figures – gods and giants, Lapiths and centaurs [134], Greeks and Amazons, with scenes of Greeks and Trojans at the Sack of Troy. Some groups are poorly planned and others seem to burst the frame of the metope. The best are tautly composed and set neatly in the field. All carried covert messages of Athenian success over the barbarian.

The frieze was set in the same place as the carved metopes at Olympia, that is inside the outer colonnade, but running continuously over the end porches and along both long sides, some 160 metres in all. Its subject is the preparation for a Panathenaic procession in honour of the goddess, in itself an unusual, mortal, subject for the decoration of a temple. It shows the progress of preparations in the town, with the horsemen moving through the streets [139], headed by burghers and attendants leading animals for sacrifice or carrying offerings, received by an assembly of the Olympian gods and Athens' own tribal heroes. The starting-point was at one corner (the south-west), the culmination at the centre east, over the main door, with a small group showing the ceremony of the handing over of the goddess' sacred *peplos*. The reception of the mortal procession by the whole family of the Olympian gods, who dominate all themes at the front of the building, in its way heroized the mortal Athenian cavalcade which forms the greater part of the frieze – those citizens, it may be, who had won their immortality on the battlefield of Marathon. With the pediments so poorly preserved we have to turn to the frieze to judge the Parthenon's art at its best. The set, Classical features are calm and thoughtful, passionless. The artists who had now little interest in portraying the emotions in features, only rarely admitted nuances of expression or age. The idealized mortal is near-divine, self-sufficient and above ordinary passions.

Within the temple stood Phidias' masterpiece, the forty-foot high gold and ivory statue of the goddess. This was the first of these colossal chryselephantine figures and the master was to add a seated Zeus in the same or similar technique in the already standing temple at Olympia, to be hailed as one of the Seven Wonders of the Ancient World. Flesh parts were ivory, dress gold (or at Olympia perhaps gilt glass) with inlays of

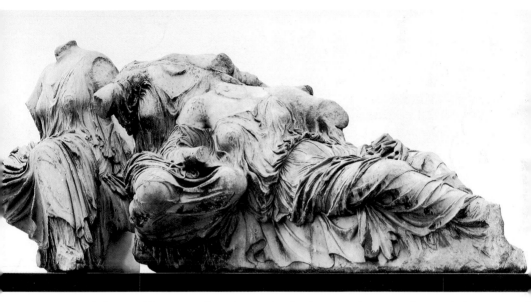

138 Group of three goddesses attending the Birth of Athena on the east pediment of the Parthenon. About 435 BC. (London)

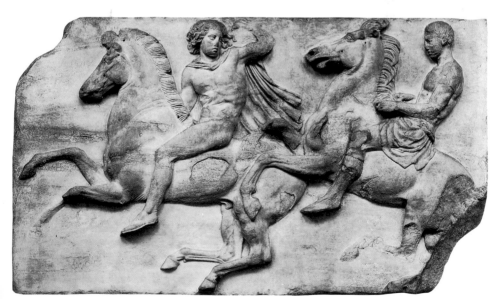

139 From the Parthenon frieze, west side. Horsemen preparing for the Panathenaic procession. About 440 BC. Height 1.03 m. (London)

coloured glass. We can get some idea of the figure from reduced copies or details reproduced in other media [185]. Even the shield, with Greeks fighting Amazons (probably gilt reliefs on silver) can be plausibly restored [271, 272]. We cannot, however, readily recapture the effect of such a figure in a comparatively dark interior, lit only from the front door and two windows, with reflected light from a shallow pool before it [140]. It relied wholly on sheer size and sumptuousness. Artistic subtlety tends to get lost in colossal realistic figures: think of the Statue of Liberty or oriental Buddhas, and contrast Egyptian sculpture or Henry Moore. But the detail of the Parthenos was clearly exquisite.

While the Parthenon style certainly represents an advance on the Olympia sculptures, it is not perhaps the advance we might have expected. At Olympia realism of body and dress was nearly mastered but there was a deliberate move also towards the particular, towards the less than ideal in features or body. In Athens the old Archaic anonymity and idealism prevailed but now allied to a total command of anatomical realism, slightly adjusted in favour of the perfect. In its way this was more in the older tradition, and Olympia was anticipating by a century any new move towards depiction of the particular. It was this new ideal realism that embodied the Classical revolution and set the standard for the future, but it was incapable of improvement on its own terms and either the ideal or the real had to be modified.

The Parthenon style depended wholly on large modelled figures which could be copied in marble (as, in other circumstances, they might have been cast in bronze). Phidias may have determined the design for all the sculptured decoration and supplied models for much of it, but the actual carving must have been in the hands of other masons, some of them notable artists, for there is outstanding work among the various hands which can be distinguished but not named.

The procession shown in the Parthenon frieze did not in fact have as its object the great gold and ivory Athena which was its cult statue. The old and more sacred figure of Athena had been kept in an older temple, opposite the Parthenon, and this building too was replaced in the new plan by a strangely beautiful, asymmetrical shrine we know as the Erechtheion [141]. Its Ionic order, the fine floral carving on the column necks and walls, and the carved external frieze, served as a foil to the austerity of the Doric Parthenon only fifty metres away. Its most unorthodox feature was the veranda-like porch, inaccessible from outside, whose flat roof was supported by six statues of women – the

140 A reconstruction model in the Royal Ontario Museum, Toronto, of the Athena Parthenos within the Parthenon

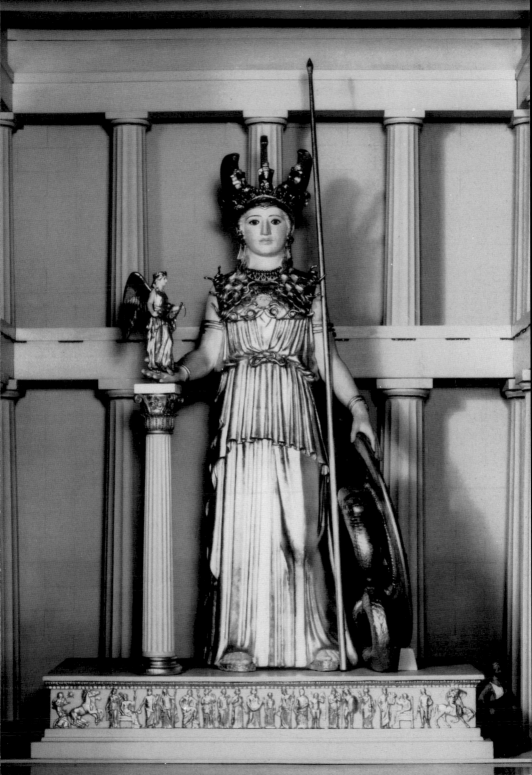

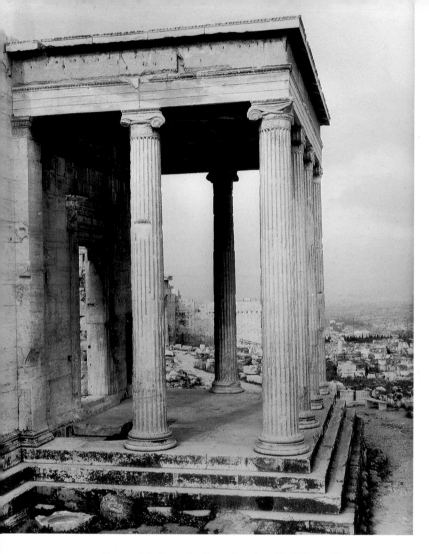

Caryatids (one in London [*142*]). These figures perform their functions as pillars with some grace. Their *peploi* hang close to the body but the flow of the material is broken by the lively, deep-cut folds, in bold contrast to the Early Classical *peplos* figures, and the straight folds covering the leg which is braced to take the weight recall the flutes of the column we would normally expect in this position.

The Ionic order of the Erechtheion offers more contrast with the Ionic of the Archaic period, than does the Doric Parthenon with its

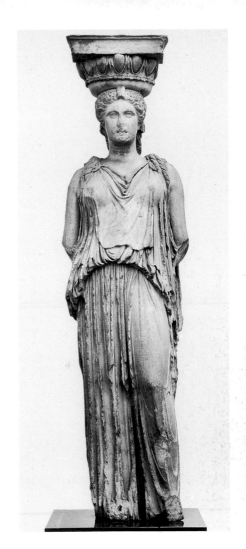

141 The Ionic north porch of the Erechtheion on the Athenian Acropolis. The holes which fastened the white marble frieze figures to the darker backing marble can be seen below the roof. The capitals and door have been much copied. Built between 421 and 405 BC

142 A Caryatid from the south porch of the Erechtheion. The figure is in London, the best preserved. Those left on the building have now been removed from the polluting atmosphere of Athens to the museum. About 410 BC. (London 407)

predecessors. In the capitals concave channels in the volutes were now the rule where earlier, but for rare and primitive exceptions, they were plump convex. In the Erechtheion capitals there are even double channels, and the usual egg-and-dart between the volutes has a cable pattern above and a floral band (as in Archaic Samos) below. There had been some variety in the bases too, the Erechtheion having a type developed in Attica. The shafts have twenty-four flutes, with flat ridges between, against the Doric twenty with sharp ridges; and the Ionic column as a

whole retains its tall slim proportions against the squat Doric, which made it a natural choice for positions where the mass of a Doric colonnade could have looked unbearably heavy. All the carved mouldings of these buildings were painted, some with coloured glass inlays also, and it now seems that even the flat wall surfaces were toned down with a colour wash to reduce the glare of direct sunlight. Add the realistic colouring of the figure sculpture and the difference between what we see today in Athens and in museums and what was seen in antiquity becomes almost impossible to conceive.

A visitor to the Acropolis would have done well to save for the end his inspection of the little Temple of Athena Nike, on the bastion overlooking the entrance. It was a small Ionic building, erected over what had become the traditional position for this shrine, a mirror in miniature of the more elaborate Ionic of the Erechtheion. A low stone balustrade surrounded the sanctuary, and the relief carving upon it offers perfect examples of the statuary style typical of the end of the 5th

143 Figures of Athena and a Victory (Nike) from the balustrade round the Temple of Athena Nike on the Acropolis of Athens. About 410 BC. Height 87 cm. (Acr.)

144 The west end of the Hephaisteion in Athens, looking up between the columns to the frieze over the back porch. About 430 BC

century, successor to the rather heavy Classical idealism of the Parthenon. Figures of Victory are shown in a frieze leading animals to sacrifice and erecting trophies, attended by Athenas [143]. The thin material of their dress is pressed so close to the body that some are in effect nude studies, an effect anticipated in the Parthenon pediments [138], the transparency and swirl of the drapery lending emphasis to the form of the body, and not either concealing it or having a mass and movement of its own apart from the body beneath. The treatment of dress and of the human body, especially of women, has come a long way during the 5th century.

Down in the city of Athens and in the countryside (at Sunium, Rhamnus, Acharnae, Thoricus) there were other buildings of the Periclean programme. In Athens the Hephaisteion (often still called the Theseum) stands still well preserved overlooking the *agora* (market place), a smaller, less subtle and earlier building than the Parthenon. On it, too, there were friezes within the outer colonnade, but only at each end and not all round, as on the Parthenon. One end showed the now familiar fight of centaurs and Lapiths. The view in our picture [144] is

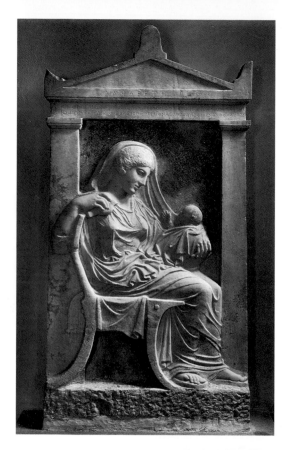

145 Gravestone of Ampharete from Athens. She holds a pet bird and a baby. The epitaph says this is for Ampharete and her grandchild. About 410 BC. Height 1.2 m. (Athens, Ker.)

146 (*Below*) Votive relief from near Athens. The hero Echelos abducts Basile. The other side shows a river-god and nymphs and is inscribed with a dedication to Hermes and the nymphs. The relief would have stood on a tall pillar. About 410 BC. Height 75 cm. (Athens 1783)

147 (*Right*) Fragmentary statue of a mourning woman – the so-called Penelope type – right arm on knee and hand to cheek, as can be judged from copies. This is an original, found at Persepolis, brought as loot or a gift from Greece to the Persian King. About 450 BC. Height 85 cm. (Teheran)

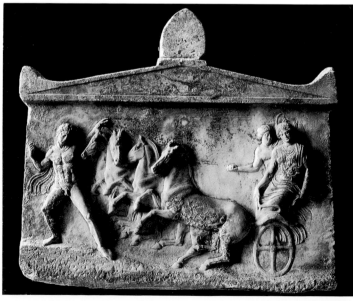

from the angle at which all such carved decoration was seen in the colonnades, as in the Parthenon or at Olympia (for the metopes). It hardly does justice to the proportion and detail of the figures, and the lighting, here facilitated by the absence of the roof, would have been wholly from the light reflected from the marble surfaces around: barely adequate by any standards.

Athens now built monumental public buildings [265] as well as her temples – law courts, council-halls and the *stoa* colonnades which provided offices, shops or shelter for the passer-by and which were to become an important feature of other Greek market places.

OTHER CLASSICAL SCULPTURE

Phidias was not the only name associated with the Classical revolution in sculpture. Polyclitus of Argos was no less famous in antiquity, and better remembered for his attempt to canonize the new style in a book and statue (which he called the Canon), known to us only in copies (on which, more below [165]). He is best known for his athlete figures, stockier in proportions than the Phidian, but no less ideally realistic. Because we turn to Athens as the yardstick for the excellence and good

preservation of its marbles, we should not forget other flourishing sculptural schools in the Greek world.

After much of the work on Athens' public projects was done the sculptors turned again to the carving of relief tombstones, generally with two-figure groups of a seated woman with her maid or child, or a husband bidding his wife farewell. The unruffled dignity of the Classical convention is perhaps seen at its best on these reliefs [145] and they challenge extreme views about the depressed role of women in Classical Athens. Something of the same quality is apparent in a type of statue in the round, of a mourning woman, which first became popular before the middle of the 5th century [147]. The pose was employed for the figure of Penelope, grieving over her lost Odysseus, and came to be adopted for mortal mourners. Votive reliefs portray deities, occasionally mythological scenes, rarely the worshipper himself [146]. A different class of relief appears at the head of inscribed decrees on some of which the personifications of states (their patron deities) seal with a handshake the treaties inscribed below them.

Other 5th-century sculptural groups had been taken to Rome in antiquity, from unknown buildings in Greece. The children of Niobe, struck down by Apollo and Artemis, were the subject of one such pediment [148]; an Amazonomachy, another. The Niobid girl I show is a good example of the sympathetic treatment of adolescent form which can be remarked at Olympia. But there is nothing sensual in this treatment, and the sculptor remained less interested in the female figure than the male. Man was the measure of all things to the Greeks, and the artist's aim was to portray him at his idealized best, indistinguishable from the gods whom he conceived in man's likeness. The heroic nudity of the gods, warriors and mortals shown by artists was a natural expression of the Greeks' open admiration for the perfectly developed male body, and would not have seemed so strange in a society where athletes regularly trained naked and in public, and where clothing for men seems often to have been minimal. The idealization of the female nude in sculpture presents a rather odd contrast with the explicitly detailed male, and it took long for the female features to progress beyond the Classical mask. The use of colour on statuary heightened the realistically naked effect and we hear of the association of distinguished painters and sculptors. Later it may have become less common, and the loss of colour through time and burial determined the Renaissance artist's colourless view of the Classical nude.

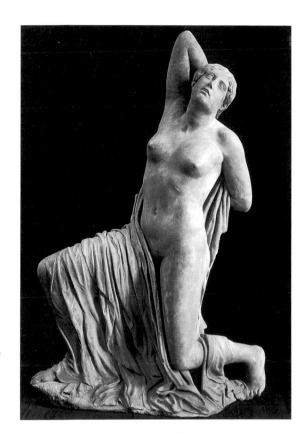

148 A daughter of Niobe, falling, struck in the back by an arrow for which she gropes. From a pedimental group taken from Greece to Rome. About 430 BC. Height 1.49 m. (Rome, Terme 72274)

Perhaps we make too much of what gets called the Greek cult of the nude, which reflects rather the popular and uncritical attitude of a hundred years ago to anything classical, and was encouraged by the Renaissance's often far less healthy preoccupation with the same theme, and its more sensual aspects. But after the 5th century the full sensual appeal of white marble *was* exploited, as we shall see, and our appreciation of realistic or semi-realistic representations of naked bodies is inevitably conditioned by this appeal. How far is the modern response to and appreciation of Classical statuary determined by the sex of the connoisseur or scholar? It is notable that every new medium for realistic art seems also to generate immediate exploitation for erotic purposes – the camera, movies, polaroid, video, Internet: Classical realism was no exception and the appeal of Classical figures, male and female, for both men and women, remains potent [*4, 228*].

The 4th century was a troubled time for the Greek world. Athens struggled to regain her supremacy, while new powers and leagues arose to challenge her position and that of Sparta: first the Thebans, then the Macedonians, and it was the Macedonian Alexander who, from 336 to his death in 323 BC, completely changed the course and climate of Greek life and political thought. In the arts this century saw important innovations and experiment, although still rigidly within the framework of the 5th-century Classical tradition. The ethos of Phidian and Polyclitan sculpture still pervaded the more sober studies, like those of senior divinities. In sculpture greater attention was paid to figures in the round, and a final break made with the earlier one-view figures in compositions which positively invite the spectator to move round them by the twist of the body, by contrasted directions of gaze and gesture, or by a pose which from no one position offered a fully satisfactory view of all important features. All this lends a sort of controlled restlessness, which only broke out into near-Baroque abandon in the succeeding period. Dress was treated with greater skill and virtuosity. The transparent drapery which leaves the body beneath almost naked remained popular and could only have been achieved through the modelling technique employed to make the originals, for copying in marble or casting in bronze.

In the treatment of the naked body it seemed that all anatomical problems had been solved and attention could be paid to the quality and texture of flesh and muscle [149]. This leads for the first time to a deliberate sensuality in the rendering of women. At the end of the 5th century Aphrodite could be shown in closely clinging drapery. Now she is naked, and so successful was Praxiteles in his cult statue of the goddess at Cnidus that (in later times) the marble was exhibited under peep-show conditions and was the object of indecent assault. (My illustration below [167] shows a Roman copy.) Certainly a new dexterity in the carving and finishing of white marble contributed to this effect. We can judge it from the Hermes at Olympia [150], almost certainly a close later copy of the original from Praxiteles' hand, waxed and polished by generations of temple attendants. The relaxed languor of the figure just stops short of effeminacy to our eyes. The athlete statues of the day present new proportions – heavier bodies, smaller heads – an adjustment from the Polyclitan canon which is associated with the name of

149 Bronze statue of a boy retrieved from a wreck off Marathon. The eyes are inset limestone, with glass pupils; the nipples inlaid in copper. About 330 BC. Height 1.3 m. (Athens 15118)

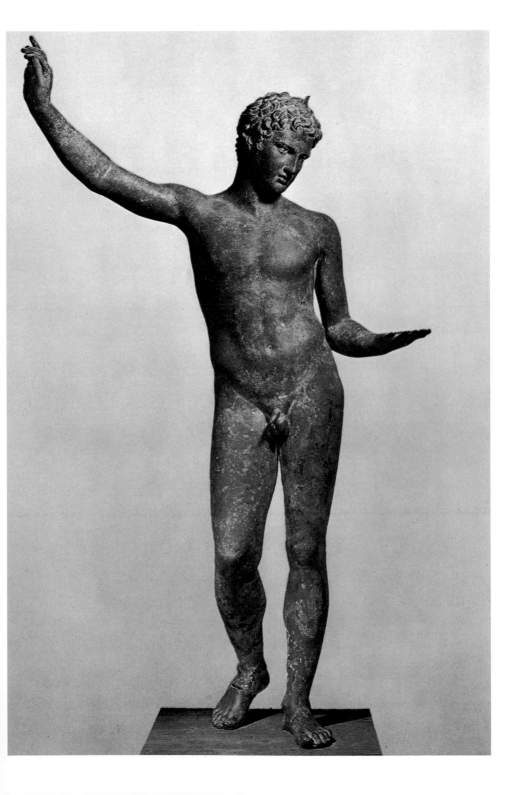

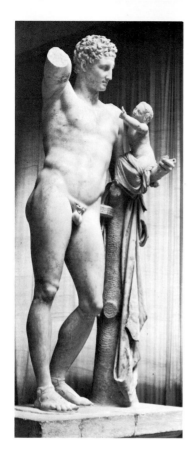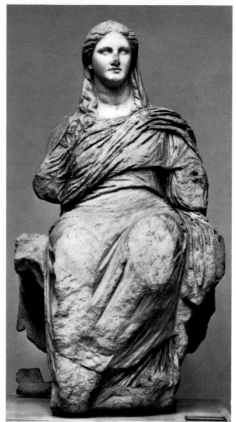

Lysippus. In the treatment of the heads themselves there is the same soft-ening and relaxing of the set Classical features which can be observed in the carving of the bodies, but the conventions of the ideal Phidian head were not forgotten. For deities or figures at rest the convention is a satisfying one [151]. Its unreality when applied to figures in violent action or under emotional stress was at last acknowledged.

An intensity of expression was realized by sinking the eyes deep below the forehead, and even the more placid figures take on a serious and thoughtful air – a trait perhaps wrongly attributed to the influence of Scopas. This treatment applied to the usual two-figure groups on Athenian grave reliefs heightens and charges the atmosphere, and for the first time we have studies in grief, conveyed by features as well as pose

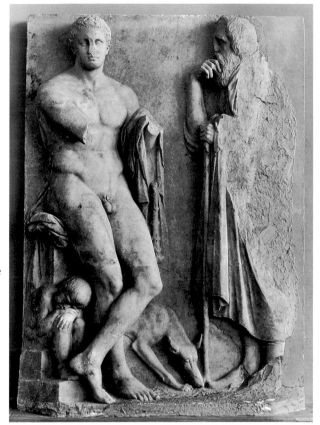

Opposite

150 Hermes holds the infant
Dionysus, after an original work
of about 340 BC by Praxiteles,
which stood just inside the
Temple of Hera at Olympia.
Height 2.15 m. (Olympia)

151 Seated figure, perhaps a cult
statue, from the sanctuary of
Demeter and Kore at Cnidus. The
head was made in a separate piece
of finer marble. About 330 BC.
Height 1.47 m. (London 1300)

152 Gravestone from near the
River Ilissos, Athens. An athlete
with his sorrowing father. A
sleepy slave boy and his dog
attend. About 330 BC. Height
1.68 m. (Athens 869)

and gesture. The figures are cut nearly in the round on some of these
monuments, and the deep shadows behind them, together with the
more restless, turning postures, enhanced the effect of both spatial and
emotional depth [*152*].

PORTRAITURE

It was a short step from this to the representation of the particular in
both identity and emotion, and in an age of great names – generals and
emperors – experience gained in portrayal of specific emotions was
readily transferred to the problems of individual portraiture. At first
most of the subjects chosen were the great men of the past, artists and

politicians. As there can rarely have been any contemporary portraits of them, other than written descriptions, the heads were more like characterizations of personality in the light of what was known of temperament and achievements. Greek portraits were of the whole figure, though we know them best from later copies where the head or bust alone is rendered. This almost idealized portraiture remained a feature of Greek work. It tried to express ethos at the expense of realism, where Roman portraiture (or rather, portraiture for Romans, since Greek artists were still normally the executants) sought this end through the equally effective means of sheer realism.

On the fringes of the Greek world portraiture of contemporaries was admitted even before Alexander the Great's appointment of a Court Artist for this work (Lysippus). On the great Mausoleum (see below) the features of a Carian prince [153] combine portraiture with a degree of ethnic appraisal.

ARCHITECTURAL SCULPTURE

With the eclipse of Athens and shift of power in Greece we have to look elsewhere for architectural practice which relies less and less on the Athenian tradition. At Bassae, near Phigaleia, hidden in the mountains of Arcadia, stood a Doric Temple of Apollo said to have been designed by the architect of the Parthenon himself, Ictinus. Although intact to just below its roof it was lost to the Western world until 1765. Provincial in position and workmanship, it incorporated dramatic new features: a side door to the *cella* with the cult statue facing it, Ionic capitals of unique pattern with high swinging volutes for the engaged columns within and a single example of a new type of capital, the Corinthian [154]. This has small volutes at each corner and a girdle of acanthus leaves beneath. It was more versatile than the Ionic capital, offering the same aspect from all sides, and it served the same type of column and other mouldings, but not until the Roman period did it become really popular. The addition of the acanthus marks the beginning of a new range of Greek floral decoration, widely applied in all media and at all scales. This temple, too, though Doric, had a frieze, here running round the top of the wall inside the *cella*. The stockier, more athletic figures of Greeks and Amazons [155], Lapiths and centaurs, are in marked contrast to the Classical Athenian style, but betray characteristics which had long been the hallmark of sculpture in southern Greece. The dress has the

153 Statute of a Carian noble (the so-called Mausolus) from the Mausoleum at Halicarnassus. The non-hellenic features and wild hair are a good ethnic characterization by a Greek sculptor working for Carians. About 350 BC. Nearly twice lifesize. (London 1000)

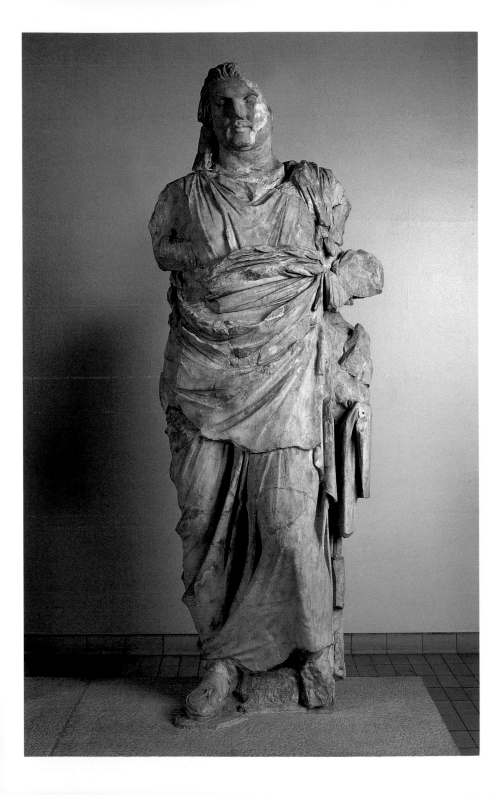

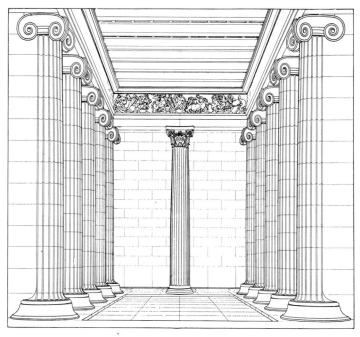

154 Restored drawing (by F. Krischen) of the interior of the Temple of Apollo at Bassae. The Ionic columns are engaged on the side walls and at the end stands a Corinthian column, opposite a side door (invisible here). About 400 BC.

155 Frieze from the interior of the Temple of Apollo at Bassae. Greeks fight Amazons. About 400 BC. Height 63 cm. (London 537)

156 Reconstruction drawing (by
G. Waywell and S. Bird) of the
Mausoleum at Halicarnassus

157 Frieze from the Mausoleum.
Greeks fight Amazons. The
anatomical expression of male
and female vigour is carefully
observed. About 350 BC. Height
89 cm (London 1014)

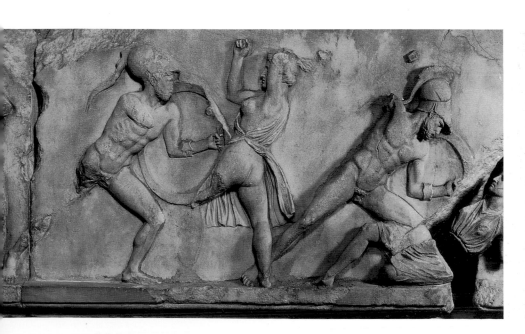

clinging quality we observed at Athens towards the end of the 5th century.

Other sanctuaries, especially in south Greece, attracted new temple building, but the most spectacular and influential new structure was not made for a Greek at all. East Greek artists had long been employed by their neighbours to design and build decorated tomb monuments. In Lycia (south west Asia Minor) they begin in the 6th century, and they culminate with the so-called Nereid Monument at Xanthos, like a Greek temple on a high base, replete with relief sculpture (now in London). But the greatest was the tomb made for the Carian King Mausolus, at Halicarnassus [156]. It gave its name to all *mausolea*, a massive structure with a high pyramidal roof, adorned with massive figures [153] and friezes in the round, as well as more conventional friezes, which are the best preserved. These display the artists' confidence in all variety of poses for men, women and animals, and a rendering of flying drapery which is used to help to bind the whole composition and not merely to enhance individual figures [157]. It was alleged that the most famous sculptors of homeland Greece had been employed, and the work is certainly of prime quality, unlike the East Greek styles which the Greeks' neighbours also commissioned. This use of Greek sculptors by the rulers of the semi-independent eastern kingdoms within the Persian Empire, is a new trait of some importance in the 4th century.

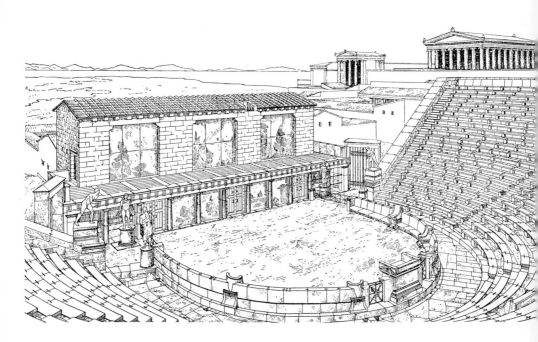

159 A Corinthian capital from Epidaurus, evidently a model prepared by the architect for masons carving capitals to be installed on the Tholos. About 350 BC. Height 66 cm. (Epidaurus)

OTHER ARCHITECTURE

Monumental tomb architecture was still unknown in Greece itself but there was a growing variety of other monumental buildings, both temples and public buildings. Theatres regularly received elaborated entrance passages. The stage buildings were given architectural façades, usually functional, for stage front and scenery, but nothing yet to rival those of the Roman period. Eventually a raised stage was added [158]. Tiers of carved marble seats replaced the bare slopes of the hillside which in earlier theatres overlooked the flat dancing-floor – *orchestra*. Colonnades and façades were bound still by the Classical orders, but increasing use was made of the Corinthian capital, and interesting new ground-plans developed. There had been few circular and apsidal temples in Greece before the Tholos at Delphi, but here the canonic Doric order of the outer colonnade was answered by slim Corinthian columns engaged on the interior of the walls. Yet another circular building offered an example of the new style in subsidiary decoration – the plump and pithy Archaic florals translated by now into writhing hothouse shrubs at the sanctuary of the healing god Asclepius, at Epidaurus, where we have the Classic statement of what a Corinthian capital should be [159]. Among other monumental buildings we find now council-houses and music-halls, *stoa*-shops and hotels. The city-states were becoming better and better equipped with public buildings

158 (*Left*) Reconstruction drawing of the theatre at Priene in its Hellenistic form, with a raised stage and panels between the engaged columns for setting stage scenery. The theatre seated more than five thousand

to serve their citizens, while private architecture remained unpretentious. The houses in 4th-century Olynthus in north Greece provided modest if rather crowded accommodation for a comfortable middle class, with uniform terrace-style houses, the courtyards all facing the southern sun, and the odd one affording a mosaic floor. But the day of the palace and luxurious private house was not far off – when new public buildings in old Greece were as often as not the gifts of princes overseas.

WESTERN GREEKS

Most of the Greek cities in Sicily and South Italy were founded in the later 8th and 7th centuries BC. They quickly grew rich and powerful. In the early 5th century they successfully resisted the power of Carthage, and they were soon being courted by the cities of mainland Greece for their support in internal disputes. Their rulers and tyrants made great show in Greece, with their victories in the Olympic chariot-races [*131*], and no mortal prince of that day could have wished for more.

The outward signs of the wealth of the Western cities are the temples they built at home, and the pavilions and presents they dedicated at the major sanctuaries of the Greek homeland. Their architecture was predominantly Doric but it admitted Ionic details, and sometimes even

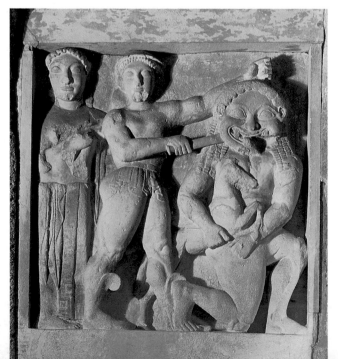

160 Metope from Temple C at Selinus in Sicily. Athena supports Perseus who is cutting off Medusa's head. She holds to her side her child, Pegasus. About 530–510 BC. Height 1.47 m. (Palermo)

161 Cult statue of a goddess (Demeter?) from South Italy or Sicily. Her face and flesh parts are white marble, the rest limestone. Late 5th century BC. Height 2.37 m. (Malibu 88.AA.76)

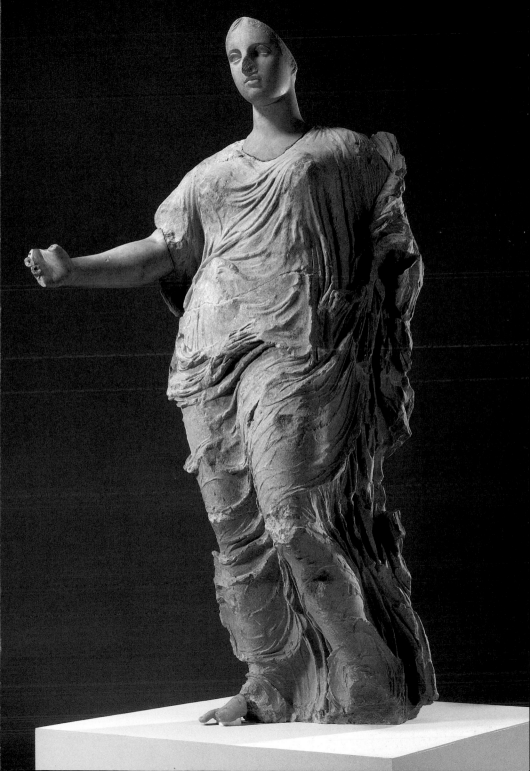

Ionic columns. In the wide spacing of porches and colonnades (pseudo-dipteral) some of the temples seem to be deliberately planned in emulation of the great temples built in East Greece. Much of the most impressive architecture with sculpture is Archaic (as at Paestum and Selinus), continuing into the 5th century, with less of note later [*160*].

The Western Greeks lacked a ready supply of fine white marble, such as was available in the Greek islands and Attica, and major works in marble should probably be regarded as immigrant, at least in terms of their sculptors. [*162*] can for its quality match anything of its date in Greece itself. The architecture is largely of limestone, stuccoed over. More attention was paid to major sculpture in clay. Both in reliefs and on larger figures made of poorer stone or wood finer marble pieces are sometimes inset for women's flesh [*161*] – the acrolithic technique, not unknown in Greece itself. There is record in ancient authors of Greek artists emigrating to the Western colonies and there are distinguished works made locally rather than imported. The style of the certainly local studios is generally conservative and often lacks the delicacy of treatment which we observe in Greece, but there was considerable vigour in narrative on Archaic buildings. The Archaic conventions of dress and features died hard and the Severe Style of the first half of the 5th century lingered on. The full Classical style is less well represented. There were more profound contributions and achievements in other arts, which were to prove influential in Italy.

COPIES

The account of Classical sculpture given above is based primarily on preserved original works and the evidence of date given by style, context or inscription. Few statues have survived which either carry their artist's signature or can be identified from any ancient author who names the artist and describes the subject. But we know the names of the great men whose work set new standards for their contemporaries from the writings of scholars, encyclopaedists and travellers of the Roman period. They often describe the most famous and influential works, and it has sometimes proved possible to recognize surviving copies of these statues, which had been made for Roman patrons and others while the original still stood. Comparing copies of the same statue, and on rare occasions comparing copies with originals ([*163*], see [*291*]), we find that many were probably very accurate, lacking only the

162 Marble statue of a youth from the Phoenician town Motya in Sicily. Certainly Greek work, probably a charioteer looted from a Greek city in Sicily. About 460 BC. Height 1.81 m. (Motya)

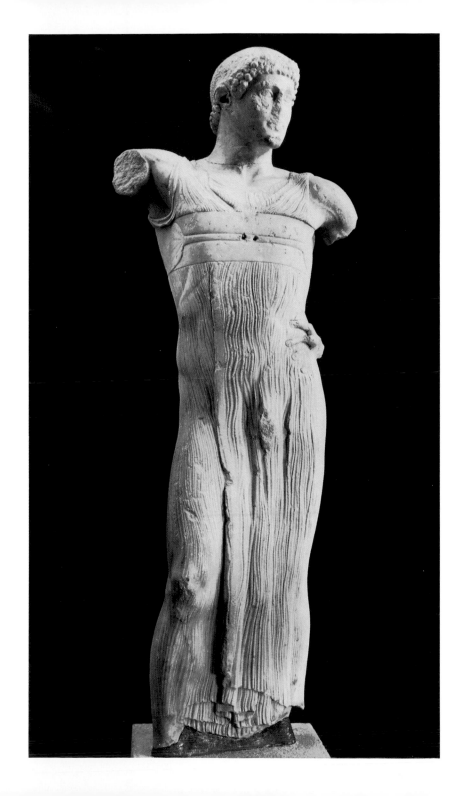

artist's touch in the final carving of details and features, and sometimes adapted in pose or expression by the copyist. Another difference, recognized in marble copies of bronzes, is the addition of struts and supports (such as tree-trunks) which were unnecessary to a bronze original.

We are thus able to associate with names and schools some of the innovations observed in the surviving series of originals. This is the main, perhaps the only value of the copies, and for this purpose some are illustrated here. But it would be wrong to dwell too earnestly on details of carving which may be far from their models, commonly of bronze.

It is comforting, however, to attach names to periods and styles, and to individual works. From the copies of Myron's Discobolus [*164*] and his group of Athena and Marsyas we can see that he contributed much to the development of the full Classical style after the comparative severities of Olympia and other work of just after the Persian Wars. Phidias' guiding hand may be read in surviving statuary from the Parthenon, but in copies of other statues by him we may judge better his personal style and glimpse a shadow of the majesty of his most impressive lost works, the great gold and ivory cult statues. Polyclitus' new canon of propor-

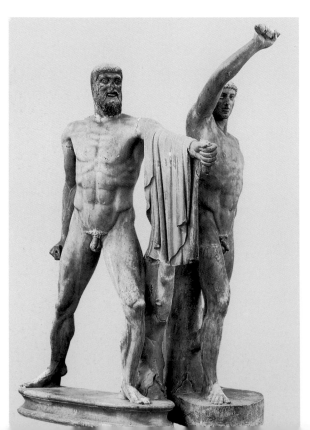

163 Marble copy of the bronze group of the Tyrannicides by Critios and Nesiotes which was set up in Athens in the 470s to commemorate the slaying of the tyrant Hipparchus in 514. Height 1.95 m. (Naples G 103/4)

164 Marble copy of a bronze discus-thrower, the work of Myron. Identified from the description by the writer Lucian. The original was of about 450 BC. Height 1.55 m. (Rome, Terme 126371)

165 Marble copy of the bronze Doryphorus (spear-bearer), the work of Polyclitus of about 440 BC, in which he embodied his Canon for the male body. The tree trunk is the copyist's addition. Height 2.12 m. (Naples)

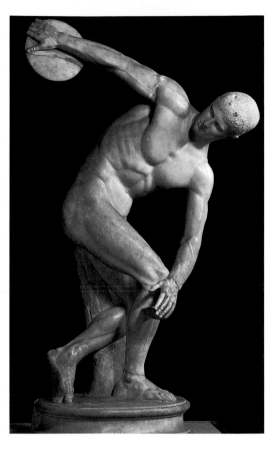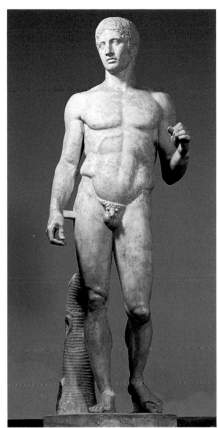

tions and model for stocky athleticism is preserved in copies of his Canon (the Doryphorus) [165]. Another story, about a competition between famous artists at Ephesus, has encouraged scholars to dispute the attribution of differing copies of wounded Amazons [166] to Phidias, Polyclitus, Cresilas or Phradmon, but might easily have been simply a guide's tale. Alcamenes' Aphrodite in the Gardens may have been one of the earliest statues to wear the exaggeratedly transparent drapery. What we think to see of Praxiteles' style in the surviving Hermes at Olympia [150] is confirmed by the other statues attributed to him and of which copies exist. His naked Aphrodite for Cnidus was copied time and again [167], but it is hard to see beyond the copies what there was to their original which made it so famous, apart from its suggestive near-nudity. Scopas' style seems to have been more vigorous and

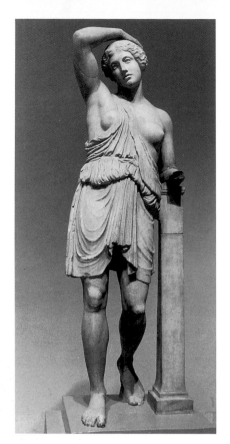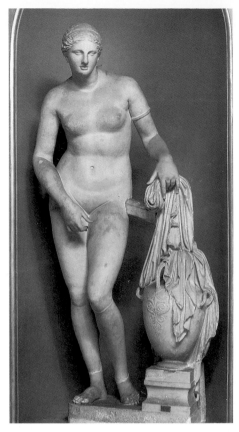

166 Marble copy of a bronze wounded Amazon, made in the 430s as one of a group of three to stand at Ephesus. She uses a broken rein as a belt. Height 2.04 m. (New York 32.11.4)

167 Marble copy of the marble statue of the Aphrodite made for Cnidus by Praxiteles in about 350 BC. She is shown surprised at her bath. Height 2.05 m. (Vatican)

work from his hand may be preserved in fragments from the Temple at Tegea of which he was the architect. In copies of Lysippus' statues we have the new canons of proportion for the human body [*168*], and his creation of a new personality for famous heroes [*169*]. We can also judge how much Alexander's favourite artist did to break with the one-view frontality of most Classical statuary. We learn too that Lysippus and his brother were the first to use casts from life in their studio, an interesting

reflection on what has been remarked already about the importance to major statuary of modelled originals. These are all names and facts which lend life to a subject which seems beset with anonymity, but they are the trappings only, and our conception of Classical statuary must be gained from what has survived, with or without an artist's name, and not from the copies. Yet Greek sculpture is still often taught with reference primarily to ancient texts and Roman copies, and it is not surprising that many people remain unaware of its quality until they are faced by original works, and until the postcard views of the copyists' gods, heroes and girlies have been set aside.

168 Marble copy of the bronze Apoxyomenos made by Lysippus about 330 BC. The athlete is scraping the oil from his forearm with a strigil. The supports for leg and arm were required by the copyist in marble; the fig leaf, by later prudery. Height 2.05 m. (Vatican)

169 Marble copy of the bronze Heracles (Farnese) made by Lysippus about 325 BC. Weary from his last labour, he holds behind his back the Apples of the Hesperides, which will guarantee him immortality and renewed youth. Height 3.17 m. (Naples 6001)

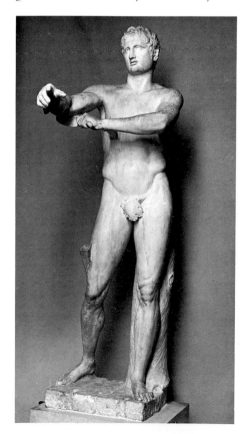
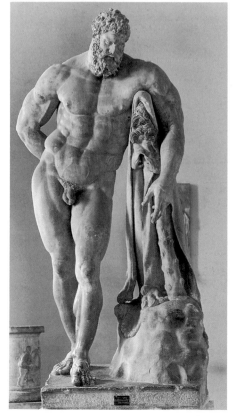

Other Arts in Classical Greece

There is no one art in Classical Greece that is without its masterpieces. We might add almost that there is no period in which the Greek artist did not realize his full potential, limited only by his mastery of available techniques and materials, though this may also be true of other periods and places. But there seems to have been no period of incompetent experiment – no period of effete decadence, though certainly periods of change and not necessarily for the better, or at least for the more durable. If we have dwelt upon sculpture and architecture it is because these were the monumental arts which had the more profound influence on the later development of Western art. Despite the individual brilliance of particular sculptors, painters, engravers, jewellers and workers in metal and clay, there is still an overriding unity of style which informs the work of each generation in whatever material and at whatever size. This might not seem so surprising in such a small country, but we have to remember too the many different artistic centres and the intense activity of the major artists, many of whom may have turned their hands to more crafts than our texts record or our wits can identify. The display of dedications in the great national sanctuaries may of course have contributed to this unity, but it is more difficult to distinguish the works of different schools in 5th- and 4th-century Greece than to distinguish the paintings of Cinquecento Florentines and Venetians.

CLAY FIGURINES

The correspondence between a major and a (miscalled) minor art is well illustrated by the clay figurines which often closely match the larger works in marble or bronze. There were, in fact, also some large clay sculptures in Greece [127], but these represent a legacy of Archaic practice and are not common. The smaller clay works are found as offerings – standing or seated figures of worshippers or divinities, and beside them more original studies of mortals or animals, the sort of thing that

170 Clay group of actors, dressed as an old woman and a man. They wear masks and the man has the usual comic costume of padded tunic, phallus and tights [cf *210*]. Mid-4th century B C. (Würzburg)

171 Clay figure of a dancing maenad with a fawn-skin over her dress and holding a tambourine. From Locri, South Italy. About 400 B C. Height 19 cm. (Reggio 4823)

172 Clay plaque from Locri. The goddess Demeter, seated holding corn ears and a cock, faced by Dionysus with his drinking cup and vine. About 460 B C. Height 26.8 cm. (Reggio)

was probably becoming more common in the house as well as serving as a dedication in grave or sanctuary. The use of moulds, and the copying of moulds, meant that few of these managed to retain much of the freshness of their original model. Hollow masks, intended to hang from the wall, were another form of clay votive, and we see them shown on vases hanging, for example, by a bronze sculptor's furnace, to solicit divine protection for the firing [274]. In the later 5th and 4th centuries the small clay figures offer a variety of subjects which the sculptor generally ignored but which were probably also rendered at this scale in bronze. Of particular interest are figures of actors [170], which can tell us much about the dress and masks worn on the Athenian stage. Beside them are graceful genre studies of dancers [171] and women at ease or in their best dresses, such as are to become characteristic of the succeeding Hellenistic period. The Western Greeks were particularly adept at preparing fine moulds for such figures. They also provide examples of a different sort of votive, the clay relief plaque, and Locri, in South Italy, has yielded an important series of Early Classical plaques with ritual scenes [172]. In the Greek homeland the island of Melos produced a notable series of cut-out plaques showing mythological scenes. Later we find gilt-clay and plaster reliefs used in various parts of the Greek world to decorate wooden boxes and coffins.

173 Clay vase in the shape of a drinking horn with a base comprising the group of a negro boy attacked by a crocodile. The neck is decorated with maenads and satyrs. In the manner of the Sotades Painter, a specialist in such curiosities. About 460 BC. Height 24 cm. (Boston 98.881)

174 Clay cup in the shape of a sheep's head. The relief group on the neck shows a fight between a griffin and an Amazon, cast from a metal relief. Made in South Italy. About 350 BC. Length 20.8 cm. (Oxford 1947.374)

Coroplast and vase painter often collaborated in figure vases. These are usually elaborate cups, in the form of human or grotesque heads, or sometimes of more complicated groups [173]. The animal-head cups copy a familiar Eastern form, and there are clay versions of the more expensive metal cups in this shape, either painted or in relief [174]. Some of these are not simple cups but pourers (*rhyta*) – for their mouths are pierced. This is a version of an Eastern type of drinking vessel, preferred for ritual in Greece, and there are also many examples in which the drinking-horn shape is closely followed.

STATUETTES IN METAL

The range of individual figures was probably very much as that in clay, but specialities were cast attachments to vessels and other utensils. Luxury goods of gold and silver have generally not survived so our main evidence is in bronze, though this could often be gilt. The practice of casting handles and decorative attachments for vases continued from the Archaic period, with less variety of subject than hitherto; sirens adorn handle bases, heads their tops. Occasionally figures in the round appear on the lip or shoulder of the larger vases – another Archaic practice; or

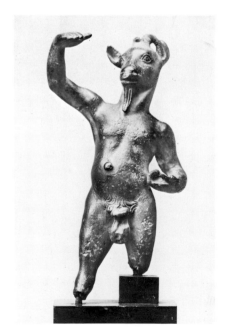
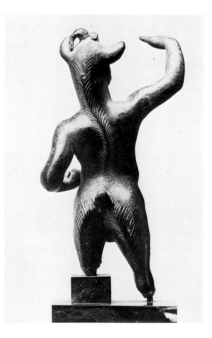

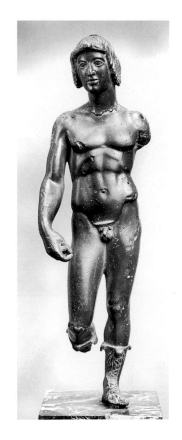

a whole relief group is fastened on the body of the vase beneath the handle. The figures of women supporting mirror-discs survive also, and in the details of their hair and dress they follow closely the patterns of contemporary sculpture [*175*]. They often stand on neat, folding stools, while figures of Eros fuss around their heads, and tiny animals and florals run over the attachment to the disc and round it. This sort of finicky embellishment is not much to modern taste nor easily reconciled with the popular idea of Classical simplicity. In the free-standing statuettes of bronze we also see a greater variety of figures – athletes, deities, dancers [*176–78*]. In much of this sort of work we begin to feel perhaps for the first time in the history of Greek art that the artist is producing an object which has no function but to please mortal eyes, which is more than an appropriate decorative addition to an implement or article of toilet, more than a proud expression of wealth or piety in a god's shrine.

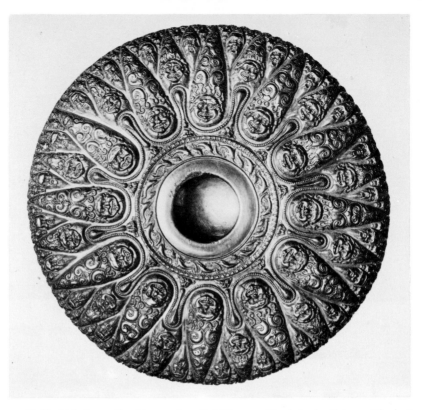

179 Gold *phiale* from a Scythian tomb at Kul Oba near Kerch in the Crimea. The basic floral pattern is embellished with heads of gorgons, animals and bearded heads, while dolphins and fish swim around the 'navel'. From the same tomb as the ivory [*190*]. 4th century BC. Diameter 23 cm. (St Petersburg)

PLATE

We have little enough by way of gold plate in Greece until we move to the fringes of the Greek world, where Greek craftsmen in Black Sea colonies worked for Scythian nobles who placed the vessels in their tombs [*179*]. The Classical fat cats, even in a democracy such as Athens, were torn between amassing great stocks of gold and silver, and an ethos which frowned on such hubris. Silver was in relatively good supply, from Persian booty or Greek mines, but much was absorbed by state coinage, and plain silver vessels, carefully weighed, served as little more than large denomination banknotes, especially in temple treasuries where they are listed (with weights). A special class is formed by *phialai*,

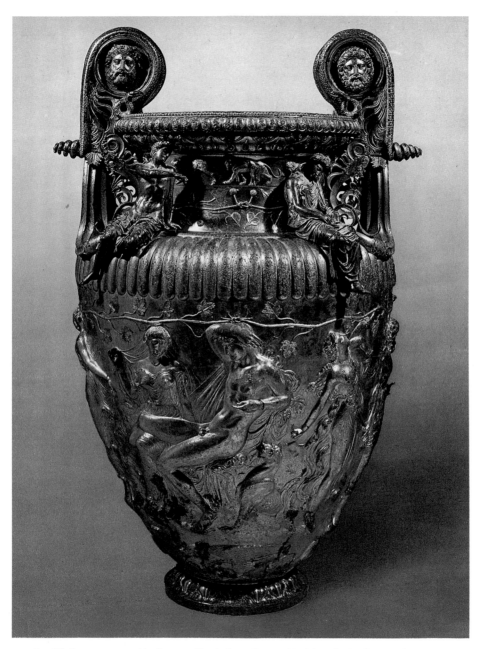

180 Gilt bronze *crater* with silver appliqués from Derveni in Macedonia, decorated with relief Dionysiac scenes, from a tomb where it served as an ash urn. Late 4th century BC. Height 90.5 cm. (Thessaloniki)

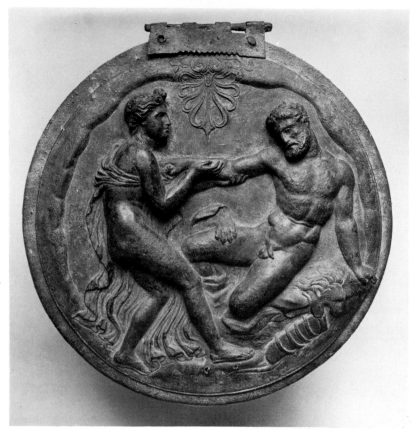

181 Bronze mirror cover with relief scenes of the drunken Heracles assaulting the priestess Auge. From Elis. 4th century BC. Diameter 17.7 cm. (Athens)

shallow bowls with small raised centres (navels – mesomphalic) beneath which the fingers would fit. The shape was Eastern, where handleless round-bottomed cups were preferred to Greek shapes. From representations on vases we can see that in Greece they were commonly used for pouring libations. But we have to judge much of what was possible in pricier metals from what has survived in bronze. Cast attachments have been mentioned already but much of the finest work was either hollow-cast or hammered (*repoussé*), sometimes with figures in exceptionally high relief and most delicately modelled. These appear on vases [*180*], but on other objects too – the cheek-pieces of helmets, belt-

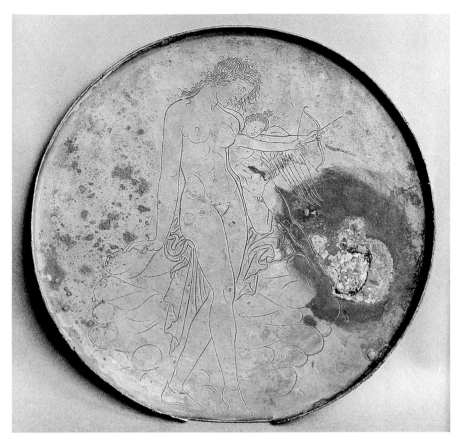

182 Bronze mirror cover with incised scene of Aphrodite teaching Eros how to shoot. 4th century BC. Diameter 19 cm. (Louvre MND 262)

clasps, and the folding backs of circular mirrors [*181*]. The reflecting surface of the mirror was a bright, polished or silvered bronze, and where mirror backs have no relief decoration there may be incised figures [*182*], the cut lines showing dark on the bright surface. This incision on silver or bronze, mirrors or cups, is a downmarket version of the finer reliefs, which are commonly gilt. This may remind us that all ancient bronzes, fresh from the artist's studio, had a bright appearance, far warmer and more realistic than the dark patina of age or the chocolate-coloured or dull brassy surface produced by some modern cleaning methods.

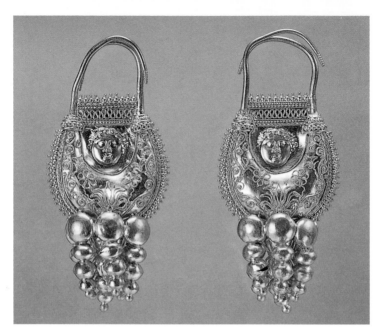

183 Pair of gold earrings, said to be from Tarentum. About 330 BC. Height 6.5 cm. (London 1872.6–4.516)

184 Gold diadem from the north-east Aegean, impressed from a mould. Dionysus and Ariadne recline at the centre of an acanthus scroll, on which are seated Muses with musical instruments. 330–300 BC. Height at centre 5.9 cm. (New York 06.1217.1)

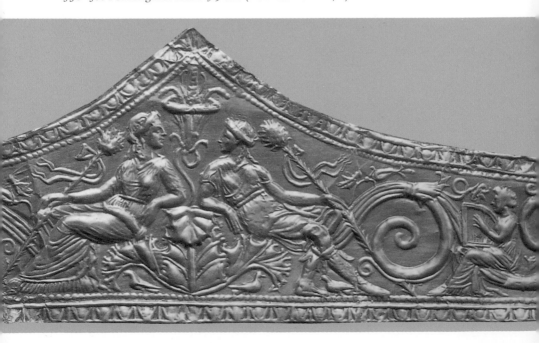

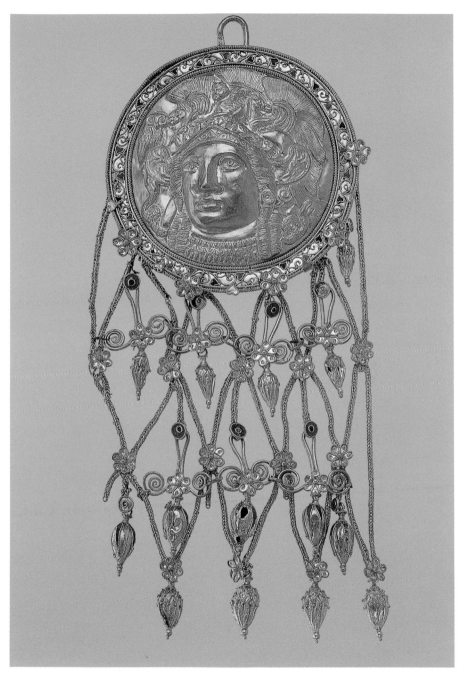

185 Gold pendant from Kerch in the Crimea showing the head of the Athena Parthenos in Athens, recognized from descriptions of the helmet by later writers. 4th century BC. Diameter of disc 7.2 cm. (St Petersburg)

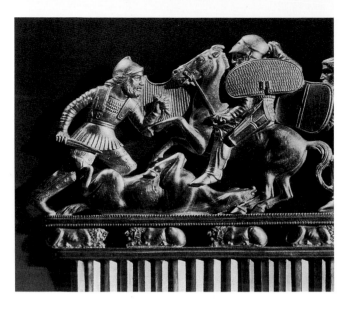

186 Detail of the handle of a gold comb from Solocha in the Ukraine. The figures are wholly in the round. Height 5 cm. 4th century BC. (St Petersburg)

JEWELLERY

The jeweller had long before mastered the arts of filigree and granulation, and from the later 5th century on, inlays of coloured stones or enamel may be added. Generally, however, Classical jewellery is monochrome, gold rather than silver [*183–85*]. The tombs of south Russia, both those of the Greek colonies and those of the neighbouring Scythians for whom Greek artists worked, are a rich source of fine Classical gold-work. The Solocha comb is effectively miniature statuary in gold, illustrating a local encounter [*186*]. Signet-rings of solid bronze, silver or gold become common for the first time in the 5th century. The devices on them are often of women, seated or standing, with wreaths or a tiny Eros, or of Victories. They were probably regarded more as decorative than as personal seals, for which smaller bronze rings seem to have been preferred. They must have been most popularly worn by women, but it is odd that they are not worn by any of the figures shown on contemporary vases which otherwise give us vivid details of dress, jewellery and furniture.

Engraved gemstones could also be set on swivels and worn as finger-rings, or be worn as pendants on necklaces or wristlets. The practice of setting an engraved stone immovably in a metal hoop only became at all common towards the end of the Classical period. The scarab-beetle

187 Chalcedony gem signed by Dexamenos of Chios. A flying heron. From Kerch in the Crimea. About 440 BC. Length 2 cm. (St Petersburg)

188 (*Below*) A silver coin of Syracuse with the head of the nymph Arethusa and dolphins, about 405 BC; a gold coin of Panticapaeum, a colony in the Crimea, with the head of Pan, about 350 BC

form of seal remained popular for a while after the Archaic, but was generally replaced by the plainer scaraboid form with a convex back. The stone is usually larger now – of chalcedony or white jasper, and the subjects are somewhat more limited. Studies of seated women and of animals are particularly common. Few artists' signatures are preserved, but we know one, Dexamenos of Chios, who in the second half of the 5th century cut a brilliant portrait head and some sensitive and detailed studies of birds and horses [*187*]. Gemstones of this type were popular all over the Persian Empire, and there is a large class, made in the East, which owes as much to Greek as to Eastern models. The arts of the Persian, Achaemenid Empire, give us a further glimpse of a return current of ideas and art forms, now from West to East.

COINS

The related art of engravers of the metal dies from which silver coins were struck flourished beside that of the gem-engraver [*188*]. We may suspect that the same artists were involved but this is hard to prove from style alone since the techniques of die-engraving were coarser than

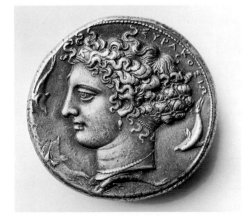

those of gem-engraving, and there are more signed coin dies than signed gems. In the heads of deities and, later, of princes and kings which appear on many coins we see a fully sculptural style and often unusually high relief – a positive disadvantage in objects so much handled and so easily rubbed, and particularly unfortunate when frontal heads were attempted. There is a great variety of animal studies too – greater than that offered by gems because coins were mass produced and more different types have survived, while each gem was a unique creation. Conservatism dictated the devices on the better-known issues of coins, which relied on the ready familiarity of the types. But although the devices on coins of states like Athens and Corinth changed but slowly, other cities struck series with brilliant and different devices, sometimes with an abandon rivalling that of the postage-stamp issues of some countries today. A few issues commemorated particular events or were at least occasioned by them, and in this way have combined the characters of medallions and coins.

PAINTING

Of all the major arts of the Classical period, painting on wall or panel is the one about which we know least, although in antiquity it was most highly valued. The names of the painters were honoured and remembered, which is more than can be said of any vase painters. We read of the great paintings by Polygnotus and Mikon on the public buildings of Athens and Delphi in the years before the mid-5th century. These were, we are told, done in a four-colour technique – black, white, red and brown, and Polygnotus especially sought to express emotion or atmosphere by nuances of pose or gesture, often repeated on vases or sculpture (as the Penelope type [147]). These big compositions had comparably big themes – the Sack of Troy, the Underworld, or a mortal but heroic battle such as Marathon. The figures were set up and down the field, not diminishing as if to indicate distance, probably at about half life size. The mode influenced some vase painters.

Later 5th- and 4th-century artists are credited with notable innovations in shading, in suggesting depth and roundness, and in *trompe l'oeil* compositions. Shaded contour drawing was the commonest, but compositions depending on colour and chiaroscuro are also described. There was only an incipient understanding of linear perspective and it seems that in major compositions each subject had its own vanishing

189 Painting of Hades carrying off Persephone on to his chariot. On the wall of a princely tomb at Vergina in Macedonia. About 340 BC. Height 1 m

190 Incised and painted ivory plaque from a Scythian tomb at Kul Oba near Kerch in the Crimea (whence also [179]). Athena and Aphrodite with Eros at her shoulder, from a scene of the Judgement of Paris. 4th century BC. Height 22 cm. (St Petersburg)

191 (*Below*) Landscape painting with hunting scene, from the façade of the tomb of Philip II (died 336 BC) at Vergina. Length of frieze 5.6 m

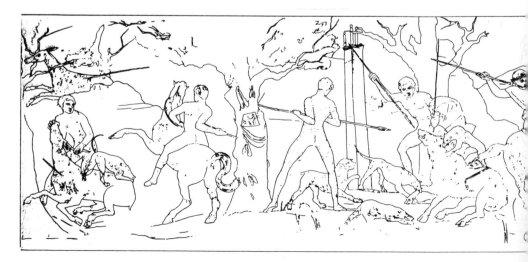

192 Purple and gold cloth from the tomb of **Philip II** at Vergina. A floral fantasy combining many different plants and flowers. Width 61.5 cm. (Thessaloniki)

point rather than one located centrally; and this, after all, more closely reflects our own manner of looking over a scene. The big names are Zeuxis and, in the 4th century, Apelles, and their fame rivalled that of their sculptor contemporaries. Of their work we can know nothing beyond the suspected influence of such styles read in contemporary vase paintings, and works like the ivory plaques found in south Russia, which were once painted, although now only the incised outlines of the figures are at all clear [190]. From the middle of the 4th century on more evidence is now emerging from the discoveries in Macedonian tombs

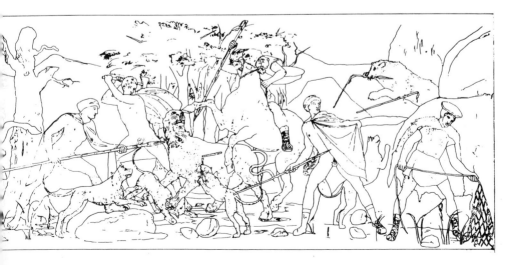

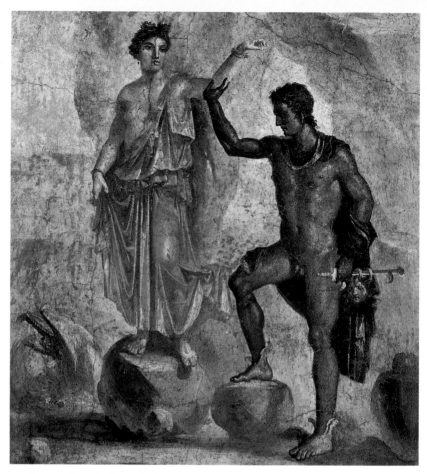

193 Perseus frees Andromeda from her fetters; the slain sea monster is seen at the left. From the House of the Dioscurides at Pompeii (destroyed AD 79), after a Greek original associated with the name of the late-4th-century BC painter Nicias. Height 1.22 m. (Naples)

[*189, 191*], where, clearly, prime Greek painters were employed: they give just a glimpse of a major Greek art form which, for colour and originality of composition, might, if better known, do much to counter the popular view of simplicity, if not austerity in the arts. This was a medium for both figure scenes and decorative floral compositions. The same must have appeared also on textiles, and Macedonia yields us one tantalizingly fine example [*192*].

196

To a minor degree we can learn from copies of paintings as we have about sculpture, but these are never as accurate as the measured marbles. Several of the wall-paintings recovered from the 1st-century AD houses of Pompeii and Herculaneum seem to be copies of Greek compositions of the 4th century BC and later [193]. Now that we have the Macedonian paintings we can better judge how close some may be to their originals. When Romans looted Greek art, they chose paintings as well as statues.

Another source of information about painting is from the pebble mosaics decorating floors of houses and northern palaces from about 400 BC on [194]. The derivation of this floor decoration from panel paintings, some of them even signed, is clear: a new art form with an important future.

194 Pebble mosaic from the floor of a house at Olynthus in north Greece. Bellerophon riding Pegasus strikes down the Chimaera. Mid-4th century BC. Width of detail 1.25 m. (Thessaloniki)

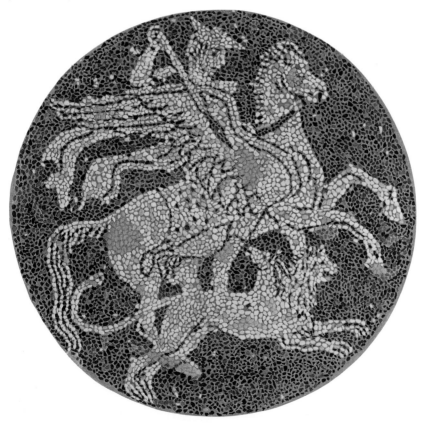

Vase painting remains a prolific source of information about styles and subjects, and at all times there are a few artists of quality whose work can bring us close to that of their seniors. But it is a craft which will not outlast the 4th century in Greece. Persian occupation of Athens in 480 and 479 BC drove the citizens and artists from their homes, and when they returned they had to build afresh. Old wells and pits in the neighbourhood of the potters' quarter are found filled with the debris from the potters' shops. But there is no significant break in production or style. The same painters are at work. In their hands the transition from Archaic to Classical in line drawing was achieved, as we have seen it was already in the work of sculptors. The cup-painters continue the tradition of the early years of the century, but have at last abandoned the formal, almost Geometric fussiness of the Archaic pleats and zigzag hemlines. The dress is shaking out into freer folds. In details of drawing we find at last a proper view of a profile eye in a profile head. Bold fore-

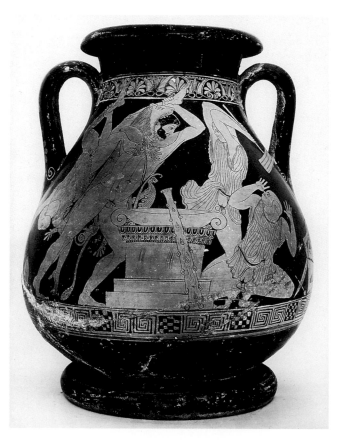

195 Athenian red figure *pelike* (oil container) by the Pan Painter. A sleek Heracles confounds the African servants of the Egyptian King Busiris, who intended to sacrifice him. They are blacks in features (face, circumcision) not colour – rather a problem in the red figure technique though surmounted by others. From Boeotia. About 460 BC. Height 31 cm. (Athens 9683)

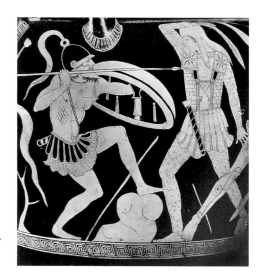

196 Detail from a vase by the Niobid Painter with a Greek fighting an Amazon. She wears a Greek corselet with oriental skin cap and tights. From Gela (Sicily). About 460 BC. (Palermo G 1283)

shortening and three-quarter views are successfully attempted and the artist can experiment further with pose and gesture to suggest emotion, and even give atmosphere to a scene where before a simple event was enacted by, as it were, lay figures. Subsidiary floral ornament generally becomes more restricted. The border and ground-line pattern of meanders and squares derives from the Archaic patterns of woven hems and selvages [e.g. *107–8, 196, 206,* cf. *90, 103*].

A group of Mannerists represent the old guard, clinging still to some of the Archaic conventions and leaving their figures to act with a stiff prettiness which seems awkward in the hands of all but the best artists. Their leader, the Pan Painter, could rise to better things [*195*]. The monumental styles of contemporary sculpture are best reflected in the work of artists such as the Altamura Painter and the Niobid Painter [*196*]. Their statuesque studies of warriors and women are a close match for the *peplos* figures and heroes of, for instance, the Olympia sculptures, and their battle scenes must owe much to contemporary wall-paintings, both for subject and compositions. The Niobid Painter is the first to set figures on different ground-lines up and down the field of the picture [*197*]; the manner was that adopted by wall-painters to suggest space (though not depth) and interrelationships of figures not confined in, as it were, a shallow one-level frieze. The device is not particularly suited to vase painting and the Niobid Painter's use of it is unique at this time, but it recurs on later vases.

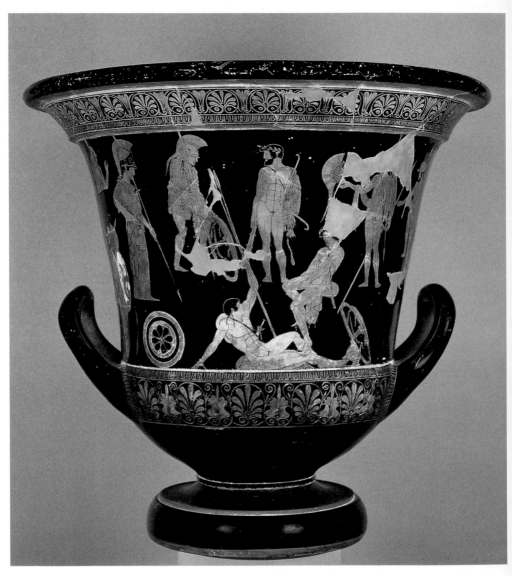

197 The reverse of the name vase (a *calyx crater*) of the Niobid Painter, showing an assembly of heroes and gods, possibly before the battle of Marathon, with Athena and Heracles prominent, perhaps Theseus below. The multiple-groundline scheme perhaps copied a wall-painting more closely than many such later compositions. From Orvieto. About 460 BC. Height 54 cm. (Louvre MNC 511)

198 The name vase of the Penthesilea Painter. Achilles slays the Amazon queen Penthesilea at Troy. From Vulci. About 460 BC. Diameter 43 cm. (Munich 2688)

The lightest work of these years is that of the Pistoxenos Painter [199], or the Penthesilea Painter, in all but his name vase [198] where he crammed a composition from a wall-painting into a recalcitrant circle and spoilt the delicacy of his drawing by crowding detail. It is the sorry fact that when the vase painters overreach themselves in their figure compositions, which are so seldom properly suited to the curving surface of a vase, the quality of their work can be better appreciated in deliberately selected details, drawings, or even fragments. The last-named artist also headed a workshop producing simple cups on what seems to be an assembly line with different painters working in succession on each vessel.

The subjects shown on the larger vases are more often now of epic encounters between Greeks and Amazons, or Greeks and centaurs, inspired in part by contemporary wall-painting, in part by the popular-

199 A white-ground cup by the Pistoxenos Painter. Aphrodite rides her goose. From Camirus (Rhodes). About 470 BC. Diameter 24 cm. (London D 2)

ity of myths which seemed to reflect Greek supremacy over barbarians and Orientals, just after their success against the Persians; this is the reason for their popularity also in the architectural sculpture of Periclean Athens. Except for the work of a few cup-painters who retained the Archaic manner we miss the fine, though short-lived tradition of the free and original pictures of dancing and drinking-parties which were so popular early in the century. Their subjects may have been trivial but they released the painter from the iconographic conventions of the usual scenes of myth and let his fancy play over poses and situations of everyday life, albeit in somewhat élitist settings. There was promise in this Late Archaic exuberance of a whole new phase in Greek representational art, but it seems to have been stifled by a measure of Severity.

200 An Athenian white-ground *lekythos* by the Achilles Painter showing a Muse seated on Mount Helicon. The inscription above praises the youth Axiopeithes. About 440 BC. Height of figure frieze about 17 cm. (Munich, von Schoen)

201 A white-ground *lekythos* (Group R) with a young warrior before a gravestone, with a youth and a girl who holds a shield and helmet. The outlines here are in matte paint. Late 5th century BC. Height of figure frieze about 22 cm. (Athens 1816)

202 A detail from the Achilles Painter's name vase, showing the hero shouldering a spear. At the centre of his corselet is a tiny gorgoneion. From Vulci. About 440 BC. Height of detail about 7 cm. (Vatican)

Wall-paintings showed their figures against a white background of paint or plaster. The red figure vase painter had eschewed the pale background of clay for his outlined figures but had experimented with a white-painted ground, such as late black figure artists had sometimes used. The effect was of course closer to that of major painting but, at first, the figures themselves were drawn as if in red figure and masses of different colour avoided. Moreover, the white ground was not always particularly durable. The interiors of some cups are painted on a white ground in the second quarter of the 5th century, but the technique came to be reserved for oil-flasks, *lekythoi*, which were mainly intended as grave offerings and so did not have to survive heavy handling or even exposure for much of their life. The earliest, with subjects much as the red figure, and by the same artists, carry a variety of scenes [200], but in the second half of the century the majority are decorated with appropriate funeral scenes showing the tomb with passers-by, relatives or attendants bringing offerings [201], departure scenes, even the cross-

203 Drawing from the name vase of the Penelope Painter, with the patiently sorrowing Penelope [cf. *147*] beside her unfinished weaving and her son Telemachos. The other side shows Odysseus' homecoming. From Tarquinia. About 440 B C. (Chiusi 1831)

204 Detail of a *hydria* by the Meidias Painter showing nymphs, and a small winged Himeros (Desire) approaching a bower where Phaon sits with a lyre beside Demonassa. From Populonia. Late 5th century B C. (Florence 81947)

205 A red figure *pelike* by the Marsyas Painter. Peleus has surprised Thetis while bathing. Her familiar, a sea monster, wraps itself round the hero's leg and bites him. But he is crowned for anticipated success by an Eros. Her companions scatter in alarm; note the three-quarter back view of the figure top right. From Camirus (Rhodes). About 350 BC. Height 42.5 cm. (London E 424)

ing of the Styx with the ferryman Charon. For these a new technique came to be adopted. The outline and details of the figures are drawn in matte paint instead of the brilliant black, and broad washes of colour laid over drapery and details. This fully polychrome style is perhaps the closest we come to Classical wall-painting. The Achilles Painter was an important artist of white-ground *lekythoi*, some of them impressively large vases nearly half a metre high. The subjects are, in their spirit at least, close to those of the later carved grave reliefs, and there are many points of comparison between the vases and Phidian sculpture. The class of white-ground *lekythoi* barely outlives the 5th century.

The Achilles Painter has been named for his work in red figure – a fine, rather dapper study of the great hero [202]. His contemporaries, of the Parthenon period, include fewer artists of top rank than we have met hitherto, but their work shows the same sort of advance as does the sculpture of these years. The equivalent to the massed drapery of the Parthenon marbles is, in vase painting, the breaking of the straight or flowing folds into interrupted lines and hooks which suggest the same bunching or broken fall of material. The range of mythological scenes increases with a preference for themes reflecting on Athens, and the old formulaic approach is somewhat abated though much relies still on stock figures and groups [203]. There are still many vases later in the century of worth and dignity, but there is a marked preference now for either large and showy pieces, or thoroughly domestic boudoir scenes. Both set the pattern for what is to come in the 4th century. We soon come to learn the detail of an Athenian woman's dressing-room, her gestures before the mirror or the wash-basin. The tiny figures of Eros swarm like gnats to adjust a veil or hold a mirror. Even Dionysus is by now a beardless effeminate youth [206], his maenads are well-mannered dancing partners, his satyrs sleek gigolos. Landscape is still ignored; it was at any rate unmanageable in red figure except for a token tree or rock.

In the last years of the 5th century, in an Athens at war and nearing defeat, some painters seem to evoke a fantasy world of elegance and peace, surely a reaction to the city's depressed condition. The transparent draperies of late 5th-century sculptures are matched by the close-set linear contours of folds which embrace the figures. For the first time on vases, where the nakedness of women had been admitted long before it was commonly shown by sculptors, we find a near-sensual treatment of bodies and dress. The vases of the Meidias Painter and his circle show this new approach at its best [204]. The old-established and unusual

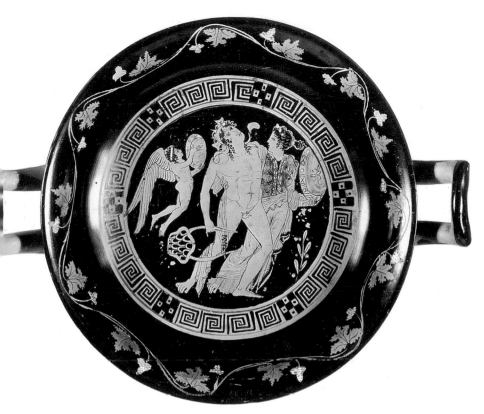

206 Interior of a cup by the Meleager Painter. A limp Dionysus holding a lyre is supported by a woman with a tambourine while Eros plays for them. The vine wreath round the scene would appear to settle over the level of the wine when the cup is used. From Nola. Early 4th century BC. Diameter 24 cm. (London E 129)

Greek readiness to create anthropoid (usually female) personifications of abstract qualities intensifies. Some had acquired a degree of divinity – Persuasion (Peitho) serving Aphrodite, Health (Hygieia) to attend the healing god Asclepius. Most require inscriptions for identification (Democracy, Good Fortune, Madness). They can sometimes serve a useful narrative function by characterizing a myth scene, but often they are no more than appropriate furniture.

On most 4th-century vases the quality of drawing is less engaging than the subject matter [206], and this too can become repetitive and

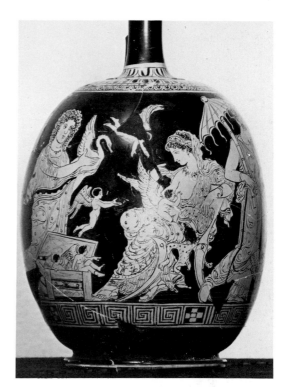

207 Detail from a South Italian red figure vase by the Karneia Painter. A woman plays pipes for Dionysus. The close-set lines of her dress accentuate her figure (compare the Athenian treatment on [204]). Her necklet and bracelets are in low relief, gilt. From Tarentum. Early 4th century BC. (Taranto 8263)

208 A red figure squat *lekythos* (lip missing) made in South Italy (Apulia). Aphrodite suckles and plays with Erotes who tumble from a box. From Tarentum. Early 4th century BC. Height 18.5 cm. (Taranto 4530)

banal. The challenge of major painting led the painter to experiment again with varying ground-lines, to add ornament and to attempt a more polychrome effect within the limitations of red figure, by the generous use of white paint, sometimes gilding, and eventually other colours. This, together with the more florid types of subsidiary decoration, produced a number of gaudy and ambitious works which seem to have enjoyed some success. But in the detail there is often much to enjoy in the extremely accomplished line drawing which some of these vases display [205].

So far in this chapter we have mentioned only Athenian painted vases. The success of Athenian black figure, and the new red figure technique had succeeded in driving the wares of all other schools out of the markets of the Greek world, and virtually all figure-decorated vases used by Greeks are now from Athens' potters' quarter. Only among the Western Greeks was there any notable production of red figure, and this was a direct offshoot of the Athenian tradition. Athens sent settlers to Thurii in South Italy in the mid-5th century. With them,

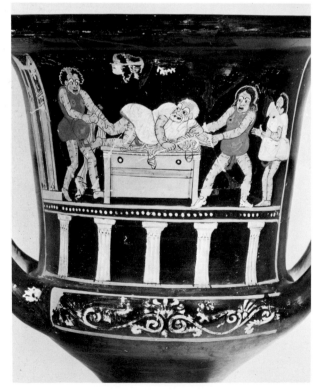

209 Detail from an Apulian red figure *crater* neck with a woman's head in a floral fantasy. About 330 BC. (Basel S 24)

210 A *calyx crater* made in Paestum, signed by the artist Assteas. Scene from a comedy of manners – the subject and costume of Athenian Middle Comedy. A miser is apparently being pulled from his treasure chest. For the costumes, see [*170*]. The stage is supported on short pillars. About 350 BC. Height 37 cm. (Berlin 3044)

211 A Boeotian Cabirion cup. A hairy ogress (a gorilla or Lamia?) is chasing a traveller who has dropped his baggage. Two men have already abandoned their plough and taken to the safety of a tree. 4th century BC. (New York 1971.11.1)

it seems, went potters and some painters, and in the second half of the century we find painting on South Italian vases of a quality which can at times match the best in Athens [207, 208], although the more lively Athenian styles of around 400 are not represented. In the 4th century other schools appear in the Greek or Hellenized areas of Sicily and South Italy. Few are at all distinguished except for the glory of their ornament which echoes new styles in major painting, mosaic and metalwork [209]. But the Westerners' love of the theatre, or at least of the theatrical, is reflected in a number of large and grotesquely over-ornamented vases made in Apulia (the heel of Italy) and decorated with tableaux many of which are thought to recall the action and actors of plays. Other products of some of these studios are more decidedly theatrical in origin – engaging studies of comedies, mainly imported from the Athenian stage, with padded and masked actors parodying the heroic and epic stories which were treated in a more solemn manner by the Athenian tragedians. We have to turn to South Italy rather than Athens to catch any visual presentation of the spirit of Aristophanes and the novel genre subjects of Attic Middle Comedy [210].

212 A Boeotian clay jar (*pyxis*) with floral patterns of the type seen on many vases made in central Greece in the 5th and 4th centuries. Late 5th century BC. Height 14 cm. (Reading Univ. 26.iv.1)

A similar mocking spirit – and humour on Greek vases is usually hard to find or identify – is seen in a class made mainly for dedication at a sanctuary (the Cabirion) near Thebes in central Greece. For these the old black figure technique was employed [*211*]. It had never been forgotten in Greece, and even in Athens it was practised on into the Hellenistic period for the Panathenaic prize vases.

The finer styles of vase painting did not survive the end of the 4th century in Athens. The attempts to imitate major painting could not succeed through the severe limitations of the red figure technique, not least its black background and essentially bichrome appearance, and the painters ceased to try. But the genre was exhausted, and the use of metal vases and imitation of their appearance and decoration was becoming more fashionable. Cheap, plain vases painted with a fine black gloss paint, often recalling details of metal shapes, had been popular in the

5th century, as were cups and other vessels with very simple but often elegant, painted floral patterns [*212*]. It seemed inevitable that these simpler vases would remain in favour for ordinary use while the painters of figure-decorated vases went out of business through the coarseness or over-elaboration of their work, and the competition (in South Italy) or indifference of their markets. The plain vases admitted simple impressed decoration, and eventually, in imitation of metalware, moulded relief decoration. These are to be the dominant styles for clay vases for many years to come.

Of other arts we know little. Wood could still be carved, but seldom for major works. Weaving or even painting on cloth, generally women's work, could include mythological subjects, and since there is a certain exclusiveness of iconographic tradition in each craft it could be that the woven scenes held something the more familiar ones in stone or on clay did not [*192*]. Our subject has something, though not a lot, to contribute to women's studies although there is room for unlimited speculation. We have touched on their possible role *vis-à-vis* Geometric art in Chapter One. Women (a very few) were admired as poets, but in the arts we cannot define what original role they had in decorative weaving or any other household craft. I would expect priestesses to have been consulted about the decoration of new temples – not the furnishing but the subject matter of sculptural detail, but we cannot be sure even of that. From about 430 BC on, they occupy an important position in the iconography of Athenian vases and tombstones, created, we must suppose, all by men, but possibly commissioned by women. Many of the vases seem to have been designed for the boudoir, but when the scenes allow an Aphrodite or Eros to intrude this says something more about their perceived status, while the majority that women enjoy in tombstone representations seems to suggest that the loss of anyone so important to parents, husband and children was very keenly felt. In what was, at least overtly, a male-dominated society, the activities of mortal women figured prominently in the public and private arts, to a degree unparalleled in any other ancient culture, so far as I know (the Indian comes closest), and this seems quite well matched by the treatment many receive in the works of Classical tragedians. Studies that search Classical sources for evidence of their subjection and exploitation will always seem well supplied; a wider view, including that of art, could reveal some interesting exceptions.

Hellenistic Art

The word Hellenistic translates the German *Hellenismus*. It was applied by scholars who thought that the period and arts displayed a fusion of Greek and Oriental traditions. The major arts of the new age are deployed more for the satisfaction of men and kings, for the embellishment of private houses and palaces, than for the glory of the gods and the state. Dedications display an even greater degree of pride and propaganda rather than anonymous piety. In these respects at least the political and social climate of the day had a most profound effect on the arts. The change was brought about by the vision, brilliance and ruthlessness of one man who seems himself to have been almost indifferent to art though not to scholarship.

Alexander the Great was a Macedonian [213] – only by courtesy a Greek and, in the opinion of his political opponents in Athens, of a race better suited to the rearing of slaves than of generals or politicians. Yet he carried the boundaries of his kingdom by force of arms, Macedonian and Greek, to beyond those of the Persian Empire which had once threatened to overwhelm Greece. The Empire that the Persians had created around them in some fifty years of expansion was undone by an outsider in ten. When Alexander died, in June 323 in Babylon, at the age of thirty-two, Greece itself had been forceably united, and the limits of Greek rule stretched to the Indus in the east, from the Black Sea to Egypt in the north and south. Only in the west was Greek power still contained by the power of Carthage and Rome, and everywhere the Greek genius for internal disarray was apparent.

After Alexander's death his empire shrank and split, but the pattern of empire had been set, and the country of Greece itself was no longer the only, or even the main, centre of influence and wealth in the Greek world. Alexander's successors created their own, smaller empires, centred in Macedon in the Greek peninsula, at Pergamum in Asia Minor, at Antioch in the Near East, and at Alexandria in Egypt.

The style, scale and content of Greek art had changed profoundly, in ways foreshadowed under Alexander. New dynastic centres promoted

213 Portrait head of Alexander wearing the ram horns of Zeus Ammon, on an engraved gemstone of tourmaline. Probably cut in the east soon after Alexander's death. The material is eastern and there is a tiny Indian inscription below the neck. Late 4th century BC. Width 2.4 cm. (Oxford 1892.1199)

palace architecture which is oriental in magnificence and of a sort not seen in Greece since Mycenae. The new Courts acted as *foci* for artists from all parts of the Greek world, and the new royal patronage had different demands from those of the city-states and private individuals who had hitherto sponsored major projects. The great works of statuary now commemorate events like major victories in Asia Minor over Gauls, they create new personifications [214], show new Greco-Egyptian deities, or they are portraits either of new royal families or honouring citizens who had deserved well of their fellows and masters. In Greece itself many of the new buildings are gifts of the Macedonian

217

princes overseas, just as later they were to be the gifts of Roman emperors. In the years that were to pass before the Roman conquest of Greece and eventual establishment of the Roman Empire the Greek homeland was to play a much-reduced part in the story of Greek art. The cities and the great buildings, as those on Athens' Acropolis, had been long established and there was no room for the magnificent new architectural and town-planning projects such as could be indulged in the many completely new foundations which were made in Asia Minor, Syria and Egypt. And even there, many of the sites of the older great cities were abandoned for new foundations in yet more commanding positions near at hand – as at Smyrna, Cnidus and the Alexandrias and Seleucias in the east.

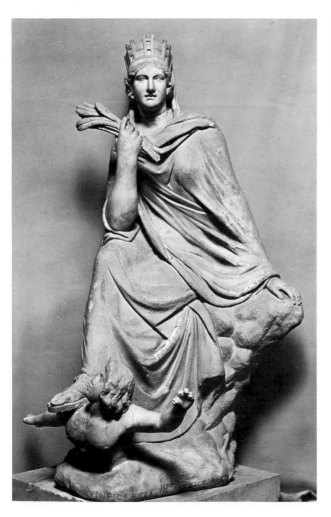

214 Copy of the 3rd-century statue of Tyche, Good Fortune, by Eutychides. The city goddess of Antioch wears a castle crown, with the River Orontes swimming before her. The turret-crowned goddess is used as the personification of many Hellenistic cities. (Vatican)

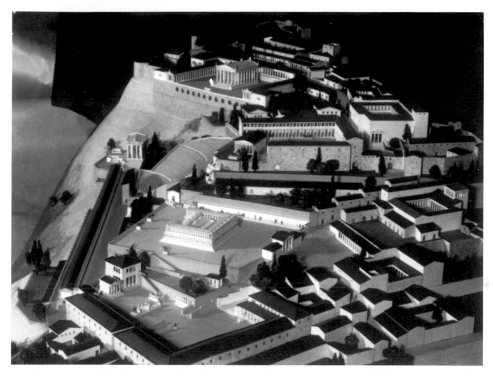

215 Restored model of the Acropolis at Pergamum. (Berlin)

ARCHITECTURE

The great city of Pergamum in Asia Minor and the buildings and sculptures commissioned by its Attalid kings could almost serve as texts for the study of all Hellenistic architecture and sculpture. It is not clear where the earlier town of Pergamum lay, but it was certainly not centred on the massive hill which rises some hundred metres above the plain beside the River Caicus, where the Hellenistic kings built their palaces. The crown of the windswept rock was laid out by successive kings as their capital. The view we have of it in drawings and models [215] is one never appreciated in antiquity, except by the birds, and we should rather put ourselves in the position of a visitor climbing to its walls, and through them on to a succession of terraces and colonnades reaching up and away. On the lowest stood an open, colonnaded market place (*agora*). The flanking *stoai* are versions of buildings which had come to

216 Restored cut-away model of the Stoa of Attalus in the market place of Athens. Broad colonnaded walks (Doric and Ionic below; Ionic and Pergamene palm capitals above) in front of rows of shops and offices. 2nd century BC. Length 115 m; depth, with promenade, 20 m. (Agora)

play an important role in Greek civic life, with rows of shops behind and often on two storeys, providing not only a market, or offices, or hotel, but a shelter and meeting place (as for the Stoic philosophers of Athens). It was a Pergamene king who gave Athens' *agora* a new *stoa*, now reconstructed as a museum [*216*]. Above Pergamum's *agora*, in an open court, stood the Great Altar of Zeus, a monumental version of a type with a long history in East Greece – a broad flight of steps rising between projecting wings [*219*] to a high platform. Higher stood the Temple of Athena in its own colonnaded court, which gave entrance to the library (our word parchment derives from *pergamena charta*, Pergamene paper). At the top of the hill stood the palace courtyards, barracks, and later a temple built by the Roman Emperor Trajan. Cut deep in the hillside was the theatre, seating some ten thousand.

The colossal temple building sponsored by the Hellenistic kings was anticipated by the rebuilding of the Temple of Artemis at Ephesus in the 4th century. At Sardis a new temple for Cybele is distinguished for the elaboration of its Ionic order, notably the capitals. At Didyma, near Miletus, the new temple is in effect a massive screen whose ruins still

0.843

217 Drawing on the inner court wall of the Temple of Apollo at Didyma, with the architect's plans (foreshortened top to bottom) for the design of the *entasis* of the columns

218 (*Below*) Decorative pilaster capitals and frieze from the wall top in the court of the Temple of Apollo at Didyma. Griffins with lyres and florals based on acanthus and other patterns. 2nd century BC

dominate the Turkish village beside it. Within its open court stood a separate small shrine. A few years ago faint drawings detected on its walls revealed how the architects gave graphic instructions from which the masons could carve the *entasis* (swelling) of columns and details of mouldings [*217*]. The outer columns, Ionic, stood nearly twenty metres high, many of them on elaborately carved, polygonal bases. Here too we meet sculptured heads and busts emerging from the volutes of the capitals, and more sculpture applied amid the usual floral mouldings [*218*]. The near-Baroque character of this decoration will be met again in the major sculpture of the period. The architect Hermogenes is associated with various of the new temples of Asia Minor in the 2nd century. He codified principles of architectural proportion which were still observed in early Imperial Rome.

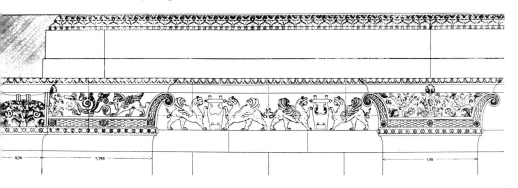

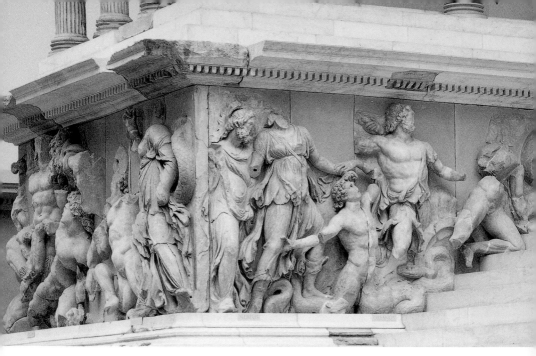

219 The north wing of the Great Altar of Zeus at Pergamum. Beneath the Ionic colonnade runs a frieze showing the battle of gods and giants with many names inscribed. About 180 BC. Height of frieze 2.25 m. (Berlin)

Apart from the temples and other public buildings there are other major architectural works, including some quite new concepts executed still within the canons of the Classical orders. Civic architecture is accorded as much architectural elaboration as temples. Theatres received more architectural ornament, though not as much as in the Roman period. Less common are buildings like the Tower of the Winds at Athens – a clock-tower of the 1st century BC; and the great light-house (Pharos) at Alexandria, one of the Seven Wonders of the Ancient World. We know it only from descriptions and sketchy representations of it on minor works. It stood over one hundred and thirty metres high. The new city of Alexandria might tell us much of civic planning that was to influence the design of cities of the Roman Empire, but it can be recovered only in fragments.

The architecture of private houses is a little more enterprising than hitherto. They offer more opportunity for painted and mosaic decoration now and are larger and more sumptuously appointed, but they

220 Detail from the frieze of the Great Altar of Zeus at Pergamum. A winged giant (Alkyoneus) is seized by the hair by Athena and attacked by a snake. About 180 BC. (Berlin)

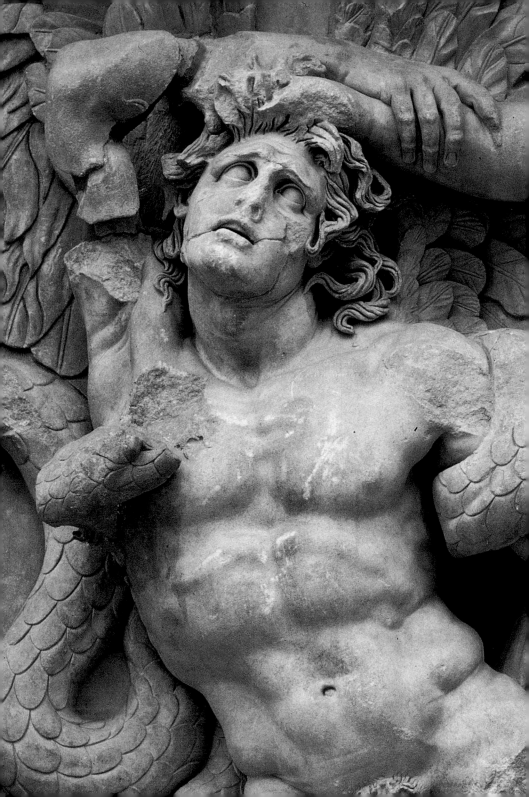

observe still the common Mediterranean introspective plan of rooms grouped round a courtyard, and there was not usually any exterior architectural order or decorated façade. The appearance of the streets in even the richer quarters of Hellenistic cities must have been as dull and unvaried as Pompeii. In a big and crowded city such as Alexandria we may suspect tenement-like buildings of the sort built by the Romans in Ostia. With the advent of the catapult and improved siege techniques fortification walls became more complex and massive, and heavily rusticated masonry is appreciated for its decorative effect as well as its reassuring solidity. Greeks were always good at walls.

Greek architects had hitherto avoided the arch, possibly for aesthetic reasons since they were aware of its value. It is occasionally used now in conspicuous positions, as for the market-gate at Priene or in fortifications, while barrel-vaulting is normal for the Macedonian chamber tombs, which also often have elaborate architectural façades although all was buried in a tumulus. For monumental above-ground tomb buildings we have still to turn to the kingdoms of Asia Minor.

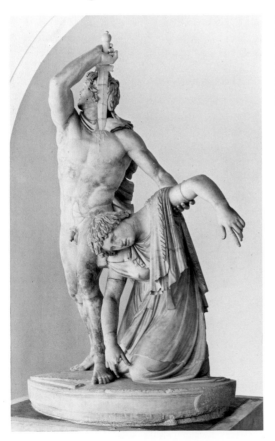

221 Copy of the group showing a Gaul slaying himself and supporting the dead body of his wife from a larger group dedicated at Pergamum by Attalus I in the late 3rd century BC. The Gauls (Celts) had invaded Asia Minor; they fought naked, a point observed and approved by the Greeks. (Rome, Terme)

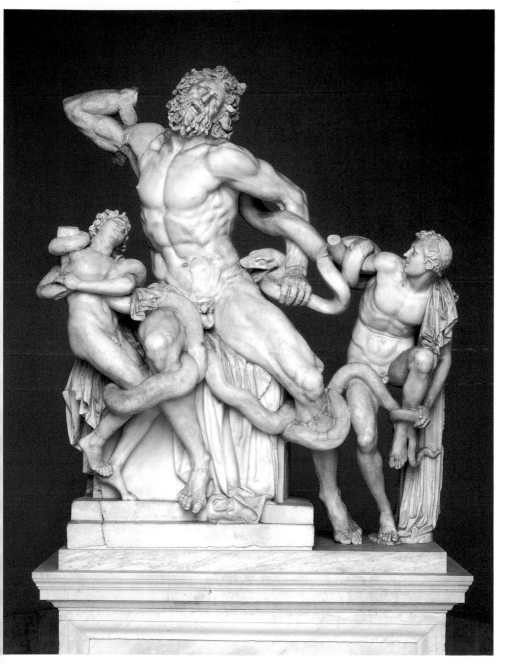

222 Laocoon, priest of Troy, with his two sons struggling against the serpents sent by Apollo. The group is that seen by Pliny who names the three Rhodian artists. These are now known to be copyists of the 1st century BC, here copying an original of the 3rd/2nd century BC. Height 2.4 m. (Vatican 1059)

In the Hellenistic period we are happily able to deal still with a large proportion of original works of sculpture rather than Roman copies, but the range of surviving work is not great – so much was soon removed or overthrown – and we are bound to turn to copies for the full picture. Indeed, the practice of copying Classical works began in the Late Hellenistic period and became a leading characteristic of the late Hellenistic view of art. But classicizing was no major concern. The only step an artist could take beyond sheer idealized realism was to elaborate it for dramatic effect, and to dwell on the particular rather than the general, in other words, through expression of emotion and mood, and with a more lifelike treatment of portraiture, though not quite warts-and-all.

Pergamum, whose architecture has already occupied us, is also the source of some notable statuary, and, it seems, was the seat of an important and distinctive school. On the Great Altar of Zeus King Eumenes II (reigned 197–159 BC) had carved a colossal encircling frieze representing the battle of gods and giants [*219, 220*]. The action virtually seethes around the monument with the figures climbing and crawling up the steps leading on to the sacrificial platform. The fullest dramatic use is made of swirling drapery, but the main force is lent by the vigorous carving of muscles and the writhing, tense bodies. If this alone were not enough to convey the horror of the struggle the faces too were carved with expressions of extreme anguish. This work shows the Pergamene style at its most intense and offers us the full measure of the difference between the approaches of the Hellenistic sculptor and that of his still Classical, 4th-century predecessor. The antecedents of this mature style can be traced at Pergamum in the 3rd-century dedications (by Attalus I; reigned 241–197 BC) celebrating the victories over Gauls. One series includes the group of a Gaul and his wife [*221*], and the famous Dying Gaul (long miscalled the Dying Gladiator). The other, dedicated in Athens, is of smaller figures of Greeks and Amazons, Athenians and Persians, gods and giants, and Gauls. Both are known only in copies. The dramatic qualities of the later Pergamum Altar are seen already here, together with studies in exhaustion or despair which are not so highly stressed, and so look back to the art of the 4th-century Athenian gravestones. These figures and groups are impeccably designed in the round, and offer many viewpoints. The closely related

223 Figures of an Athenian couple, Cleopatra and Dioscurides, from their house on Delos. 138/7 BC. Height 1.67 m

224 Statue of a boy dressed in a short cloak, perhaps an athlete (boxer?; his ears are bruised) leaning against one of the track turning-posts. From Tralles in Caria. 2nd century BC (perhaps a copy). Height 1.47 m. (Istanbul 542)

Laocoon group [*222*], now seen to be one of the most famous copies of an original work of the Hellenistic period, was designed for a single viewpoint and reproduces all the expressive modelling and anguish of features seen on the altar.

Introducing Hellenistic sculpture with the Pergamene style highlights the contrast with what went before, but does little justice to the continuing Classical tradition in the treatment of features and drapery which can be observed in the work of other cities [*223*]. This seems left to the schools of Alexandria, Rhodes and mainland Greece, but definition of the styles of these regional schools is not at all clear-cut. The all-round viewpoints for free-standing statues, which Lysippus had

227

225 The Venus de Milo. 2nd-century BC version of the type devised in the 4th century, with a more relaxed, twisting pose. She was found on Melos in 1820. Height 1.8 m. (Louvre 399/400)

226 The Victory from Samothrace (a north Aegean island) alighting on the forepart of a ship. She was set in the upper basin of a fountain to commemorate a sea victory. Early 2nd century BC. Height 2.45 m. (Louvre MA 2369)

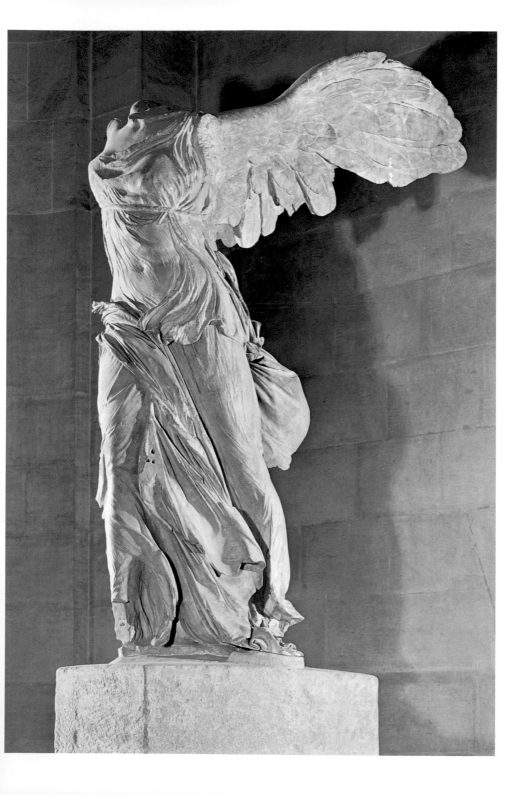

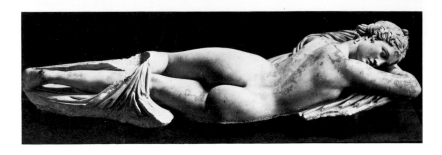

introduced, were achieved by the design of dress with folds running counter to folds, even seen through upper garments as though they were transparent, and by twisting poses which seem to force the spectator to move around the statue. Drapery can even be used to express mood, from the swirling folds of fighting groups, or even flying figures [226], to the quiet foldless dress of more reflective subjects, like the boy from Tralles [224]. Sheer size was appreciated as never before, and new skills in bronze-casting made possible works like the colossal statue of Apollo at Rhodes (*the* Colossus), thirty metres high. It fell in an earthquake, just over fifty years after its erection in the early 3rd century. More than a millennium later it took a train of one thousand camels to carry off the scrap metal.

Nude studies of male figures remained the norm for heroes, gods, and even distinguished mortals, but the female nude had also become a very common subject. Praxiteles' Aphrodite was famous enough, but the Hellenistic figures with their slim and sloping shoulders, tiny breasts

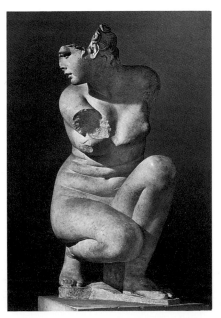

227 (*Above*) Copy of a 3rd/2nd-century BC statue of a sleeping Hermaphrodite. Apart from the boyish hips and genitals the forms of the body are mainly feminine. Length 1.47 m. (Rome, Terme 593)

228 Copy of the 3rd-century statue of Aphrodite crouching at her bath. Height 1.07 m. (Rome, Terme 108597)

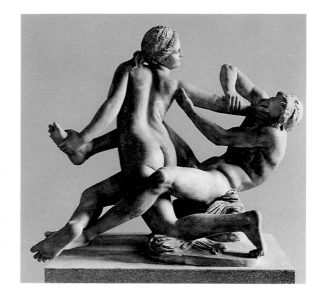

229 Copy of a 3rd/2nd-century BC group showing an Hermaphrodite rebuffing a satyr. Height 91 cm. (Dresden)

230 (*Below*) Copy of a group of about 200 BC showing the blinding of Polyphemos, made in the 1st century BC and later placed in a grotto dining room at Sperlonga (south of Rome). Width of whole group about 9 m. (Sperlonga)

and swelling hips are almost aggressively feminine. The softer model-ling, blurring details, such as seems to have been introduced by Praxiteles, is carried further in these new studies of femininity. The Cnidian Aphrodite was often copied but there are new poses now, notably of the goddess crouching at her bath [228]. In the Venus de Milo [225], the new, restless spiral composition is expressed vividly in a variant on the old pose. The hermaphrodite figures offer a mean between the current fashions in male and female physique [227, cf. 229].

We have so far dealt mainly with single-figure studies but far more characteristic of the age are the groups – narrative groups we might almost call them – which tell a story and study the emotions of the pro-

231 Bronze statue of a seated boxer. The brutalized features, bruised ears and broken nose are carefully observed. Over lifesize. (Rome, Terme 1055)

232 The Barberini Faun, a sleeping satyr. Copy of a statue of about 200 BC found in the Castel S. Angelo in Rome and partially restored by Bernini. Height 2.1 m. (Munich 218)

233 Copy of a 3rd-century BC portrait of the philosopher Epicurus. Height 40.5 cm. (New York 1911.90)

tagonists. The Gauls and Laocoon [221, 222] are examples. A massive Hellenistic group showing Odysseus and his companions blinding the giant Polyphemos was copied for the grotto dining room of a Roman villa at Sperlonga [230]. The silen Marsyas, bound to a tree, waits help-lessly to be flayed by the brutish slave who sharpens his knife, watched by a bored Apollo; rough Pan teaches young Olympus how to play his pipes; an hermaphrodite wriggles free from a satyr [229]. The realism of expression and emotion seen in Pergamene sculpture has its counter-part in the characterization of over-developed athleticism [231], wasting old age (the drunken woman in Munich or the Louvre fisherman) and – at last – good child studies (the boy and goose, Erotes). The sleeping satyr in Munich is a fine study of abandon and exhaustion [232]. Its massive musculature, like that of the famous Belvedere torso, reminds us of Michelangelo, and both these works were indeed known to Renaissance sculptors. The satyr reminds us too of the great popularity now of a wide variety of Dionysiac subjects in all media.

Portraiture is very much in the spirit of the age, heralded by Alexander's appointment of Lysippus as official Court Artist. Portraits

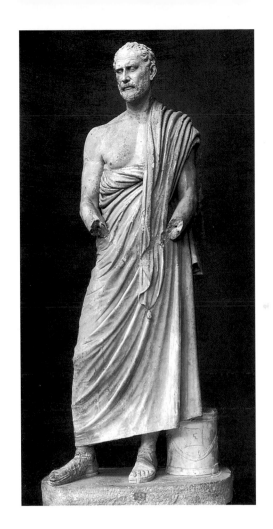

234 Copy of the portrait statue of the
Athenian orator and statesman
Demosthenes, made by Polyeuktos about
280 BC (forty years after Demosthenes'
death) to stand in the Athenian *agora*. The
hands were clasped. Height 2.07 m. (Vatican)

of poets, philosophers and statesmen remain largely character studies
[*233*]. The treatment of the whole figure plays its part in the character-
ization, even of contemporaries – the statesman Demosthenes in
pensive mood [*234*], obese seated philosophers, surly extrovert athletic
rulers. We do not know who the figure in [*235*] was, but may doubt
whether he often appeared naked in public. The unruly hair, heavy fur-
rowed brow and disdainful mouth are abetted by the massive and
proudly displayed body in a study of princely arrogance. This attention
to the character of the sitter, making a portrait a compromise between

235

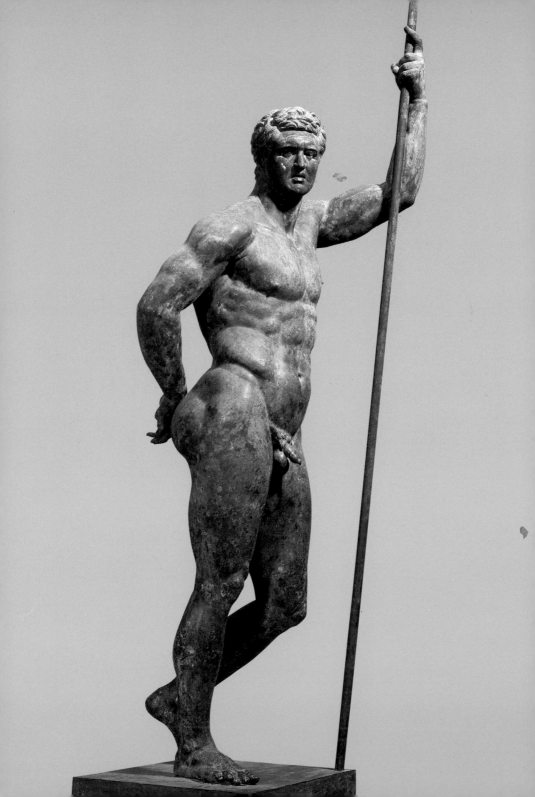

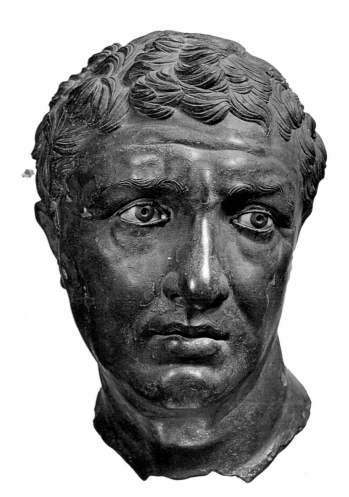

235 Bronze portrait statue of a Hellenistic prince. 2nd century BC. Lifesize. (Rome, Terme 1049)

236 Bronze portrait statue of a man from Delos. About 100 BC. Height 33 cm. (Athens 14612)

realism and an idealized study of statesmanship or intellectual or physical power is the hallmark of the Greek portrait [*236*]; beside them many portraits of the Roman period are more like effigies.

The fine series of Athenian gravestones had been stopped by an anti-luxury decree passed by Demetrius of Phaleron, who governed Athens between 317 and 307 BC. We look now rather to marble sarcophagi, generally made in the eastern Hellenistic kingdoms, on which whole friezes or single figures are shown in an architectural setting. The genre seems to begin in the 5th century with works commissioned from Greek artists by the Phoenician kings of Sidon, still under the Persian

237

237 The Alexander Sarcophagus from the Phoenician royal cemetery at Sidon. The sides are decorated with hunting scenes, including the figure of Alexander, and a fight of Greeks and Persians (shown here). Colours are unusually well preserved. About 315 BC. Height 1.95 m. (Istanbul 370)

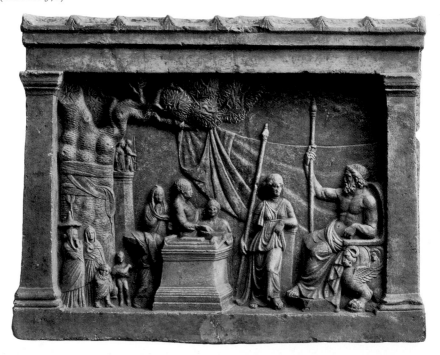

238 Votive relief showing a sacrifice in a rural shrine. A hero and his consort at the right, before an altar approached by worshippers. The tree supports an awning; beside it statues of Apollo and Artemis on a pillar. From near Corinth. 3rd century BC. Height 61 cm. (Munich 206)

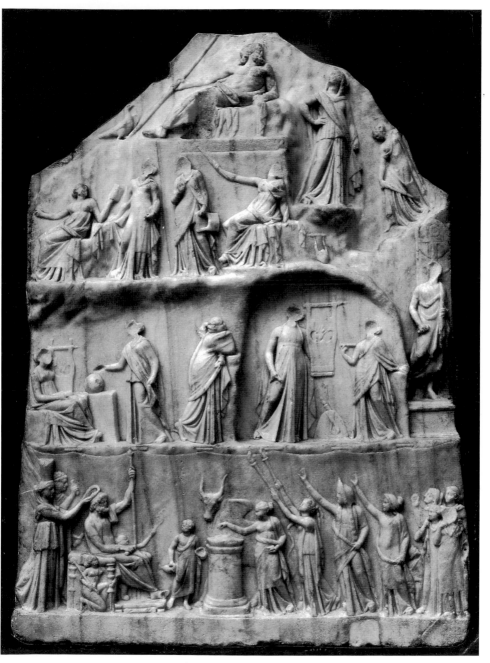

239 Votive relief made by Archelaos of Priene, showing the deification of Homer, being crowned below left, greeted by actors and others. Above are the Muses and other gods; at the right a statue of a poet, possibly Apollonius, writer of the *Argonautica*. 2nd century BC. Height 1.18 m. (London 2191)

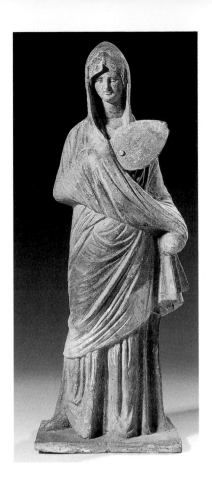

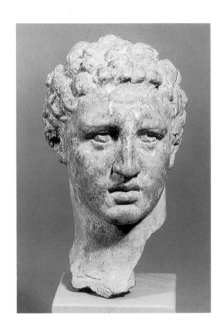

240 (*Left*) Clay figure of a woman from Boeotia (Tanagra). Her cloak is coloured blue. Height 32 cm. (Louvre S 1633bis)

241 (*Above*) Gilt clay head from a statuette. From Smyrna. Height 12 cm. (Oxford 1911.8)

Empire. The latest of these, the so-called Alexander Sarcophagus [*237*], keeps close to the architectural reliefs of earlier years. The tradition of the Classical gravestone with relief figures is continued only in East Greece, but there are many new varieties of votive relief being made [*239*], including a common type showing the deity, or more often hero, approached by a family or worshippers shown on a smaller scale. Some of these reliefs admit landscape elements and attempts at perspective by reducing the height of figures – features borrowed, not usually with great success, from contemporary painting [*238*]. The arabesques which decorate architectural members and smaller marble objects like funeral vases, and the friezes of heavy floral swags on altars and walls represent the last stage in the development of the old Orientalizing florals, but the

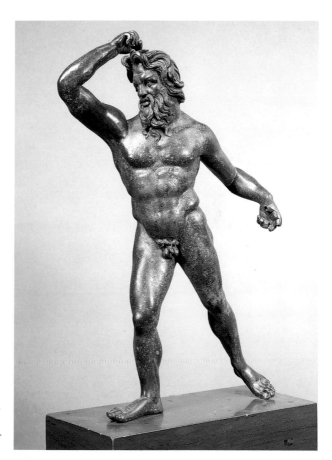

242 Bronze statuette of a god, probably Poseidon striking with his trident. The eyeballs were inlaid silver, the nipples copper. 2nd century BC. Height 25.5 cm. (Louvre MND 2014)

4th century had already introduced new floral fantasies which were to be influential.

STATUETTES

The small clay and bronze figures of the Hellenistic period offer many ambitious and original compositions. In clay the use of the mould, or of several moulds combined, lent greater variety to what had become a rather repetitive and trivial art form. The model girls of the so-called Tanagra figurines are deliberate essays in prettiness with their mannered pose and coy charm [240]. It is little wonder that they won immense popularity in the last century and that they were widely (and skilfully)

241

forged or mocked up, with their bright colours restored to them, for the collector's cabinet. They are named after the site in Boeotia where they were first found, but the style is common to all parts of the Greek world, with important schools in South Italy and Asia Minor. The South Italian schools had always been active and original centres for the production of terracotta figures and plaques. In Asia Minor, though, it is the example of the new Hellenistic capitals and their art which probably inspired the new activity. One important class of figurines of gilded clay, well known in examples from Smyrna, was inspired by types of

243 Bronze statuette of a naked woman from Verroia in Macedonia. 3rd century BC. Height 25.5 cm. (Munich 3669)

244 Bronze statuette of a negro boy singing to the music of an instrument now missing from his right hand. 2nd century BC. Height 20.2 cm. (Paris, BN 1009)

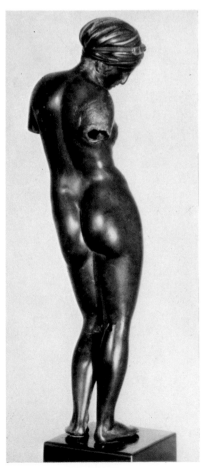
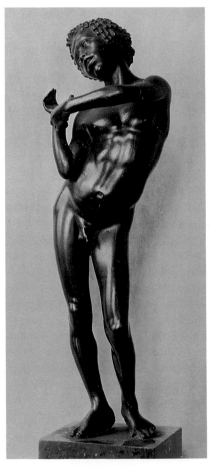

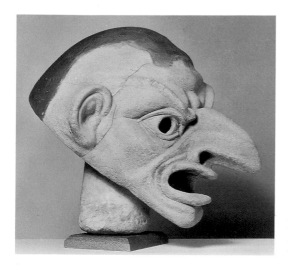

245 Clay mask of a grotesque head from Tarentum. 2nd century BC. Height 26.5 cm. (Taranto 20068)

major sculpture [*241*]. But these, and many bronze statuettes, whether of deities or mortals [*242, 243*], are often more than just reduced versions of larger works.

The realism of major sculpture is reflected in miniature in the studies of the grotesque or deformed [*245*], and the semi-portrait studies of non-Greeks. Alexandria was a meeting-place of the races, and the Macedonian conquests in the East had offered the artists even more opportunity to reflect on the un-Greekness of the foreigner, in looks at least. Hellenistic (Ptolemaic) Egypt has yielded engaging clay studies of typically foreign faces – Scythians, Persians, Semites, Indians, negroes. The negro head had occupied the Greek artist in the Archaic period, and he continued to use negroid features to depict any African [*195*]. There were no doubt more dark-skinned slaves in Hellenistic Greece, and we find more sympathetic treatment of negro slaves and entertainers in the clay figurines and bronzes of the period [*244*].

PLATE AND JEWELLERY

Decorative metalwork was applied to the same objects as hitherto: vases, mirrors, boxes [*246*]. Precious metals suited kings, and the Eastern victories and loot had provided new sources. Relief cups, including animal-head vases, are well represented. Shapes betray an element of

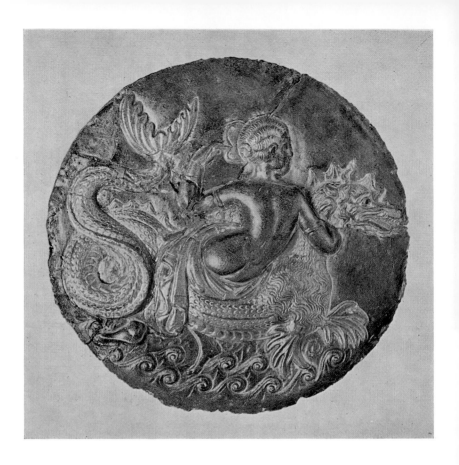

Eastern taste in the preference for round-bottomed cups decorated with a wide range of floral ornament [250]. The cups and dishes continued to carry figure scenes in high relief [251] and the line is hard to draw in date and style between those made in the late Hellenistic cities of Greece and those answering the demands of the new rulers in Rome and its provinces. All were likely to be the work of Greeks, at any rate. South Italy was a busy source, and others served princes on the periphery of the Greek world, in Thrace [249] and Scythia.

In jewellery colour became more important, and inlays in glass, enamel or semi-precious stones far more common. Our main sources are the princely tombs of north Greece and south Russia. A new belt form, with a false clasp like a reef-knot, became a popular feature [247], and the new earrings were plump crescents with human or animal heads

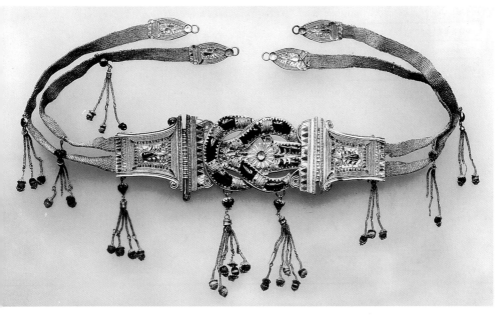

246 (*Left*) Lid of a gilt silver box, with a nymph riding a sea-monster (*ketos*), found near Tarentum. Late 2nd century BC. Diameter 10 cm. (Taranto 22429)

247 (*Above*) Gold diadem from Thessaly with a 'Heracles knot' at the centre, inlaid with garnets. 2nd century BC. Length 51 cm. (Athens, Benaki)

248 (*Below*) Gold oak wreath from the Dardanelles. There is a cicada among the leaves at either side, and a bee on the clasp, centre below. 350–300 BC. Diameter 23 cm. (London 1908.4–14.1)

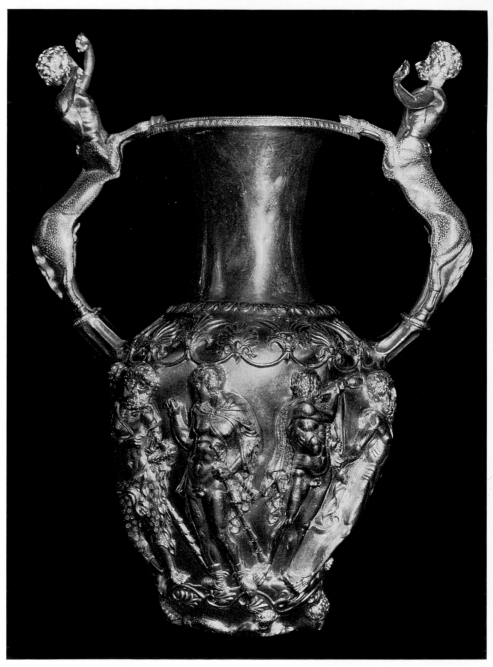

249 Gold *amphora* with figures of centaurs as handles, and an unidentified attack shown on the body. The shape derives from Persian forms, the subjects are Greek. From a rich find of gold vessels at Panagurishte in Bulgaria. Probably 3rd century B C. Height 29 cm. (Plovdiv)

250 Silver cup decorated with florals in high relief. 2nd century BC. Height 7.6 cm. (Toledo 75.11)

251 Silver dish with relief scene of a satyr attacking a nymph at a fountain. 2nd century BC. Diameter 15.6 cm. (Toledo)

as terminals. Gold funeral wreaths reproduced the forms of oak and laurel leaves with startling virtuosity [248]. Finger-rings acquired big round bezels and bulky hoops but with diminished figure intaglios.

CLAY VASES

The art of the vase painter went into a rapid decline at the end of the 4th century BC, but the more simply decorated wares persisted in the Greek East, and some classes, like the Hadra funeral vases found in Egypt (but whose source was in Crete), offer a lively variety of floral and animal decoration [254]. Only among some of the Italian schools do we find a polychrome style of painting [253], usually over the black paint covering the vase, which approximates to the new realistic styles of major painting, with their greater command of colour, shading and high lights [252]. Plain black vases, sometimes metallic in their shapes and in the bright gloss of the paint, had been increasingly popular in the 4th century. The paint, often miscalled a glaze, is in fact a clay preparation which will fire to a permanent black gloss if the atmosphere of the kiln is changed from oxidizing to reducing, and then back again. The

252 Interior of a cup from Vulci showing a boy relaxing with a wine flask, his throwing stick at his knee. The drawing, with shading and high lights, reflects major painting. Made in Etruria (the Hesse Group). 3rd century BC. (von Hessen Coll.)

technique of this painting has only in recent years been rediscovered. Wedgwood sought it without success, then turned to imitating the easier dull black *bucchero* of Etruria, and making relief vases, the technique of which is also Hellenistic in origin.

Where before the black vases carried slight impressed or applied decoration there may now be white-painted floral patterns, as on the Gnathia vases from Italy, or scrolls picked out in low applied relief (West Slope Ware). This was a style of decoration which must have been copied directly from the more expensive metal vases, and an even more direct influence from this source can be seen in the so-called Megarian Bowls (but made in all parts of the Greek world). These are hemispherical cups, made in a mould and painted black or brown, with low-relief patterns of florals and figures [255], very similar to metal and glazed cups found in Egypt. Rarely, on the Homeric Bowls, we see elaborately composed mythological scenes. The decoration was generally composed only in applied vignettes of figures or groups in floral settings. The type and technique were copied in the Roman period on the Arretine and Samian bowls of red ware.

248

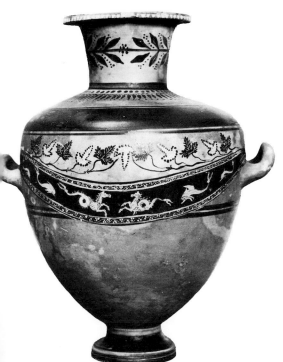

253 A plate showing a battle elephant, rendered in added colour, not red figure. From Capena. 3rd century BC. Diameter 29.5 cm. (Rome, Villa Giulia 23949)

254 (*Left*) A clay *hydria* from Arsinoe in Cyprus, of a type most familiar in the Ptolemaic (Hadra) cemeteries of Alexandria. 3rd century BC. Height 37.5 cm. (Brussels A 13)

255 (*Above*) Clay relief bowl (so-called Megarian). Applied relief motifs include goats at a *crater*, a Triton and a nymph riding a lion. 2nd century BC. Height 9 cm. (London 1902.12.–18.4)

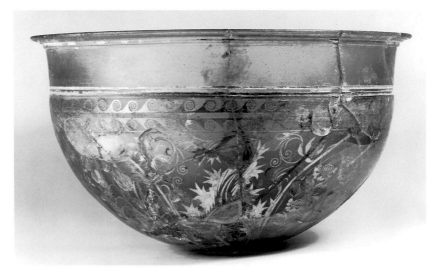

256 Clear glass bowl with a gold leaf decoration of florals; compare the cloth [*192*]. From Canosa in South Italy. About 200 BC. Height 11.4 cm. (London 1871.5–18.2)

OTHER ARTS

In the Archaic and Classical periods Eastern and Egyptian techniques were practised in Greece to produce opaque, coloured glass, used for small flasks or decorative inlays, moulded, cut or built up in coils. Only towards the end of the Hellenistic period were the techniques of blowing glass learned. It becomes a luxury craft with gilt [*256*] or cut decoration and considerable colour variety, but the full potential is only achieved under Rome.

Moulded glass intaglios are found also, set in metal finger-rings. The earlier types of engraved gems, set in swivels or worn as pendants, gave place wholly now to stones set in rings. The subjects tended to be less varied: portraits, studies of deities, standing figures in relaxed poses [*258*] – far less narrative; but the high technical skills are no less apparent. Later there was brisker production of smaller ringstones, often with trivial subjects, of a type which goes on being made through the early Roman period. At the same time a new type of gem-cutting was practised – that of the cameo. Stones with multi-coloured layers (onyx, readily imitated in glass) were cut in relief so that different colours are picked out

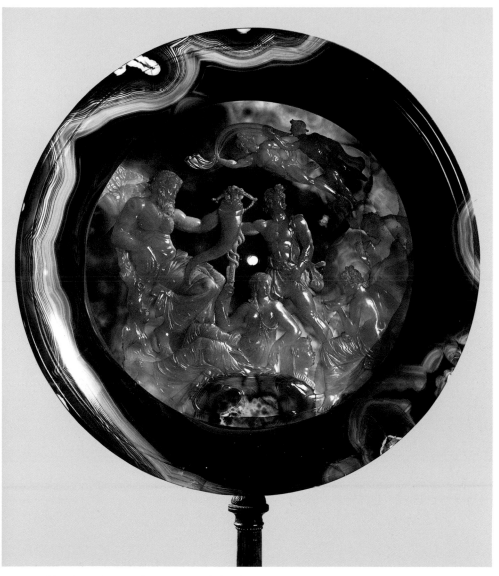

257 The Tazza Farnese. A cameo-cut dish of banded sardonyx, probably made for a Ptolemaic prince, with an unexplained subject in an Egyptian setting (notice the sphinx, below). 1st century BC. Diameter 20 cm. (Naples 27611)

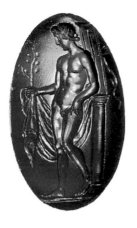

258 Cornelian ringstone. Apollo with laurel branch leans against a pillar supporting a tripod. 3rd century BC. Height 2 cm. (Once London, Ionides Coll.)

259 (*Below*) Silver coins with portrait heads of Mithradates III of Pontus (died about 135 BC) and Arsinoe III of Egypt (died about 204 BC)

in different strata, generally pale figures against a dark background. The cameos were set in rings or pendants. On a larger scale the same technique was used in the great Tazza Farnese [257], probably a treasure of the Alexandrian court. In the cognate art of the engraver of coin dies it was also in the field of portraiture that the masterpieces are found [259]. Where before the idealized features of a god or local deity graced a city's coins, there are now portrait heads of princes and their families – a tacit comment on the decline of the city-state and forms of democracy – and a fashion which has persisted, even for many republics, to the present day.

Original evidence for wall-painting is as scanty as it was for earlier periods, and what has survived in the way of major painting is usually second rate, or, we may suspect, untypical. Again, many of the wall-paintings in Roman houses must reflect Hellenistic originals, but the nearest we come to their sure handling of light and shade is on a few painted tombstones from the Hellenistic cemetery at Pagasai (modern Volo), or in the painting which decorated the interiors and sometimes the façades of the Macedonian chamber tombs [260, compare 189, 191]. Here we can recognize a style of painting which might pass as modern beside the earlier Classical outline-drawn figures with their flat washes and rudimentary indications of depth. It makes us yet more conscious of our loss of Classical originals.

There are other sources from which we may get some idea of the appearance of ancient painting. There is polychrome painting on some clay vases of South Italy and Sicily, while some gravestones in Chios [263] and Boeotia continue an earlier, Classical tradition, with designs outlined on the polished stone against a roughened background. Colour must certainly have been applied to these stones, though it is still not clear with what effect. We find on them hunting scenes and some engaging still life.

The school of Sicyonian painters had been influential, and to the 4th-century Pausias might be attributed the invention of intricate floral and leaf patterns which became an important element of decoration in all media [as 192, 209, 250]. It is perhaps no accident that Sicyon was also Lysippus' home-town. The Ionian Apelles had studied at Sicyon. He was Alexander's Court Painter, famous for his portraits and Aphrodites. Of his work, and that of his fellows, who are often associated with famous sculptors of the day, we can only guess from the accounts and descriptions of ancient authors. But we may be sure that it was they who evolved the brilliant techniques which inform the Pompeian paintings. One major innovation, presaged in the frieze that decorated the tomb of Alexander's father at Vergina in the mid-4th century [191], is the use of landscape for the setting of figures in action. At Vergina it was the forest setting for a hunt, elsewhere it was no more than a garden or sanctuary setting such as we see also on reliefs. Eventually the landscape can dominate the figures though we have to judge this from Roman period copies in paint or mosaic of presumed Hellenistic originals [264]. Before

260 The figure of a Judge of the Dead, Rhadamanthys, painted on the façade of a Macedonian tomb at Lefkadia. Other figures were of another Judge, Hermes and the dead man. Early 3rd century BC. Height of figure about 1.1 m

261 Pebble mosaic from Pella in Macedonia, Alexander's capital. A stag hunt, signed by the artist Gnosis, probably copying a painting. The painter Apelles had visited and worked in Pella. About 300 BC. Height 3.1 m. (Pella)

262 Detail from the Alexander Mosaic, made to be placed in a house at Pompeii about 100 BC, copying a Greek painting of about 300 BC. Alexander is charging the Persian king Darius at the Battle of Issus. Height of detail about 60 cm. (Naples)

this Greek pictorial art displayed very little sense of composition in space, especially when compared with the arts of Egypt and the East. Appreciation of the natural, non-animal world, came late. The prime interest was in the presentation and interaction of live forms and much was dictated by the field to be decorated – panel, frieze or tondo – and by purpose, which was generally best served by figures not settings.

Mosaic copies may also bring us close to other types of Hellenistic painting. In the capital of Alexander's successors in Macedon, at Pella, there are mosaics in the old style, with coloured pebbles, and the linear quality of the figures is enhanced by the lead and clay strips outlining some of them [261]. Battle paintings had been popular since Polygnotus' and Mikon's Marathon at Athens in the 5th century, and Euphranor's Mantinea in the 4th. The Alexander Mosaic at Pompeii [262] had translated a wall painting into a floor mosaic. It depicts Alexander's victory at Issus, the young king storming against the Persian Darius, already being cut off by the Macedonians and Greeks whose long spears are

263 Gravestone of Metrodorus from Chios. The top frieze has musical sirens; the next a fight with centaurs; the bottom one, chariots. In the main panel an athlete's strigil, sponge and flask hang beside a column supporting a prize vase; at the left his clothes hang over another column. The incised figures stand out against the roughened background. 3rd century BC. Height 89.5 cm. (Berlin 766A)

264 (*Right*) Painting from a house on the Esquiline Hill in Rome. A copy of a late Hellenistic painting with a landscape setting for a scene from the *Odyssey*: Laestrygonians attack Odysseus' men. Height 1.16 m. (Vatican)

seen passing across the background. Bold foreshortening and skilful use of highlights and reflection lend depth to the complicated but brilliantly lucid composition. In this mosaic the tiny cubes (*tesserae*) are of stone and coloured glass, a technique probably introduced in the 3rd century. The original painting may have been of the late 4th century. The limitations of this technique and the few colours used do not conceal the promise these works hold of later achievements in painting and mosaic.

'Then art stopped', said the Roman author Pliny, but he was referring to the beginnning of the Hellenistic period and had something else in mind. Greek art did not stop. Once Greece fell within the Roman Empire Greek artists worked for Romans in Italy, and were no less busy in the old Hellenistic kingdoms and Greece itself. Hellenistic flair ended in styles nostalgic for the Classical past, and under Rome, east or west, novelty no longer lay in design but in the uses to which versions of the basic classical style might be put. If no glimmer of the Classical spirit seemed to have survived, this was as much the fault of Greek artists as of Roman patrons. There was to be much still essentially Greek in inspiration, and certainly appearance, throughout the Empire and beyond it, but an account of this is not for this book.

Greek Art and the Greeks

We look at Greek art in museums and galleries where it is displayed in the same manner as are most western arts from Renaissance to modern. But the majority (not all) of the latter were designed for such display, isolated in frame or case to be admired individually, even as Art for Art's sake. This was not true of ancient Greek art which had a function and a live context, and although we may derive some satisfaction from viewing a Greek vase or sculpture as we might a Titian or Maillol, we are as far as we can be from seeing it as it was intended. And if we value our appreciation of Greek art as a complement to all else that we have learned about the Greeks from their literature, and wish to measure it against the achievements of other cultures, it is surely worth the effort of trying to see it in ancient terms, whether of the artist and writer, or the reader and spectator. Even Greek architecture is divorced from the reality of antiquity by being viewed in dignified or picturesque ruin, although *in situ*: Roman is often better preserved, or remains in an urban setting, and there is always Pompeii. I have made observations in earlier chapters about this virtually archaeological problem – of divorcing statues from their original setting, of forgetting all the colour, of ignoring the intention and function, but there is a social problem too. For an urban or sanctuary setting we would need to add other ingredients, crowds of people who were not art tourists, the noise, not least the smell. But the visual experience of the ancient Greek may not be totally beyond our powers of imagination, given our other sources of evidence for the nature of Greek society and its history. A reflection on the very different role of Art in our own lives may be illuminating. The art of modern galleries may be for the rich or the thoughtful, and although the subject matter (if any) may relate directly to our experience, it is viewed in scrupulous isolation from it, and a great deal depends upon its historical, educative, sometimes pecuniary appeal. In daily life we are conditioned to an art of symbols (road signs, etc.) and a figurative art that is descriptive or persuasive (advertising), or humorous (cartoon and caricature), spoilt by our easy access to the realistic images of people and

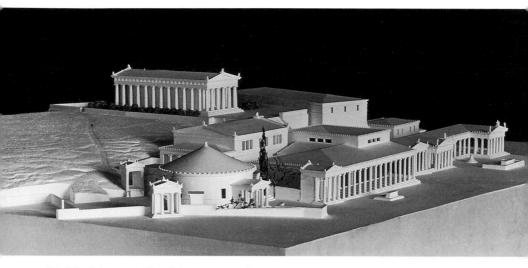

265 Model of the west side of the *agora* at Athens, mainly of the late Classical and Hellenistic period. The Doric temple of Hephaistos stands on the hill behind. The other, civic, buildings employ the canonic architectural orders with various plans. The round building (Tholos) is a magistrates' club house; behind it is the Council House (like a small enclosed theatre) in front of which is the Metroon with a colonnade façade leading to a temple and state archives. Beyond is a little temple of Apollo, then the Stoa of Zeus, with projecting wings, the office of the magistrate in charge of cults. (Agora)

action afforded by film. Otherwise we are constantly aware of an art of Design in everyday objects, and except where the artist abets education or satire, there are few serious messages and a lot of entertainment. The most general message is about wealth and status, reflected in buildings, what we wear, what we use. Walk down a street and think what art there is in it and what its function may be — intended or effective.

The man in a Greek street had a very different visual experience. Our clothes reflect our wealth and status and some aspire to art or fine craftsmanship (or they used to); in antiquity there was a uniformity of dress, usually untailored and so made distinctive through colour or pattern rather than cut or material. Jewellery seems not to have been worn every day. Then turn from the people to the urban environment, where much must have depended on period and place. The shape of many Greek cities was determined by the presence of a defensible acropolis, which may have been conspicuous, as in Athens or Corinth, or the

placing of a harbour or anchorage. In the older cities layout was irreg-
ular and only with time did open areas such as the *agora* acquire a degree
of order [*265*], although this often went little beyond rather mechanical
rectangularity. City vistas were not deliberately created. Rectangular,
grid layouts were known from the 8th century on (Old Smyrna) and
introduced in some new colonial foundations. At the end of the 5th
century Hippodamus introduced more sophistication by allocation of
groups of blocks to civic and divine buildings, but it seems to have been
by their size rather than deliberately created architectural approaches
that these buildings made their mark, and this is true of both remod-
elled cities and new foundations [*266*].

Independent sanctuaries were not much better, determined by the
placing of temple and altar and by the processional way [*268*]. During
their elaboration in the Classical period planned view lines may have
been determined here and there, or architectural counterpoints, as in
the Propylaea–Erechtheion–Parthenon at Athens, but most seem fortu-
itous. Landscape had sometimes helped to determine the placing of a

266 Reconstruction (by A. Zippelius) of the new city of Priene, laid out in the later 4th
century BC, showing the grid plan with open civic areas, the acropolis rising behind

267 A view of the sanctuary of Apollo at Delphi, looking down from the slopes of Mount Parnassus towards the Gulf of Corinth

sanctuary, as at Delphi [267], but seems not to have been any more exploited by architects than it had been by artists, while garden planning was rudimentary – parallel lines of trees beside the Hephaisteion at Athens. With the Hellenistic period new city plans (Pergamum) and sanctuaries (of Asclepius on Cos or at Lindos on Rhodes nearby [269]) aspire to grander schemes, even to rising symmetrical layouts which might owe something to the example of Eastern or Egyptian palaces and temples. But the Greek in the street was not as constantly aware of the architectural excellences of his home as, for instance, the Parisian or New Yorker; more like the resident of suburbs of Florence or Delhi.

The architectural decoration apparent on the monumental buildings, and no doubt in simpler, often wooden forms on lesser structures, was

268 Model of the sanctuary of Zeus at Olympia. The central square held the new (left) and old temples of Zeus; the round building was for the statues of the Macedonian royal family (Philippeum). Outside are offices, hotels and gymnasia. At the right, a row of Treasuries overlooks the approach, bottom right, to the start of the Stadium. (Olympia)

269 Model of the acropolis at Lindos on Rhodes, standing on a high promontory overlooking the sea, mainly as laid out in the Hellenistic period. A broad stoa and Propylaea lead to the relatively small Temple of Athena at the top. (Copenhagen)

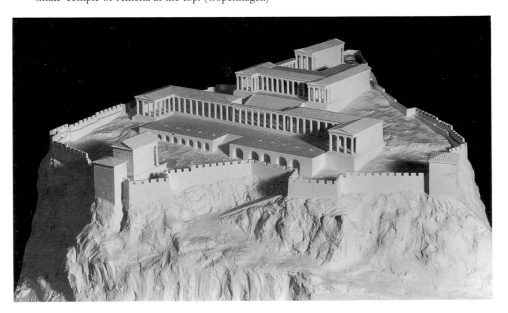

determined by the classical orders, and after the Archaic period these changed very little except in the detail explored by archaeologists. We are used to the classical orders on banks and public buildings, but they are not, thankfully, universal. Classicism commonly means uniformity and this is something again unfamiliar in most of the modern western world. Even in other arts and crafts, which we have yet to consider in this context, there was an overall uniformity of style despite medium or scale, which we would find taxing, even boring: like living in a whole town, not just a house, of post-modern or Art Nouveau design. The application of the canonic orders to structures of different sizes and purpose, or, to turn to other arts, devotion to realistic representation of all human and animal forms, may to some degree seem to impoverish the potential for artistic diversity which we appreciate in other cultures and in our own. It at least provided a unified prospect for a spectator who was always at home with it. This may be a factor in any classical art's durability and potential for ready transmission outside the environment in which it was created.

With the uniformity went a high quality of finish apparent in most of the arts that have survived. Exceptions are things like mass-produced clay figures or the feebler black figure vases, and there was no doubt more, but there is nothing shoddy about even very cheap Greek clay cups, and each period and craft seemed able to achieve the best of what its materials and techniques allowed. Nowadays we would attribute this to a natural sense for design and workmanship, qualities we might look for in modern Italy rather than Greece or anywhere nearer home. It was something to which the Greek was, it seems, acclimatized and which he might expect.

Today we are well aware of the past or past styles around us – Gothic, Georgian, Victorian. It is not clear whether the average classical Greek had as much of an eye for the truly primitive in what he saw as did later commentators and guides to classical sites. The Archaic style was unmistakably different from the Classical without being wholly foreign, and Archaic buildings and sculpture remained visible; even something of the Greek Bronze Age was still visible, mainly in stray finds, but sometimes in architecture as at Mycenae [12] or the Athenian Acropolis' own pre-Persian walls. Neither nostalgia nor any positive aesthetic choice may have played a major role in the record of persistent archaism through the Classical period. It was never an important factor and can often be explained in terms of religious conservatism. On vases it led to an odd

form of mannerism where style became almost more important than subject. It is easy to draw the line between simply continuing in an old idiom for a century after it had been replaced, and conscious copying of the Archaic style. Archaizing becomes more deliberate with the late Hellenistic period [270], too far removed from the ethos of the original to be plausible. But in both cases it either answered a demand or at least found an appreciative if limited market. A renewed interest in pure Classicism in the later Hellenistic period (neo-Attic) is a different matter, no little encouraged by the market provided by acquisitive Romans and decidedly élitist.

It is doubtful whether many Greeks valued their antiquities, rather than that reassuring homogeneity of classical form that surrounded them. In their literature and religion their past was all-important, but this was not expressed in their art with any attempt at archaeological accuracy. Collecting or creating relics for temples (the Gorgon's tooth, Heracles' shield, heroes' bones) had a certain appeal or was politically expedient, and led to the creation of what amount to the first histori-cal museums in the modern sense (not art galleries), but in representa-tions of the past dress and objects were never anachronistic. So even in the message-laden images of Greek myth-history the classical Greek always viewed the stories in modern dress. This must have reinforced the immediacy of those messages: the problems of an Achilles or Antigone look more relevant when the figures are not dressed up as antique, whether on stage or in art. The Greeks' more recent history was brought to their eyes by trophies and the dedicated armour of enemies in sanctuaries.

At home, in the street, in sanctuaries, cemeteries and public build-ings, the Greek was incessantly reminded of figurative arts. They were not purely decorative, although often the significance of choice of subject may have been forgotten or was too trivial to puzzle the passer-by. Archaic statues confronted the viewer and sometimes addressed him in an inscription cut on the base or the figure itself. Later statues were generally more detached, but more thought-provoking. Even pots could carry mottoes proclaiming handsome youths (*kaloi*) regardless of the figure scene in which they were inscribed. There seems to have been a constant challenge to understand, to share. Art was a means of communication, at all levels from the moral and political to the appropriately entertaining, far more effective than word of mouth or writing. Literacy was not high, books and scripts few and not easy to

270 Archaizing relief showing Dionysus with three Seasons (*Horai*). 1st century BC. Height 32 cm. (Louvre MA 968)

come by, and recited scripts, in rhapsode performances or on the stage, were mostly one-off affairs and not to be lingered over by other than a small intelligentsia of other writers. Watching five or more plays in one day, over several days, at the main dramatic festival, was no way for the ordinary Greek (including artists) to inform himself in detail about new plots and subjects rather than be moved by what was being made of them. The stories themselves were for the most part familiar already, from mother's knee or informal recitation; as familiar as Bible stories used to be even to the very young. If we think that the narrative arts of the Greeks are to be understood only as illustrations of their formal literature, we lose almost all of their message. But this is also a point in which they meet. The messages of public art (architectural sculpture) were generally of political and civic relevance in the broadest sense, including the practices of cult, the military and to a lesser degree every-

271 Marble relief from a wreck off Piraeus. A Greek seizes an Amazon by her hair. The group is copied and adapted from part of the composition on the shield of the Athena Parthenos; see [272]. Height 97 cm. (Piraeus)

day life, and they were similar, sometimes the same as those of the humbler arts, such as vase painting. Athenian tragedy, on the other hand, was concerned with eternal human and personal problems of family, duty, anger, revenge, retribution. But, visual or written for performance, they all depended almost wholly on the same body of subject matter – what we call myth, but what was to the Greeks their earliest history, when gods and heroes spoke and walked with men. The present was always explored through the past; a fact I have had occasion to refer to often already and which should never be forgotten in trying to understand the Greek's perception of the images around him and the reason why they appear as they do. Problems were generalized and expressed through versions of old stories, rather in the way that images were for long generalized and idealized, not presented in terms of contemporary reality. In this the Greeks seem unique among ancient peoples since this is something that goes far beyond ancestor worship. So our Greek was constantly reminded, not as we are of our political, military and entertainment élite, but of his heroic past, and this was no

266

272 Reconstruction drawing of the shield held by the Athena Parthenos, based on copies in various media [as 271]. Theseus and Athenian heroes rebuff the Amazons from the walls of Athens, a paradigm for the defeat of the Persians in 480/479 BC. The original was about 440 BC

simple story-telling since in every case there was a moral to be drawn, explicit or not. Only the approach of the Hellenistic period heralded a readiness to comment on contemporary life and people directly in art and literature, and even then, when a Hellenistic king celebrates his defeat of invading barbarians, he will do so both through direct reporting (Greeks fight Gauls) and through myth (gods defeat giants). It was a symptom of the decline of the small city-state and the rise of empires

and the cult of the individual. The practice lingers: Olivier's film of *Henry V* was planned to appear as a commentary on the 1944 invasion of Europe from Britain.

How aware was the classical Greek of these messages? We have to work hard enough to understand them, even to determine that they may be there. 'Pictures are for entertainment; messages should be delivered by Western Union.' Sam Goldwyn's view was probably the sort shared by a majority of Greeks. There would have been many different levels of understanding. When a new public monument like the Parthenon was unveiled it is likely that the message of its sculpture was unmistakable, even if not in all nuances, by the citizenry, many of whom had worked to help create it. They would not need to peer at it as we do to determine − is this a cushion or a shroud, a clipboard or a lyre-box? − and to explain figures and subjects accordingly. If privileged to enter the building he would have found the great gold and ivory statue [*140*] expressing his city's divinely protected destiny and its wealth, with other and mythical reminders of her successes [*271–72*]. But messages of civic arrogance need not outlive the period of their currency. By 400 BC the citizen of a defeated Athens may have seen or wished to see more myth than message in the sculptures. Later still the point would probably have been totally lost unless it had been explicitly recorded in literature (which, so far as we know, it was not). In the 2nd century AD the guide Pausanias dwelt on the Parthenos and the Athena stories of the pediments and ignored the metopes and frieze.

The same story could mean different things to the ancient viewer in different periods. The fight of gods and giants appeared woven on the robe given to Athena's statue in Athens from before the mid-6th century, perhaps because the warrior goddess was shown at her most effective there, always beside Zeus and her favoured Heracles. On the Siphnian Treasury of about 525 BC it may have been no more than a statement of Olympian power in the sanctuary of the god-lawgiver Apollo. On the Parthenon there may well have been hints that the gods' defeat of giants to save Olympian power paralleled Athens' struggle to save Greece; while on the Pergamum altar the implied enemy was probably the invading barbarian Gauls. Or take the Amazons: at first respected distant foes, the object of an expedition by Heracles, or at Troy; in the 5th century playing the part of a mythical parallel to invading and defeated Persians. Or centaurs: at first simply forest hunters, recruited for a role in some myths, even educating heroes in the skills

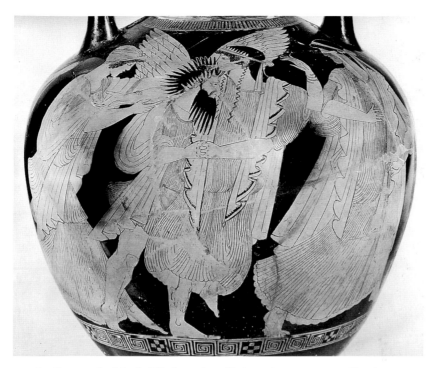

273 Icy Boreas, the North Wind, carries off the Athenian princess Oreithyia on an Athenian vase of about 475 BC. The Athenians had been told to worship Boreas because the Wind had helped them twice against the Persian fleet. The subject immediately became popular in Athenian art and literature. (Munich 2345)

of a country gentleman; but also out of control in civilized company, breaking up a marriage feast, and so a paradigm for barbaric behaviour, which might then be related to the Persians (who behaved as badly, it was said, and who invaded from a northern area which sided with the invader and where centaurs lived); and finally just fun creatures to be teased by Eros or Dionysus' rout. Yet for most Greeks any given image of an Amazon or centaur probably held no specific message, whatever the direct or indirect inspiration or intention may have been.

The society for which pictorial or other messages were being created would have understood them instinctively. In Athens the city goddess, representing the city's fortunes, would have been omnipresent, not least on coinage. In the 6th century her association with her favoured hero,

Heracles, meant that he could be used to mirror the fortunes and aspirations of Athens' rulers, by allusion to deeds that could be made to appear relevant, or the creation of new ones. The many images, on temples or thousands of everyday objects such as pots, would have become so commonplace that the Athenian lived rather than repeatedly re-read their messages. In the 5th century Heracles is supplanted by Theseus who becomes the hero of the new democracy and defender of Athens against the mythical forerunners of the Persian invaders – the Amazons. The medium for the change may have been hymns or recited poems, but the message was most widely dispersed in popular art. There are many comparable but minor historical or ritual events whose effect on art can be identified in the same way [273].

As Hellenistic rulers allowed themselves to be assimilated to gods and heroes, so representation of them and their stories proliferated, especially in parade or processional occasions, which surely accounts for the strong Dionysiac element in later Hellenistic art, when every other ruler thought himself a New Dionysus. The art of monuments and of everyday objects reinforced such interpretations. The images that beset the man in the Greek street mirrored his whole society, its history and religion. We can barely imagine such power in commonplace visual experience.

I have written of gods and heroes. What of images of the Greeks' own lives? These were never a dominant element in imagery, and certainly not on public monuments, except in cemeteries, or on votive monuments where the dedicator might dare to show him- or herself, much reduced in size, approaching a deity. The cemeteries were perhaps the most poignant memorials to the common man and woman, placed as they were conspicuously (though for practical reasons) on the roads leading away from cities. Such a public, everyday display of generally quiet homage to lost wives, husbands and children is unparalleled in any other place or period. If we look at vase painting, which probably gives an accurate idea of the range of commonplace images on objects in various media, we find little enough depicting farming or trade or the domestic life of women, nothing at all of contemporary civic life (the Assembly, law courts), and little even of the theatre. Only the workplaces of artists themselves are rather better represented in the Archaic period [274] or generic trivia [275]. In the later Archaic period the high life of the symposion and drunken dance (komos) were common themes on vases (made for symposion use), and the low life of the courtesan (hetaira) was fairly dispassionately recorded. Greek pornographic art was

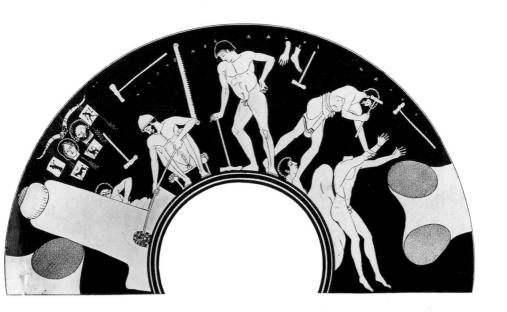

more reportage than titillating, and often shifted into the life of the unrequited satyr, the Athenian male's *alter ego*. This rather diffident attitude to the uncontrolled and ineffectual male, especially when expressed by male artists, is as endearing as the many TV programmes in which the male is regularly the idiot or incompetent, the woman in control. The Greek man was not on the whole invited by his art to glorify himself except in the defence of his city, although with time the existence of true portraiture and the hints in grave monuments of a heroized afterlife might have suggested something to aim for. The Greek woman was better served in art, as mortal or heroine.

274 (*Above*) On an Athenian vase workmen assemble a bronze statue (right) in a studio where model parts and implements hang and (left) the furnace is stoked and a boy works the bellows. From the horns above hang little votive plaques and masks. By the Foundry Painter, about 480 BC. (Berlin 2294)

275 A fishmonger, on a South Italian vase, 4th century BC. (Cefalu)

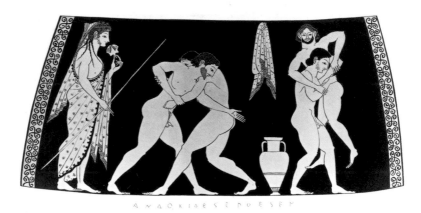

276 Naked wrestlers exercise on an Athenian vase by the Andocides Painter, about 520 BC. The trainer at the left sweetens the air with a nosegay. (Berlin 2159)

Male nudity in art was not heroic but appropriate for the young or vigorous, no more than a reflection of contemporary behaviour, especially in athletics [276], but recognized as a peculiarly Greek practice when compared with the non-Greek. Female nudity in art was, at all times, either religious or with an erotic connotation; women were not publicly naked. This is what was to make statues of naked goddesses so potent. If women's contribution to the planning or execution of major works outside the domestic (which was hardly trivial but of real everyday importance) is not apparent in sources or on monuments this is probably because it was slight. For all the male chauvinism and their

domination of civic and much private life, Greek artists and writers are not unsympathetic to the achievements of the other sex; poetesses were honoured and heroized. I doubt whether any other female contribution was suppressed in the record, although equally no opportunities outside the domestic were probably offered. As we have seen, for a while the private, and even public [277] activities of women were acceptable subjects for vase painting. A woman's understanding and appreciation of the messages of civic and private art would have been limited only by her education, which was not ignored for some classes, but more seriously limited by opportunity.

The imagery of Greek art was not all anthropoid. Greek artists showed themselves good observers of animal forms and behaviour, and images of them could be easily related to wealth (flocks), status (horse), hunting (deer, hares), sport (cock-fighting), or a degree of domestic comfort (pets). Floral patterns, always highly stylized – this was generally not an area for realism – were not always secondary, and they had a function enlivening an artefact, as it were wreathing it permanently (the Greeks were fond of leafy wreaths rather than flowers). With sturdy logic the Greek artist of the earlier period would not let pass any stray appendage without adding a snake's head (as on the *aegis* or the *caduceus*), and were ready to animate any object. We speak of a vase's lip, shoulder, belly; the Greek used the same terms and could express them by,

277 An Athenian wedding on a vase of about 430 BC (the scene unrolled). The couple leave the bride's home at night on a chariot (for such a special occasion), accompanied by folk carrying torches and presents, as well as the vase (left) which was used for the bridal bath. (London 1930.12–21.1)

278 Drinking from an eye-cup makes the vessel like a mask, its foot like a mouth, its handles ears (which is what Greeks called handles – *ota*)

for example, painting eyes on a cup, which then becomes like a mask [*278*], and in many other ways. A ship's ram is a charging boar's snout; eyebrows on armour become snakes, kneecaps gorgon faces. This is a form of animation that generally seemed to come more readily to nomadic (Scythian, Celtic) than to urban arts in antiquity.

Greek literature says little enough about contemporary arts. In Euripides Athenian women visiting Delphi recognize subjects in the temple sculpture and relate them to their weaving. The philosophers, such as Plato, could mistrust any art form that seemed to counterfeit reality yet fail to express absolute, ideal forms. Art was not big business until major and expensive projects required the attention of experts (a Phidias), or workshops attracted series of major dedicatory commissions. The major architects and sculptors seem to have been well paid but the masons who worked for them, though highly skilled, seem to have commanded only a standard day's wage. Yet many were available and able to work to a high degree of competence. We have the names of many otherwise unknown Classical Athenians who could very effectively copy models of figures and groups into marble for the

274

Erechtheion frieze (we have some of the accounts). This hardly makes a population of artists, but it does imply one in which what we regard as specialized artistic activity was almost a matter of everyday familiarity. Domestic crafts were part of daily life. In a structured society specialist craftsmen – potters, jewellers, smiths, masons – may still have had to work seasonally and tend their crops between whiles, but it is likely that as soon as, for example, pottery acquired a vigorous domestic and export market, the families of potter/painters worked virtually whole time at it. They would not, however, have earned as much as the middlemen who carried their wares far afield, over sea and land. Potting is a grubby, smoky job, but we know of potters from the Archaic period on who could afford rich dedications and receive civic recognition for their work. Some craftsmen, such as jewellers and silversmiths, were highly mobile and might generally expect their raw material to be provided by their customers.

I have concentrated on urban societies and their visual experience, because these are our fullest source. Many Greek cities were no bigger than villages by our standards, and familiarity with works of architecture or display which we so highly prize were unexceptional to their inhabitants. In the smaller and remoter settlements life was surely hard and the impedimenta of life impoverished. The show places were the local shrines – the parish churches – but also to a lesser degree household shrines, and even these might be graced by a painted vase or bronze figure which would have differed in no significant way from those seen in Athens or Olympia, or recovered from the export market. Greece was a small country, Greeks ready travellers. All this would have reinforced some uniformity of visual experience even if not of conduct of life. The real differences lay in whether you used clay or silver, slept on the floor or on an inlaid couch, had stone walls and a tiled roof, or mudbrick and thatch. But even then there was a common experience of a type which we must doubt ever to have been shared by the *fellahin* of the empires of the Nile and Mesopotamia with their masters. Perhaps small *is* beautiful, and even a pseudo-democracy the best of all environments for the effective deployment of arts and crafts for public benefit, instruction and delight. We know we cannot judge the quality of any society by whether it has gunpowder or penicillin or a Social Charter; better perhaps by how its craftsmen create a visual environment for their fellows that answers their aspirations, and encourages their sense of community and their society's needs.

The Legacy

Previous chapters have here and there dwelt on the unique character of Greek art among those of other ancient cultures: not better, whatever that means, but different and apparently readily absorbed by non-Greeks. In the Archaic period Greek art was not that unlike other arts of the Near East and Egypt; it was significantly influential only to the west, in Italy. With the Classical revolution it appeared to offer more, and by the end of antiquity traces of the classical idiom could be detected from Britain to China, from Siberia to the Sudan. This is less the achievement of Greek artists (except in the west) than of what they had created, which appeared to evoke a ready response among peoples whose own arts were quite differently composed and orientated. Much might be explained by the realism which may communicate more readily than more stylized forms do to those unfamiliar with them; much by the sheer convenience of the decorative package offered in the form of well-defined architectural orders, a repertory of geometric and floral ornament, and an easily organized and formulaic narrative style. Although this chapter is not about Greek art itself, consideration of what it offered others may help us define better what its essential qualities may have been for Greeks also.

IN ANTIQUITY

Greek artists were not evangelists. Others imposed their arts with their religion on the conquered or converted; not the Greeks, or at least not with the deliberation of Islam or Christianity. The physical presence of Greek artists in Italy certainly explains what happened there, and to a lesser degree this is true, for strictly limited periods, of what happened in Persia and farther east. More depended on travelling objects, and on copying and re-copying. Trade carried even cheap Greek goods like painted pottery (though not cheap to the purchaser) far beyond even the Mediterranean shores, while luxury objects travelled as far or further, by trade or gift. The Greeks were not always themselves the car-

riers, but the results were the same. Objects and copies do not inevitably carry with them the ideas and identifications which their makers intended, no museum labels or operating instructions, so the vestiges of Greek art in many places were subject to drastic reinterpretation, and in most instances what we observe is local artists borrowing what may already have been roughly familiar to them in their own arts, or something which they could use effectively in the service of their masters, priests or fellows.

In the Archaic period the East Greeks had foreign neighbours in Asia Minor (modern Turkey) and were at home in other areas of the Near East and Egypt, where they had trading stations. In Asia Minor what they had to offer was mainly in matters of stone sculpture and architecture. By the later 6th century the Persian king Cyrus was recruiting East Greek and neighbouring masons (working in a common style) for his palace building in Persia itself, and we can easily trace evidence of Greek techniques and some forms in what became Persian (Achaemenid) court architecture and sculpture, especially in the Archaic disposition of dress [279] and in masonry techniques, beside other and more

279 Relief at Persepolis. Compare [75, 77, 81] for the treatment of the stacked folds of dress

280 Stone relief from the Peshawar area, N. Pakistan. The man at the centre and the women are dressed as Greeks, a style deriving from Greek presence in the area. This was from a Buddhist monument of the 1st century A D, forerunner of the rich series of Gandara reliefs. Height 14.5 cm. (Peshawar)

281 Clay statue of Vajrapani, guarding the Buddha. The figure is derived from the Lysippan type for Heracles, replacing the club with a thunderbolt. In a monastery at Hadda near Kabul. 2nd/3rd century A D?

282 Silver cup from Afghanistan? In the company of music-making monkeys of Eastern type a clubman attacks a man beside a boar, a group adapted from, perhaps, some Heraclean scene in Greek art. Early centuries A D. Diameter 14.5 cm. (St Petersburg)

283 Stone statue of the Buddha. The pose and gentle contrapposto with the clinging dress emphasizing the figure are Greek-inspired. 2nd century AD. (Once Mardan)

influential forms derived from other areas of the Persian Empire – Mesopotamia and Egypt. In parts of the empire in the 5th and 4th centuries Greco-Persian styles developed, blending Greek treatment and attitudes (more relaxed than the oriental) to eastern subjects. The tendency was towards the adoption of Greek pattern and towards more realism in natural, especially animal, forms.

Alexander's Macedonians and Greeks eclipsed the Persian Empire in the 4th century, leading, in his successors' kingdoms, to a further blend of Greek and oriental. He had marched to India, and in Bactria (north Afghanistan/Tadjikistan, around the River Oxus) an independent Greek kingdom developed. It had become isolated from the rest of the Greek world by the Parthians who had pushed back the Greeks from Persia but were still customers for Greek art [284]. The Bactrians pressed even into India (as Indo-Greeks), where they ruled and built, on into the 1st century BC, and where Greek art was influential in forming sculptural expression of Buddhism [280]. In the 2nd century AD classical influence was reinforced by a new flow of trade with the Mediterranean, sponsored by Rome but conducted by Greeks, mainly from Alexandria. The resultant blend of Greek and Indian arts created the basic idiom of Buddhist art which can be traced thereafter wherever Buddhist art was carried, to China, Korea and Japan. It appears in architectural pattern, in re-identifications of the images of Greek deities [281] and of Greek myth [282]. It was probably influential in the adoption of a figure type for the standing Buddha that clearly owes much both to Greek anthropomorphic gods and to Greek realism in the rendering of a relaxed standing figure [283].

In Persia, the Sasanian successors to the Parthians enjoyed their own versions of Greek subjects but in a style of more obviously local inspiration. Islam effectively put an end to further classical influence, generally abjuring figure art, although it readily absorbed and developed classical floral patterns and rinceaux of flowers and leaves. We may look on them as typically Islamic 'arabesques', but their western derivation is clear.

We turn now to the north where, by about 600 BC the East Greeks were busy planting colonies around the Black Sea. In the north their neighbours were nomad Scythians, whose own arts (the Animal Style) were expressed on non-monumental objects and with wondrously fluid and stylized animal figures as unlike Greek as they could be. Greek artists were soon making luxury objects for their neighbours, but gener-

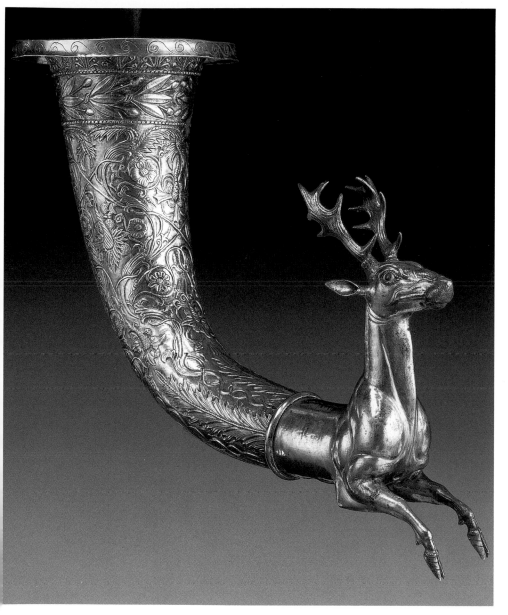

284 Gilt silver rhyton. The shape is Eastern but the floral is Hellenistic and so is the realistic rendering of the stag, so this is Greek work for a Parthian master. 1st century BC. Height 27.4 cm. (Malibu 86.AM.753)

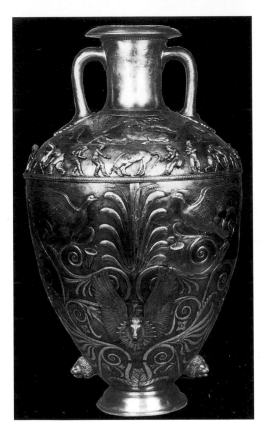

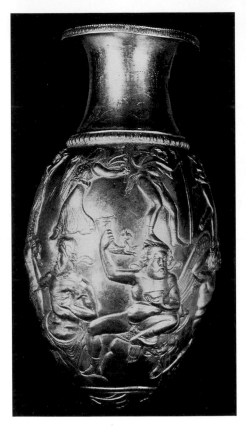

285 Gilt silver amphora, made by Greeks but found in a Scythian grave at Chertomlyk, in the Ukraine. The shape is Greek but it is provided with sieve and spouts for the Scythian drink of fermented mare's milk. The florals are early versions of the Hellenistic extravaganzas. On the shoulder are animal fights and scenes of Scythians with their horses. 4th century BC. Height 70 cm. (St Petersburg)

286 Gilt silver flask from Borovo in Bulgaria (Thrace). The figures are Greek but unusually occupied; the shape and work are probably local. About 300 BC. Height 18.2 cm. (Rousse)

ally on shapes already familiar to them, introducing their own view of the Scythians [*186, 285*]. Local arts effectively ignored the incompatible Greek style (and Greeks made some abortive attempts at a blend) but the market encouraged a phase in Greek art which could hardly have developed in the way it did elsewhere. To the west, in Thrace (south of the Danube), the story is different, and local artists soon became adept

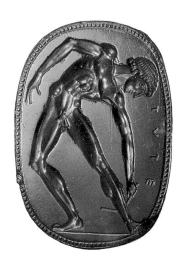

287 A fine anatomical study of an athlete on an Etruscan carnelian scarab. The youth is identified as the Greek hero Tydeus (Tute in Etruscan). About 470 BC. Height 14 mm. (Berlin F 195)

copyists of Greek style [286], sometimes in the service of their own religion, sometimes simply adopting Greek myth without apparent reinterpretation.

In the west the Greeks effectively colonized all the shores of South Italy and the eastern half of Sicily between the later 8th century and the 6th. It became Great Greece, Magna Graecia. The cities were rich, their rulers patrons of major architectural projects, but the impetus had to come from homeland artists and, with the best will in the world, it is difficult to call local styles other than provincial until the advanced Classical period when the luxury arts in particular became highly developed. Local populations were the losers, mainly kept at arm's length, their arts roughly hellenized.

To the north, Etruria was a different proposition. A country of strong, independent cities, wealthy in metals, courted from the beginning by both Greeks and the Phoenicians who had settled in Sardinia and Carthage. The native arts were hitherto unpretentious, and what we call Etruscan art is entirely the product of the absorption of Greek art and artists, with a significant addition in early years from Phoenician art. Etruscans learned quickly and in some arts they excelled, especially the luxury arts. They used Greek art to figure their gods, and adopted Greek myth to a degree that suggests no serious reinterpretation in the interests of any local corpus of myth [288]. Some work is barely distinguishable from Greek, and the enquiry whether the craftsmen were Greek or not is meaningless [287]. But much that was produced locally betrays a special quality that we must acknowledge to be Etruscan, for

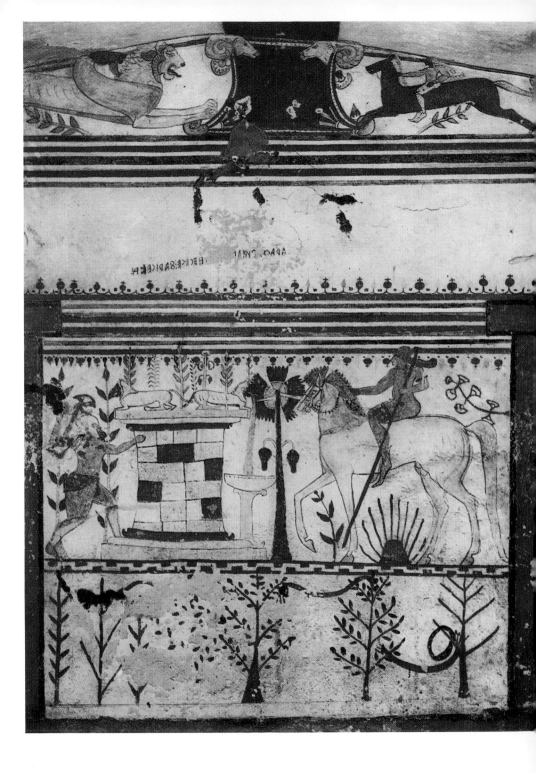

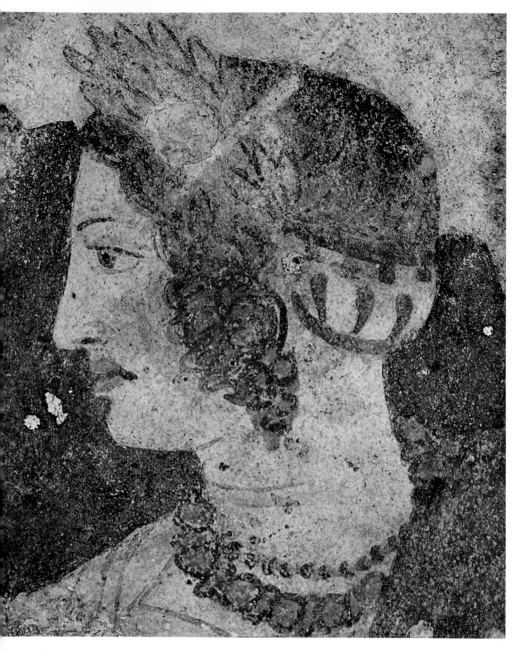

288 (*Left*) Painting from the Tomba dei Tori at Tarquinia in Etruria. A version of the Greek scene of Achilles (left) ambushing the Trojan prince Troilos, with exotic florals. About 530 BC

289 (*Above*) Head of Velia, wife of Arnth Velcha, from the Tomba del Orco at Tarquinia. She was shown reclining on a couch with her husband. 3rd century BC

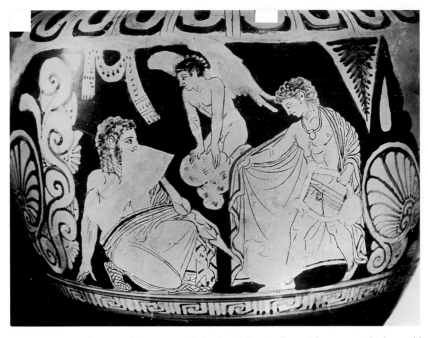

290 From an Etruscan red figure vase, imitating Athenian but with a scene which would have been improbable in Athens: Ganymede exposes himself to a kneeling Zeus, with thunderbolt, while a cynical Eros watches. 4th century BC. (Oxford 1917.4)

all that there is nothing in it not derived from Greek [290]. There is a tendency to a more florid use of colour and less regard for proportion in figures and ornament. This is not provinciality but an expression of Etruscan taste, and they were a people whose ways of life and thought seem profoundly un-Greek.

In the Hellenistic period Etruscan arts remain distinctive but also become more hellenized through contact with the Greeks to the south and employment of Greek artists [289]. By the end of the period both Etruria and Magna Graecia had been effectively absorbed by Rome. Early Rome was barely distinguishable in its arts from Etruria. Exposure to Greek art from the south meant less than the effect produced by the introduction to Rome of booty, in the form of metalwork, statuary and paintings, from conquered Greek cities in Italy, and soon from Greece itself. Temples had already acquired classical Greek orders, and now

some acquired whole pediments taken from Greek sites [148]. There is record of the Greek architects and sculptors employed in the city. The old wax busts of ancestors were no match for the new Greek realism in portraiture and myth, and the Romans adopted the Greek idiom and mythology as completely as had the Etruscans, but choosing a Trojan ancestor, Aeneas. Private collections of Greek art developed, and this created a demand for more, readily supplied by Greek artists who tirelessly copied Greek originals [291], a major source for scholars and museums today. These artists had been schooled in the Hellenistic idiom but a taste both for versions of the Archaic and especially for the High Classical led to deliberate production of archaizing [270] and classicizing [292] works for the new patrons. Art for Art's Sake was born, and with it the Art Market, with little precedent except in the practices

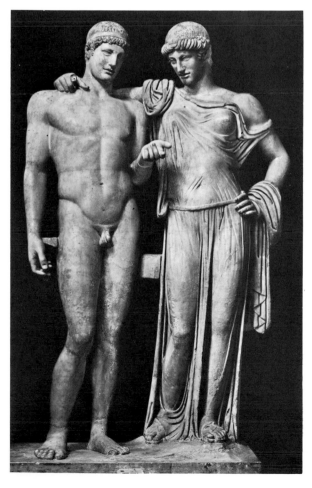

291 Fragmentary ancient plaster cast of a head from the original bronze group of the Tyrannicides which stood in Athens' *agora*. This was part of a full cast kept at Baiae (Bay of Naples) as a model from which marble copies could be made for Roman customers, as [163]. Height 20 cm. (Baiae; copy in Oxford)

292 Marble group of a youth and a woman, sometimes identified as Orestes with Electra. The types are Early Classical and Classical but the group is a creation of the 1st century BC. (Naples 6006)

293 Early Christian art adopted the Greek sea-monster (*ketos*; see [*246*]) to represent Jonah's whale. It appears here on a 12th-century AD *ambo* at Ravello

of a few Hellenistic princes. When the Emperor Augustus boasted that he had turned Rome from a city of brick into one of marble, he meant he had turned it into a Greek city, while his writers (who *were* Roman) very successfully adopted Greek epic and lyric forms to create far more original art forms than did the artists.

The Roman Empire ensured that classical Greek style was dominant over a far wider area than Greek colonialism and trade had reached. In some areas, especially architecture, portraiture, true perspective painting, and the use of narrative techniques to depict recent history and not just myth, there were important developments, but classical standards of realism and proportion were relaxed and artists no longer sought either to counterfeit or improve on nature. The results are effective, often entertaining, seldom moving, at least to us, except to the degree that they express the Imperial achievement of Rome and the *pax Romana*. But they were influential enough through their accessibility of style and sheer quantity to guarantee the survival of classical art for centuries to come.

The oldest and most distinguished of the arts of the Mediterranean world was that of Egypt, impermeable to classicism. Egyptian artists adhered to a basic idiom which successfully expressed their views about life and especially the afterlife for some four millennia. They knew about realism, but recognized its limitations, and used life as a source, not a model, with brilliant results. Even domination by Persians, Greeks and Romans had little effect until the collapse of the old religion in the face of Christianity. This, in Coptic art, signalled at last the adoption of a version of classical art, even of its pagan mythology, a strange epilogue to the history of the most singular and distinctive of ancient arts.

The creation of an eastern Roman Empire and the rise of Byzantium saw what seems to be a deliberate withdrawal from classical semi-realistic forms to something more stylized and spiritual in intention, though classical themes and styles could still be expressed. This is a significant period for the legacy of classical art only inasmuch as the arts of Byzantium returned west, into Italy, and in their purest classical form. But in the east and in the Greek homeland, especially once the barrier of Islam (7th century) was reinforced by an Ottoman Empire (14th century), and despite the intrusion of Crusaders and Italian merchants, the heritage of classical art was almost extinguished.

The dissolution of the Roman Empire had left classical arts visible though less influential, and to the west and north Celtic and nomad arts, not unaffected by the classical, became more dominant. The Middle Ages were not darkly unclassical, but the heritage was intermittent in time and place. Classical literature was better understood than classical arts, and much illustration of it showed total unawareness of classical images; the figures of a Jupiter or Venus had to be recreated. Yet Romanesque art can carry much that is classical in ornament and occasionally in figure work, mainly derived from its appearance on monuments of the Roman period and not at all from Greek antiquity. The classical elements in sculpture and painting make them no more true descendants of Greek art than any Buddha, but they own the same source.

Classical art and architecture were more visible in Italy than Greek Bronze Age art had been to Greeks in their Dark Age (Chapter One). Some classical images had embedded themselves successfully in the arts of Christianity [293]. A renaissance of classical literary interests led to

more careful observation of the physical heritage and how it related to literature. The architecture was drawn and copied, the sculpture collected. Popes and princes built palaces quite unlike anything classical but decorated with the classical orders. The nudity of the classical reliefs was copied both in statuary and painting for comparable classical subjects, but also for Biblical ones – whence Michelangelo's *David* [*294*]. Assimilation of princes to gods and heroes was copied (though usually without the nudity). Leonardo's anatomy drawings depend ultimately on Lysippus, Michelangelo's *Pietà* on Hellenistic groups, while ancient technical achievements of bronze casting and massive architecture were more closely observed and copied. Classical mythology was plundered for new subjects to render in a classical manner, and masterpieces of ancient artists known only from descriptions were recreated, such as Apelles' famous painting of *Calumny*. Italian, and European Renaissance art was totally unclassical in its conception, purpose and the visual experience it offered, but also totally dependent on classical models.

294 *David* by Michelangelo. Heroic classical nudity used for a Biblical subject (as before, by Donatello). AD 1501–4. Height 4.34 m. (Florence)

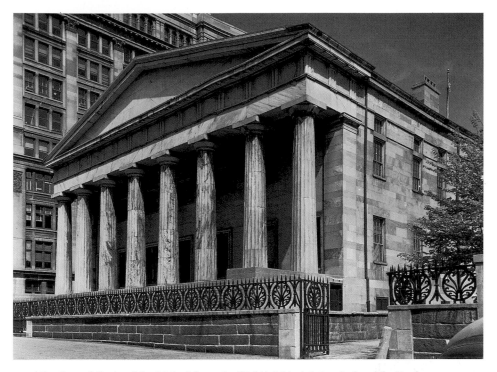

295 The Second Bank of the United States in Philadelphia (1818–24). A purely Greek Classical façade, even to the cast iron railings

All this was essentially the product of observation and collecting in Italy. Further exploration of Greek lands led to new views about Greek architecture and art which, added to the Italian experience and encouraged by the travels of artists and patrons, led to a new, neo-Classical movement, strongest in the 18th and 19th centuries. Classical buildings were more closely copied now, in part or whole, guided by architects' studies on the ground. In Britain the Greek Revival buildings are splendid precursors of many less imaginative essays in the use of the classical orders. The mode was followed no less enthusiastically in Europe and the United States [295], although it is as often the architecture of Rome as that of Greece that provided the model. Even the architecture of modernism and post-modernism makes repeated reference to the classical in detail or proportion. The only real competition has been native Gothic, which seems not to have survived into the second half of this century.

296 Neo-classical engraved gems formerly in the Poniatowski Collection. Hermes (Mercury) rescues Lara from Hades; Leto turns the Lycian peasants into frogs. (Impressions 215, 149, Oxford)

297 (*Below left*) *Napoleon*, by Antonio Canova. This marble version was given to Lord Wellington by the British Government, and installed in his home, Apsley House, at Hyde Park Corner. AD 1803–06. Height 3.45 m

298 (*Below right*) Bronze medallion showing Napoleon as Heracles receiving the submission of Vienna and Presbourg. AD 1805. (Oxford)

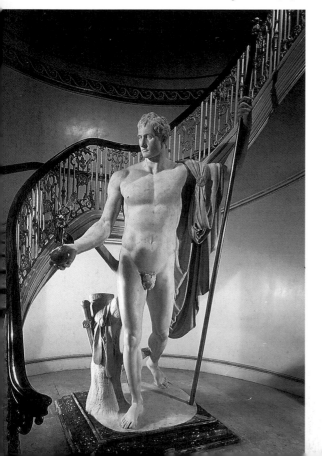

299 (*Right*) Hyde Park Gate, London, a classical design by Decimus Burton (1825), crowned by John Henning's version of the Parthenon frieze, here celebrating victories in the Napoleonic Wars. Napoleon [*297*] is next door

In the figure arts the classical style was adopted in attempts to recapture the idealized simplicity of ancient Greece that Winckelmann had tried to define. It was also borrowed by sculptors, painters and engravers to render new expressions of classical myth, including many a subject that no ancient artist cared for [296]. The results range from, to us, rather painful parodies of Greek art (then virtually unknown to artists except in Roman versions of sculpture or on Pompeian walls), to majestic recreations by a David or Ingres of epic and historical occasions. And soon archaeology intrudes to provide the *realia* for tableaux of daily life in Greece and Rome, far too good to be true but full of intelligently observed detail and a lot of gratuitous female nudity, bringing us back to where our book started, dancing on the steps of the Parthenon [3]. Napoleon can emerge as a naked Greek god with Victory on his hand [297], like the Parthenos, or as a Heracles [298] receiving the submission of cities classically personified with the city-crowns of a Tyche [214], images determined in Greece more than two millennia before. And the Parthenon Frieze can be recruited to help celebrate his defeat [299]. The

truths about classical art which were being revealed by the display of original works such as the Parthenon Marbles seem to have had little effect on this activity, although it was artists who first perceived their value. Either the challenge was too great or the need not apparent. In the last hundred years the spirit of classical art, as understood by artists and the general public rather than scholars, has provided an idiom for the arts of totalitarian states (Soviet or Nazi), for popular entertainment and advertising, for bogus attempts to regain classical innocence through imitation. 'I suppose it is some sort of tribute to its reputation that Greek sculpture could so readily serve the noble, the sinister and the absurd' (I quote myself). But much depends on views about Greek excellence which were brilliantly advertised by the Greeks themselves, and which a sober and sometimes resentful, revisionist modern world is beginning to question.

The camera has never quite eradicated the call for classical realism in western art, and in early days was subservient to it. *Trompe l'oeil* in two

300 Albrecht Dürer's engraving of the Fall of Man. Both figures derive from classical models, the Adam from the Apollo Belvedere [*11*]. AD 1504

301 The drawing on a gold-anodized aluminium plaque attached to the antenna of the spacecraft, Pioneer 10, launched in March 1972. The planetary system (below) and human figures are intended to indicate the source of the craft, its time of launching and the creatures which created it. It was expected to travel a distance of 3,000 light years in the next 100 million years, the time it might take for an alien civilization to discover it. It is now (1996) 5.8 billion miles away, and still reporting back

or three dimensions has a continuing appeal, whether realistic or ideal, and the western classical, ultimately Greek, tradition can even dictate the forms of protest adopted by modernists. The classical fragment continues to inspire and the nude has lost none of its potency. It remains the archetypal way in which western men and women depict themselves in important contexts, a very different attitude to that adopted by other cultures. It was chosen in the 16th century after Christ, and with classical figures, to represent the Fall of Man [300], and in the 20th century for his Apotheosis [301], both derived in pose and detail from that idealized view of humanity devised by the artists of Classical Greece.

Chronological Chart

B.C.	Events and People	Sculpture
1200		
	Collapse of Mycenaean society	
1100		
1000	Migrations to East Greece	
900	Increased contact with Levant	
800	Greeks trading in Syria Greek colonies in Italy and Sicily	Minor bronzes
700	Homer, Hesiod Greeks in Egypt Greek colonies on Black Sea	Daedalic style Monumental marble statuary begins 640 Archaic *kouroi* 630–480
600	Sappho, Alcaeus Solon Persians win Lydia and part of East Greece Pisistratus (Athens), Polycrates (Samos) Inception of democracy in Athens	Athenian Archaic gravestones 600–480 Ionian-type *korai* Limestone pediments, Athens 'Peplos kore' 530 Marble pediments, Athens 510
500	Battle of Marathon 490 Persian invasion and defeat 480–79 Defeat of Carthage 479 Athenian rule in Aegean 478–450 Aeschylus Herodotus, Sophocles Pericles Peloponnesian War and defeat of Athens by Sparta 431–04 Thucydides, Euripides, Aristophanes	Aegina pediments Tyrannicides group 470 Olympia pediments, metopes 460 Myron 450 Phidias and the Parthenon 460–430 Polyclitus 440 Athenian Classical gravestones 430–310
400	Socrates, Plato Rise of Macedon – Philip II Demosthenes, Aristotle Defeat of Greeks by Macedonians 338 Alexander King of Macedon 336–23 Foundation of Alexandria 331	Kephisodotos 370 Scopas 360 Praxiteles 340 Portrait sculpture begins Lysippus 320
300	Dissolution of Alexander's Empire Gauls invade Asia Minor Western Greeks absorbed by Rome	Alexander sarcophagus 315 Tyche of Antioch 290
200	Defeat of Macedonians by Romans 197 Sack of Corinth by Romans 146	Pergamene statues of Gauls Great Altar of Zeus at Pergamum Victory of Samothrace Venus de Milo
100	Greece a Roman province Rome destroys walls of Athens 86	Laocoon Archaistic and Neo-attic

Architecture	Vase Painting and other Arts	B.C.
		1200
		1100
	Submycenean pottery	
		1000
Lefkandi heroon	Protogeometric pottery	
		900
	Geometric pottery 9th–8th c.	800
	Cretan bronze shields	
	Protocorinthian 725–625	700
First peripteral temple (Samos)	Protoattic 700–625	
	Island relief vases	
	Island gems 675–550	
	Corinthian vases 625–550	
Doric order evolved by 600	Athenian black figure 625–475	600
Ionic order evolved by 560	Coinage begins	
Apollo Temple, Corinth 550	'François vase' 570	
Hera temples, Samos 560, 530–	Spartan cups, bronze vases	
Artemis Temple, Ephesus 550–	Amasis, Exekias 550–530	
Siphnian Treasury, Delphi 525	Chalcidian, Caeretan vases	
	Red figure invented 530	
	Euphronios, Euthymides	500
First Parthenon	Berlin, Kleophrades Painters	
Zeus Temple, Olympia 460	500–470	
	Pan Painter 470	
	Niobid Painter 460	
Hephaisteion 449–	White ground funeral *lekythoi*	
Parthenon 447–33	Achilles Painter 440	
Propylaea Athens 437–32	South Italian red figure beings	
Erechtheion 421–05		
	Dexamenos, gem engraver	
	Pebble mosaics begin	
Apollo Temple, Bassae	Meidias Painter 400	400
Corinthian capital invented		
Asklepios Temple, Epidaurus	Kerch style vases	
Apollo Temple, Delphi	Marsyas Painter	
Artemis Temple, Ephesus rebuilt	Vergina tomb paintings	
356–	End of red figure in Greece	
Mausoleum 350	Cabirion, Gnathia vases 4th–3rd c.	
Apollo Temple, Didyma 313–		
	End of red figure in in S. Italy	300
	Tanagra figurines	
Stoa of Attalus, Athens 150	Relief cups 3rd–2nd c.	200
	Tazza Farnese	100

The floruits of artists and approximate dates for works of art are given

Selected Bibliography

* indicates a good source of illustration; + indicates a standard handbook on a major subject

GENERAL BACKGROUND

Cultural History

+ *Cambridge Ancient History* new edition vols. 3–7, Cambridge 1982–94 and accompanying Plates Volumes. *Oxford History of the Classical World* (eds. J. Boardman, J. Griffin, O. Murray) Oxford, 1985 and in separate volumes, Greek and Roman. MURRAY, O. *Early Greece* London, 1993. HORNBLOWER, S. *The Greek World 479–323 BC* London, 1983. GREEN, P. *From Alexander to Actium* London, 1990

Mythology

+ ROSE, H.J., *Handbook of Greek Mythology* London, 1960. *Oxford Classical Dictionary* new ed. forthcoming

GENERAL ART AND ARCHAEOLOGY

All periods

+ ROBERTSON, M. *History of Greek Art* Cambridge, 1975, detailed narrative. ★ RICHTER, G.M.A. *Handbook of Greek Art* London, 9th ed. 1987, by subjects not periods. + POLLITT, J.J. *The Ancient View of Greek Art* New Haven, 1974. + POLLITT, J.J. *The Art of Greece: Sources and Documents* Cambridge, 1990. BIERS, W. *The Archaeology of Greece* Cornell, 1987. ★ PEDLEY, J.G. *Greek Art and Archaeology* Englewood Cliffs, 1993, includes Bronze Age. ★ *The Oxford History of Classical Art* (ed. J. Boardman) Oxford, 1993, including Roman. SPARKES, B.A. *Greek Art* Oxford, 1991, survey of recent literature for students

Geometric and Archaic

HAMPE, R. and SIMON, E. *The Birth of Greek Art* Oxford, NY, 1981, for possible continuity from Bronze Age. BOARDMAN, J. *Pre-classical Style and Civilisation* Harmondsworth/Baltimore, 1967 + BOARDMAN, J. *The Greeks Overseas* London/New York, 1980, on loans and influence before about 500 BC. +★ COLDSTREAM, N.J. *Geometric Greece* London, 1977. ★ AKURGAL, E. *The Birth of Greek Art* London, 1968, for Eastern arts, 8th/7th cent. ★ JOHNSTON, A.W. *The Emergence of Greece* Oxford, 1976. + HURWIT, J.M. *The Art and Culture of Early Greece* Ithaca, 1985

Classical

POLLITT, J.J. *Art and Experience in Classical Greece* Cambridge, 1972. LING, R. *Classical Greece* Oxford, 1988. HOPPER, R.J. *The Acropolis* London/New York, 1971

Hellenistic

★+ POLLITT, J.J. *Art in the Hellenistic Age* Cambridge, 1986. ONIANS, J. *Art and Thought in the Hellenistic Age* London, 1973

Western Greek

★ LANGLOTZ, E. and HIRMER, M. *The Art of Magna Graecia* London, 1965

SCULPTURE

General

+ ADAM, S. *The Technique of Greek Sculpture* London, 1960. ★+ ASHMOLE, B. *Architect and Sculptor in Ancient Greece* London/New York, 1972, mainly Olympia, Parthenon, Mausoleum. ★ LULLIES, R. and HIRMER, M. *Greek Sculpture* London/New York, 1960. ★ MATTUSCH, C. *Classical Bronzes* Cornell, 1996. + RICHTER, G.M.A. *The Sculpture and Sculptors of the Greeks* London, 1971 (4th ed.), dated but good on names. ★+ RICHTER, G.M.A. *Portraits of the Greeks* (ed. R.R.R. Smith) Oxford, 1984. + STEWART, A. *Greek Sculpture* New Haven/London, 1990. ★ HOUSER, C. and FINN, D. *Greek Monumental Bronze Sculpture* London, 1983. ★ ROLLEY, C. *Greek Bronzes* London, 1986. SPIVEY, N. *Understanding Greek Sculpture* London, 1996. STEWART, A. *Greek Sculpture* New Haven, 1990.

Archaic

★+ BOARDMAN, J. *Greek Sculpture, the Archaic Period* London/New York, 1978, student handbook. ★+ RIDGWAY, B.S. *The Archaic Style in Greek Sculpture* Chicago, 1993. ★ PAYNE, H. and YOUNG, G.M. *Archaic Marble Sculpture from the Acropolis* London, 1936. ★+ RICHTER, G.M.A. *The Archaic Gravestones of Attica* London, 1961. ★+ RICHTER, G.M.A. *Korai* London, 1968. ★+ RICHTER, G.M.A. *Kouroi* London, 1970

Classical

★+ ASHMOLE, B. and YALOURIS, N. *Olympia* London, 1967 ★+ BOARDMAN, J. *Greek Sculpture, the Classical Period* London/New York 1984, student handbook. ★+ BOARDMAN, J. *Greek Sculpture: the Late Classical Period* London/New York, 1995, student handbook, also Western Greek sculpture. ★+ RIDGWAY, B.S. *The Severe Style in Greek Sculpture* Princeton, 1970. ★+ RIDGWAY, B.S. *Fifth Century Styles in Greek Sculpture* Princeton, 1981. ★+ BOARDMAN, J. and FINN, D. *The Parthenon and its Sculptures* London, 1985. ★+ PALAGIA, O. *The Pediments of the Parthenon* Leiden, 1993. ★+ JENKINS, I. *The Parthenon Frieze* London, 1994

Hellenistic

★+ BIEBER, M. *The Sculpture of the Hellenistic Age* New York, 1954. ★+ SMITH, R.R.R. *Hellenistic Sculpture* London, 1991, student handbook. ★+ SMITH, R.R.R. *Hellenistic Royal Portraits* Oxford, 1988. ★+ RIDGWAY, B.S. *Hellenistic Sculpture* I Wisconsin, 1990

Copies

★ BIEBER, M. *Ancient Copies* New York, 1977. + RIDGWAY, B.S. *Roman Copies of Greek Sculpture* Ann Arbor, 1984

Western Greek

★+ HOLLOWAY, R. *Influences and Styles in the Late Archaic and Early Classical Sculpture of Sicily and Magna Graecia* Louvain, 1975, student handbook. ★+ BOARDMAN, J. in *Greek Sculpture: the Late Classical Period* see above.

ARCHITECTURE

★ BERVE, H., GRUBEN, G. and HIRMER, M. *Greek Temples, Theatres and Shrines* London, 1963. + DINSMOOR, W.B. *The Architecture of Ancient Greece* London/Chicago, 1952, dated but comprehensive. + LAWRENCE, A.W. *Greek Architecture* (ed. R.A. Tomlinson) Harmondsworth, 1996. + COULTON, J.J. *Greek Architects at Work* London, 1977. WYCHERLEY, R.E. *How the Greeks built Cities* London, 1962

PAINTING

General

★+ ARIAS, P., HIRMER, M. and SHEFTON, B.B. *A History of Greek Vase Painting* London, 1961. + COOK, R.M. *Greek Painted Pottery* London, 1972. ★ ROBERTSON, M. *Greek Painting* Geneva, 1959. ★+ *Greek Vases: Lectures by J.D. Beazley* (ed. D.C. Kurtz) Oxford, 1989. WEBSTER, T.B.L. *Potter and Patron in Ancient Athens* London, 1972. SPARKES, B.A. *Greek pottery* Manchester, 1991, student introduction. BRUNO, V. *Form and Colour in Greek Painting* London, 1977. ANDRONIKOS, M. *Vergina* Athens, 1984, the Macedonian tombs

Geometric and Archaic

★+ DESBOROUGH, V.R.d'A. *Protogeometric pottery* Oxford, 1952. ★+ COLDSTREAM, J.N. *Greek Geometric Pottery* London/New York, 1968. + BEAZLEY, J.D. *The development of Attic Black Figure* Berkeley, 1951. ★+ BOARDMAN, J. *Athenian Black Figure Vases* London/New York, 1974, student handbook. ★+ BOARDMAN, J. *Athenian Red Figure Vases, the Archaic Period* London/New York, 1975, student handbook. ★+ HASPELS, E. *Attic Black Figured Lekythoi* Paris, 1936. ★+ PAYNE, H. *Necrocorinthia* Oxford, 1931. ★ AMYX, D.A. *Corinthian Vase Painting* Berkeley/L.A., 1988. COOK, R.M. forthcoming on East Greek pottery

Classical

★+ BOARDMAN, J. *Athenian Red Figure Vases, the Classical Period* London/New York, 1989, student handbook. ★+ ROBERTSON, M. *The Art of Vase-painting in Classical Athens* Cambridge, 1992. ★+ KURTZ, D.C. *Athenian White Lekythoi* Oxford, 1985. ★+ BEAZLEY, J.D. *The Berlin Painter, The Kleophrades Painter, The Pan Painter* Mainz, 1974. ★+ KURTZ, D.C. *The Berlin Painter* Oxford, 1982, anatomical observation. ★+ TRENDALL, A.D. *Red Figure Vases of South Italy and Sicily* London/New York 1989, student handbook

OTHER ARTS

★+ BOARDMAN, J. *Greek Gems and Finger Rings* London/New York, 1980. ★ RICHTER, G.M.A. *The*

Engraved Gems of the Greeks and Etruscans London, 1968. ★+ PLANTZOS, D. forthcoming on Hellenistic gems. ★+ KRAAY, C.M. and HIRMER, M. *Greek Coins* London/New York, 1966. ★+ HIGGINS, R.A. *Greek and Roman Jewellery* London/New York, 1961. WILLIAMS, D. and OGDEN, J. *Greek Gold* London, 1995. ★+ HIGGINS, R A *Greek Terracottas* London, 1963. ★+ STRONG, D. *Greek and Roman Gold and Silver Plate* London/Ithaca, 1966. BARBER, E.J.W. *Prehistoric Textiles* Princeton, 1990

ICONOGRAPHY

★+ *Lexicon Iconographicum Mythologiae Classicae* I-VIII, Zurich/Munich 1981–97, detailed, multilingual. ★+ CARPENTER, T.H. *Art and Myth in Ancient Greece* London/New York, 1991, student handbook. ★ SCHEFOLD, K. *Myth and Legend in Early Greek Art* London, 1966. ★ SCHEFOLD, K. *Gods and Heroes in Late Archaic Greek Art* Cambridge, 1978. Four other books by SCHEFOLD (in German, Munich) cover the rest of the Classical and Hellenistic periods. SHAPIRO, H.A. *Myth into Art* London/New York, 1994. ★ SHAPIRO, H.A. *Personifications in Greek Art* Zurich, 1993. ★ JOHNS, C. *Sex or Symbol?* London, 1982. WEBSTER, T.B.L. and TRENDALL, A.D. *Illustrations of Greek Drama* London, 1971. ★ BÉRARD, C. (ed.) *A City of Images* Princeton, 1988, non-myth scenes. *Ancient Greek Art and Iconography* (ed. W.G. Moon) Madison, 1983, essays and bibliography

PERIPHERAL

★ | BOARDMAN, J. *The Diffusion of Classical Art in Antiquity* Princeton/London, 1994. ★+ PORADA, E. *The Art of Ancient Iran* London/New York, 1965. ★ PIOTROVSKY, B. et al. *Scythian Art* St Petersburg/London, 1987. ★ VENEDIKOV, I. and GERASSIMOV, I. *Thracian Art Treasures* Sofia, 1975. ★+ BRENDEL, O. *Etruscan Art* Harmondsworth, 1978. + HARDEN, D.B. *The Phoenicians* London, 1962

RELATED SUBJECTS

★ BIEBER, M. *A History of Greek and Roman Theater* Princeton, 1961. + KURTZ, D.C. and BOARDMAN, J. *Greek Burial Customs* London/Ithaca, 1971. ★ RICHTER, G.M.A. *The Furniture of the Greeks, Etruscans and Romans* London, 1966. ★ RICHTER, G.M.A. *Perspective in Greek and Roman Art* London, 1970. SNODGRASS, A.M. *The Arms and Armour of the Greeks* London, 1982

THE LEGACY

SEZNEC, J. *The Survival of the Pagan Gods* New York, 1953. CLARK, K. *The Nude* Harmondsworth, 1960. HONOUR, H. *Neo-Classicism* Harmondsworth, 1968. IRWIN, D. *Winckelmann. Writings on Art* London, 1972. HASKELL, F. and PENNY, N. *Taste and the Antique* New Haven, 1981. ONIANS, J. *Bearers of Meaning* Cambridge, 1988, the classical orders to the Renaissance. JENKYNS, R. *Dignity and Decadence. Victorian art and the classical inheritance* London, 1991

Acknowledgments

The author and publisher are grateful to the following institutions and individuals, as cited in the captions, for supplying illustrations and for permission to use them:

Ankara Museum 121. Argos Museum 22. Collection Duke of Norfolk, Arundel Castle 7. Athens: Acropolis Museum 71, 76–7, 82, 105, 124, 132, 143; Agora Museum 115, 216, 265; Benaki Museum 3, 247; Kerameikos Museum, 16, 20, 85, 145; National Museum 18–19, 23, 25, 28, 36, 42, 46, 61, 70, 75, 83–4, 87, 112, 130, 146, 149, 152, 181, 195, 201, 236. Basel: Antikenmuseum 91, 110, 209; Skulpturhalle 137. Staatliche Museen, Berlin 58, 73, 86, 92, 103–4, 133, 177, 188 right, 210, 215, 219–20, 263, 274, 276, 287. Courtesy Museum of Fine Arts, Boston 27, 107, 173. Museo Civico, Brescia 101. Musées Royaux, Brussels 254. Museo Mandralisca, Cefalu 275. Musée du Chatillonnais, Chatillon-sur-Seine 119. Nationalmuseet, Copenhagen 21, 269. Delphi Museum 66, 68, 78, 81, 131. Albertinum, Dresden 229. National Museum, Dublin 175. Eleusis Museum 48. Epidaurus Museum 159. Archaeological Institute, Eretria 14. Florence: Galleria dell' Accademia 294; Museo Archeologico Nazionale 89–90, 204. Antiquario, Gela 114. Heraklion Museum 32. Prince Philipp von Hessen Collection 252. Archaeological Museum, Istanbul 65, 224, 237. Archaeological Museum, Izmir 64. Badisches Landesmuseum, Karlsruhe 102. London: British Museum 33, 40, 43, 49, 93, 106, 108–9, 120, 122, 134, 138–9, 142, 151, 153, 155, 157, 183, 185, 188 left, 199, 205–6, 239, 248, 255–6, 259 left, 277, 300; By courtesy of the Board of the Trustees of theVictoria & Albert Museum 297. Collection of J. Paul Getty Museum, Malibu, CA 98, 161, 284. Whitaker Museum, Motya 162. Antikensammlungen, Munich 41, 69, 80, 111, 198, 232, 238, 243, 273. Mykonos Museum 51. Museo Archeologico Nazionale, Naples 163, 165, 169, 193, 257, 262, 292. Metropolitan Museum of Art, New York 39, 166, 184, 211, 233. Olympia Museum 10, 30, 34–5, 125, 127–9, 150, 268. Ashmolean Museum, Oxford, 8, 9, 15, 94, 174, 213, 241, 290–1, 296, 298. Museo Nazionale, Palermo 160, 196. Paris: Bibliothèque Nationale 26, 55, 56, 123 right, 244, 259 right; Musée du Louvre 17, 24, 45, 53, 59, 74, 88, 97, 100, 178, 182, 197, 225–6, 240, 242, 270. Archaeological Museum, Pella 261. Archaeological Museum, Peshawar 280. Piraeus Museum 118, 271. Archeologisceski muzej, Plovdiv 249. Private collection 123 left. University Museum, Reading 212. Museo Nazionale, Reggio frontispiece, 4, 171–2. Rome: Museo Nazionale delle Terme 148, 164, 221, 227–8, 231, 235; Vatican Museums 11, 96, 167, 168, 202, 214, 222, 234, 264; Villa Giulia 44, 253. Rousse Museum 286. Hermitage, St Petersburg 179, 185–7, 190, 282, 285. Samos Museum 29, 38, 57, 117. Sperlonga Museum 230. National Museum, Syracuse 52. Museo Nazionale, Taranto 207–8, 245–6. Teheran Museum 147. Thasos Museum 47. Thessaloniki Museum 180, 192, 194. Tocra Museum 95. Museum of Art, Toledo 250–1, Royal Ontario Museum, Toronto 2, 140. Antikensammlungen des Archäologischen Instituts der Universität, Tübingen 176. Kunsthistorisches Museum, Vienna 50. Martin von Wagner Museum, Würzburg 99, 170.

Other photo sources are:

Alinari 227, 253, 264, 286, 292. Wayne Andrew 295. Arts of Mankind 180, 228, 262. Athens: American School of Classical Studies 216, 265; British School 13; DAI 10, 20, 25, 29–30 left, 34–6, 38, 42, 57, 85, 105, 112, 117, 145–6, 167, 268; Ekdotike 51, 192, 260; French School of Archaeology 22, 47, 75. John Boardman 6, 8, 32, 96, 291, 293, 296, 299. A.C.L., Brussels 254. Oriental Institute, Chicago 147, 279. J.M. Cook 37, 64. Michael Duigan 18, 59, 74, 76, 131, 144, 200. M. Dudley 26, 297. David Finn 294. Alison Frantz 61, 71, 83, 157, 160. Giraudon 182, 226, 244. Hirmer Fotoarchiv 11–12, 16–17, 28, 46, 52, 63, 65–6, 68, 70, 78, 81, 84, 87, 89–90, 96, 101, 103–4, 111, 114, 120, 123, 125, 127–30, 132, 135, 138–9, 141–3, 149, 150–2, 163, 169, 171–2, 188, 195–6, 201–2, 204, 206–8, 221, 223–4, 236–7, 245–6, 259 left, 271. J.M. Hurwit 124 left. Kaufmann 238. London: AKG 219, 232; AKG/Erich Lessing 220; Fratelli Fabbri, Milan/Bridgeman Art Library 189; Royal Academy of Arts 7; Ronald Sheridan/Ancient Art and Architecture 1. Mansell 5. Foto Marburg 159. Jean Mazenod, L'Art Grec, Editions Citadelles & Mazenod, Paris 48, 77, 82, 134. M. Mellink 113. © Photo R.M.N., Paris 45, 53, 97, 100, 197, 225, 242. PHA/Rowland 283. DAI, Rome 230, 234, Scala frontispiece, 4, 44, 89, 164–5, 193, 222, 231, 235, 257. R. Schoder 267. F. Tissot 281. U.S. Information Services 301. M.-L. Vollenweider 55, 187, 213. R.L. Wilkins 9, 122, 258, 278.

Drawings derive from the work of the following:

After Andronikos Vergina 1984 191. From H. Berve, G. Gruben & M. Hirmer Greek Temples, Theatres and Shrines 1963 126. S. Bird 156. J.J. Coulton 13, 136. G. Denning 62. A. von Gerkan 158. E.B. Harrison 272. L. Haselberger 217. H. Knackfuss 218. F. Krischen 67, 154. After Kunze Meisterwerke der Kunst, Olympia 1948 54. After H. Payne Perachora Vol 1 1940 31. K. Reichhold 203, 275. E.-L. Schwandner 79. A. Zippelius 266. Marion Cox created 60, 72 and added to 62.

Index